SEPTEMBER 11, 2001

A Record of Tragedy, Heroism, and Hope

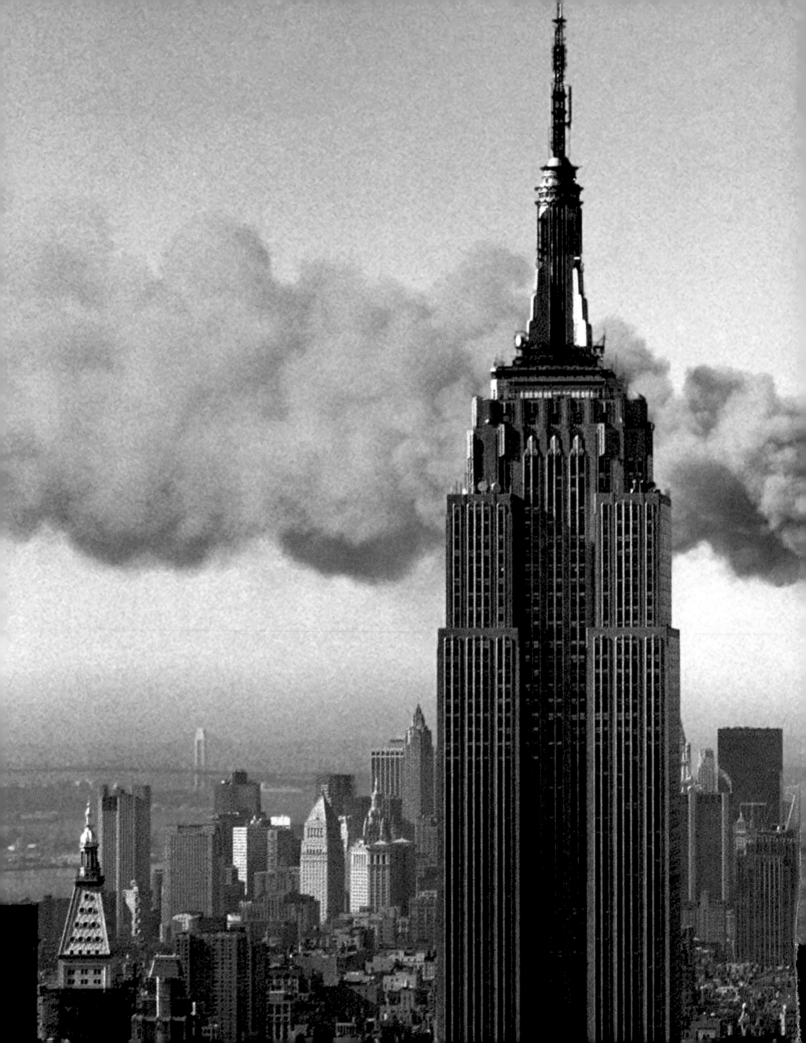

New York City, September 11, 2001: On a day pilots described as "brutally clear," two hijacked passenger jets slammed into the 110-story towers of the World Trade Center and set off massive fires visible throughout the city.

PHOTOGRAPH: Marty Lederhandler/AP Wide World Photos

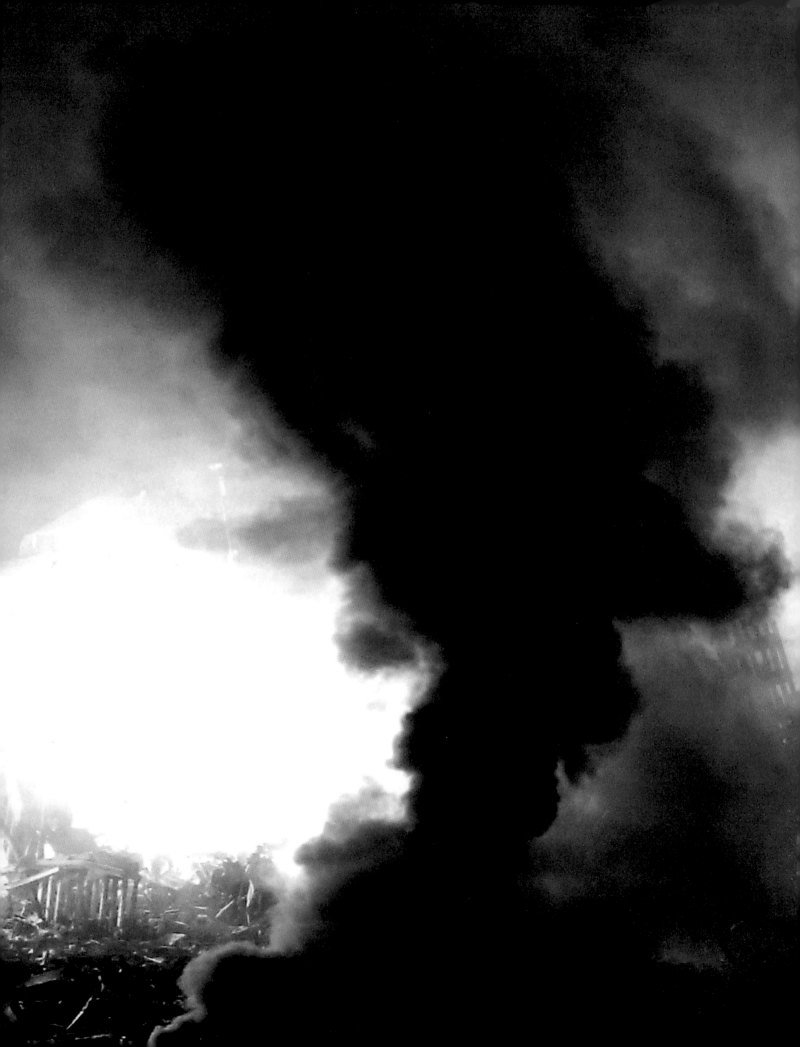

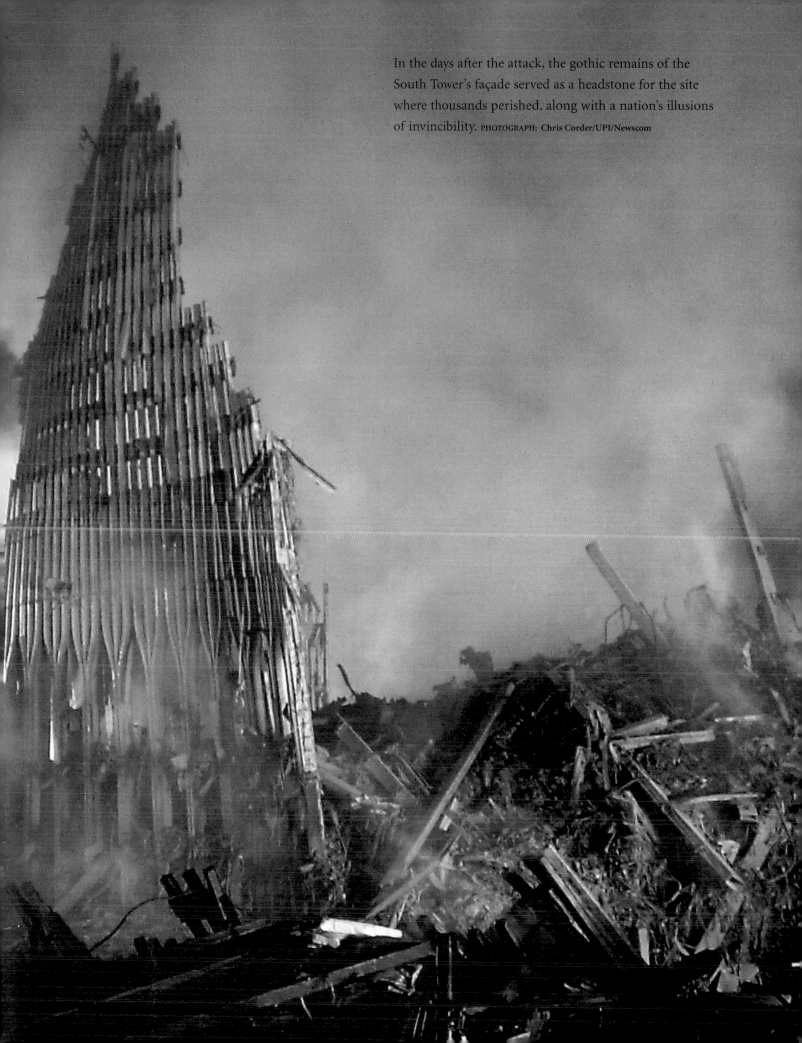

In the days after the attack, the gothic remains of the South Tower's façade served as a headstone for the site where thousands perished, along with a nation's illusions of invincibility. PHOTOGRAPH: Chris Corder/UPI/Newscom

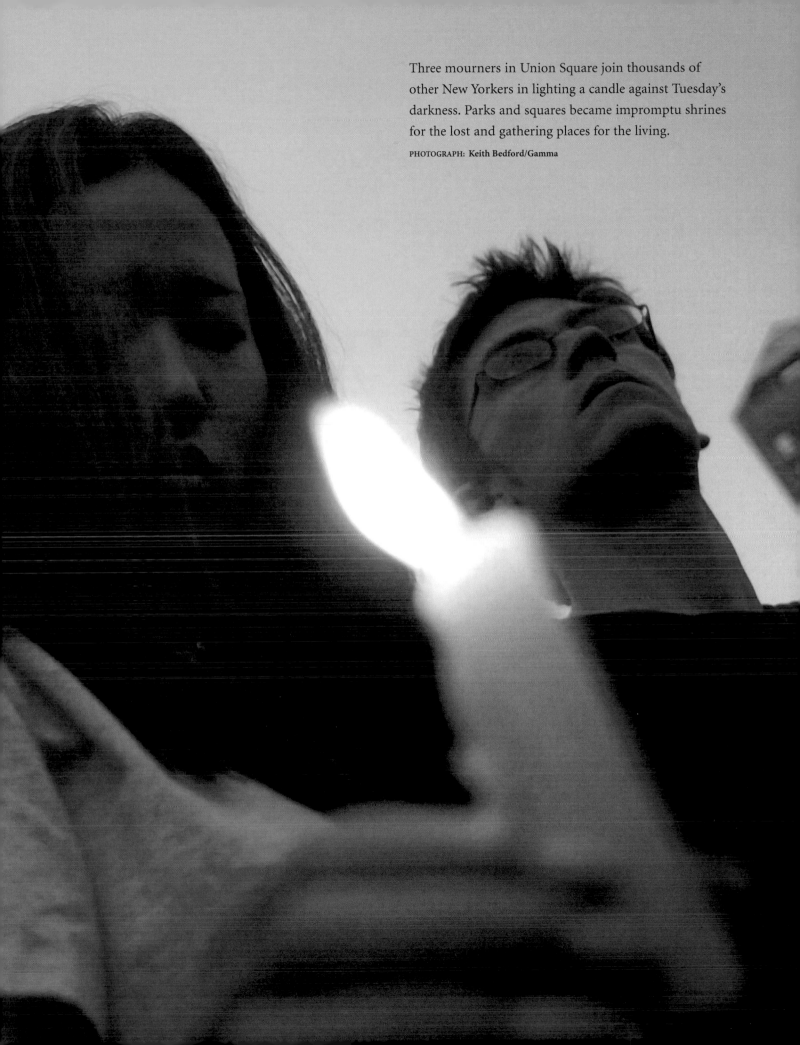

Three mourners in Union Square join thousands of other New Yorkers in lighting a candle against Tuesday's darkness. Parks and squares became impromptu shrines for the lost and gathering places for the living.

PHOTOGRAPH: Keith Bedford/Gamma

SEPTEMBER 11, 2001

A Record of Tragedy, Heroism, and Hope

By the editors of

New York

HARRY N. ABRAMS, INC., PUBLISHERS

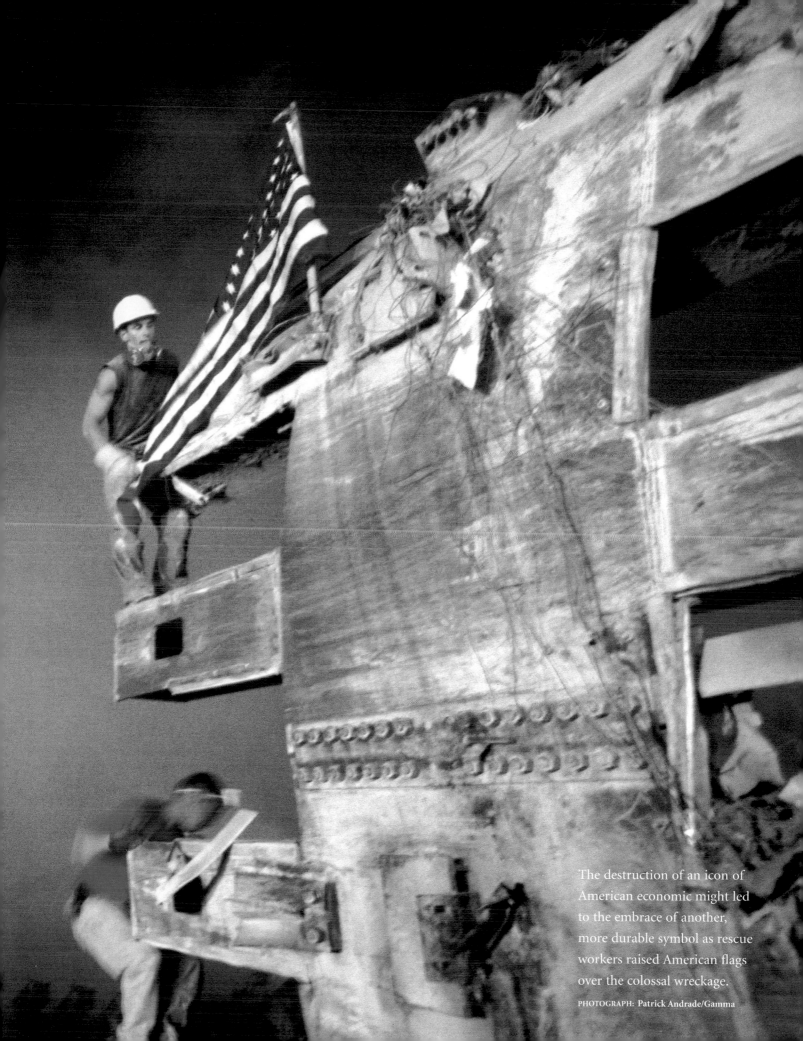

The destruction of an icon of American economic might led to the embrace of another, more durable symbol as rescue workers raised American flags over the colossal wreckage.

PHOTOGRAPH: Patrick Andrade/Gamma

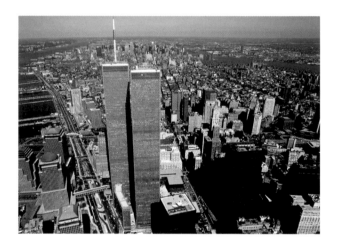

IT WAS A HORROR THAT ARRIVED, LITERALLY, OUT OF BLUE SKIES, slicing low through the fabric of a perfect, perfectly ordinary September morning on the island of Manhattan. Looking up, as tourists do but New Yorkers mostly don't, a few saw the terrible blossom of flame. More, in the next moments, saw that a great wound had been opened in the steel façade of the North Tower. But no one yet could imagine what this meant.

Silvery, abstracted monoliths—to New Yorkers the twin towers (a tourist's term, after all) weren't symbols of Wall Street, or capitalism, or America, or anything. They were landmarks, fixed and solid as a mountain range, and their inhuman immensity at first concealed the event's real meaning. But after the second plane veered in, malevolent, and vanished into the South Tower, giving birth to a pulsing, thirty-story plume of flame, the unthinkable began to sink in: there were people in there.

So it became a human story. Trade orders and memos and briefs and wills glittered in the air. Dress shoes (symbols of professional careers, of frivolity, of our strange and precious way of life) littered the streets leading from the towers, discarded by fleeing people.

Focusing on what was on the upper floors was harder. But gradually it dawned that those falling specks had arms and legs. The fire imposed terrible choices. People—who'd kissed their spouses and children and gone to work that morning just like us—were jumping eighty stories to their death as we watched.

A door had been opened to a new city, and a future we could never have imagined, a sense that was heightened when the South Tower—how could it happen?—came down in an accelerating rush, crushing fire trucks and ambulances, sending mammoth clouds rolling down city streets. What a place New York became—dark as night at noon on a flawless summer day, smothered beneath a thick blanket of dust and ash, lit by candles, clothed in flags, papered by the photos of the missing, stalked by hero firemen, soldiers, grieving widows, ghosts.

From the first moments, there were volunteers. Scrums of young people who'd found their way past the security checkpoints at Canal Street begged for a chance to pitch in. Construction workers and morticians drove all night from points west and south to contribute their sweat and expertise. Three-star chefs manned mess-hall kitchens; Harrison Ford served meals. New York City never felt more American—and not just because everyone had a flag on his hard hat.

Then there was the tangle of steel and concrete that still smoked, in which gold and bodies were mixed, in which nothing was alive. Ground Zero. Hell. Metaphors can't bring us to that place.

But of course, we were there, and we're still there. That's the meaning of all those flags—they were symbols of our neighbors who showed courage or fear, who suffered and died. These pictures are a record of our own lives, our own history—and of a week like no other.❡

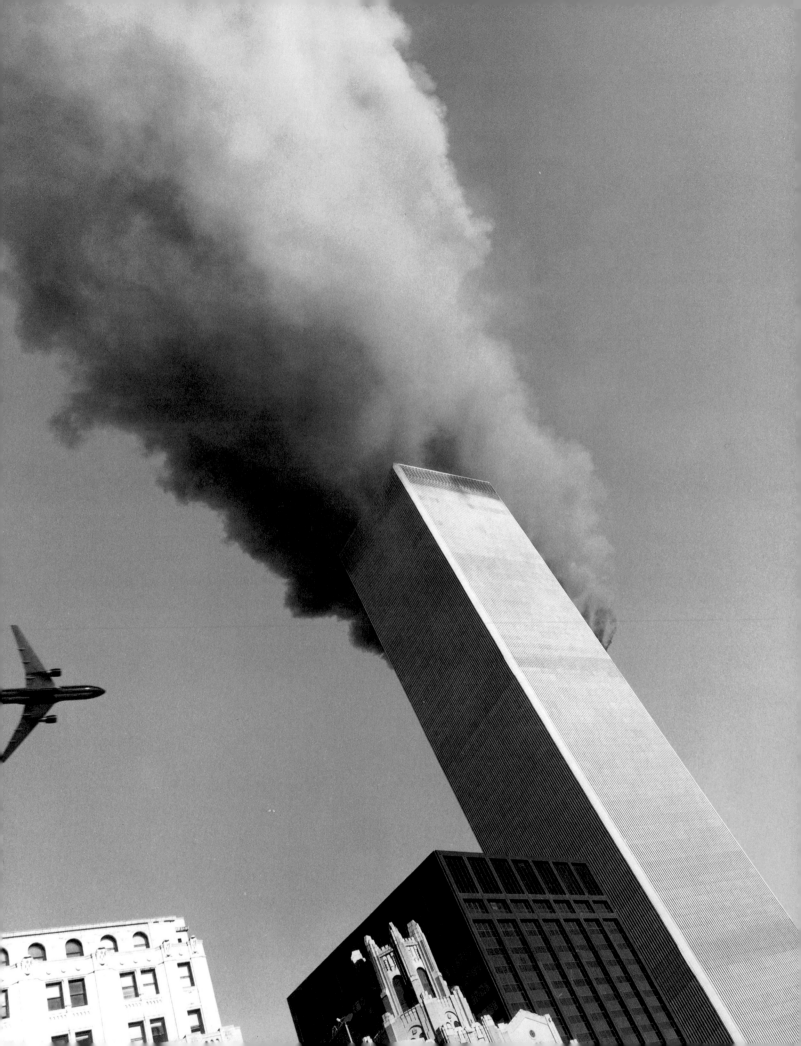

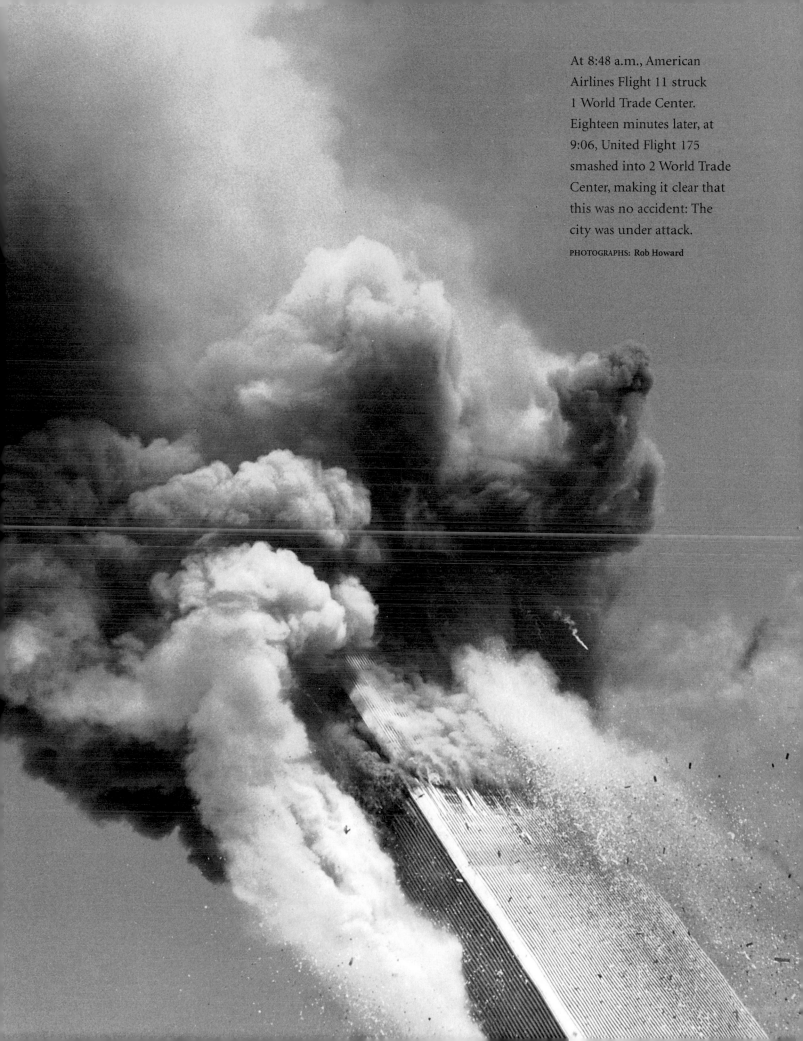

At 8:48 a.m., American
Airlines Flight 11 struck
1 World Trade Center.
Eighteen minutes later, at
9:06, United Flight 175
smashed into 2 World Trade
Center, making it clear that
this was no accident: The
city was under attack.

PHOTOGRAPHS: Rob Howard

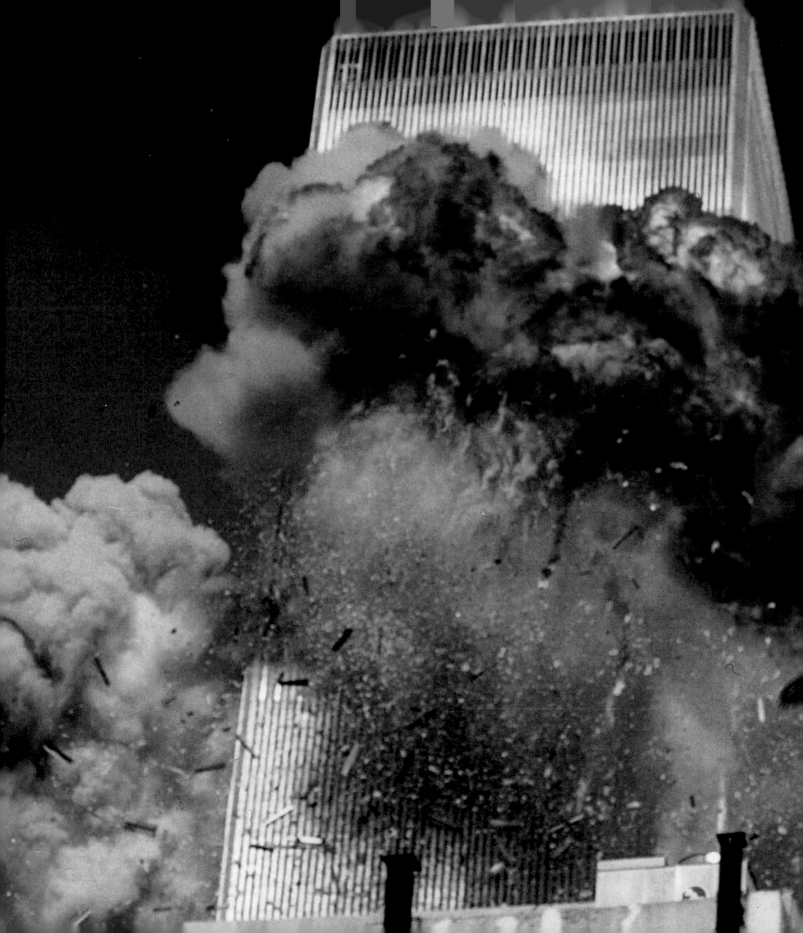

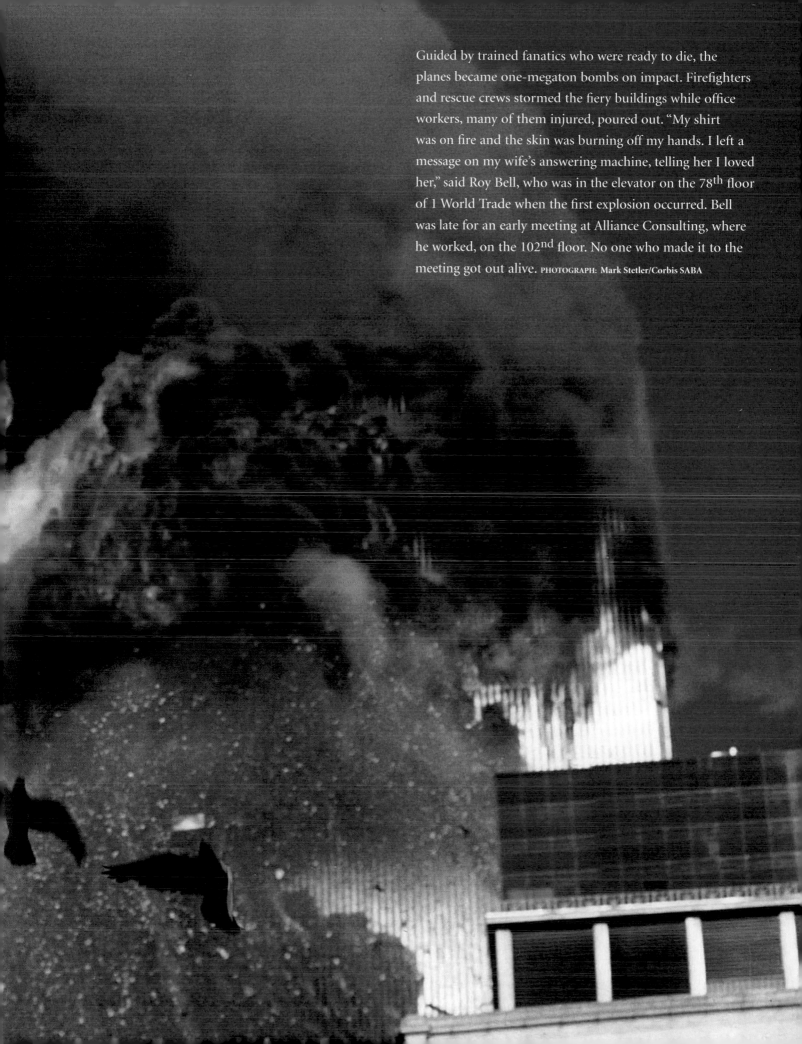

Guided by trained fanatics who were ready to die, the planes became one-megaton bombs on impact. Firefighters and rescue crews stormed the fiery buildings while office workers, many of them injured, poured out. "My shirt was on fire and the skin was burning off my hands. I left a message on my wife's answering machine, telling her I loved her," said Roy Bell, who was in the elevator on the 78th floor of 1 World Trade when the first explosion occurred. Bell was late for an early meeting at Alliance Consulting, where he worked, on the 102nd floor. No one who made it to the meeting got out alive. PHOTOGRAPH: Mark Stetler/Corbis SABA

As word of the unfolding tragedy ricocheted around New York, people spilled out of offices, apartment buildings, and subways all over the city. A crowd massed on Broadway, fifteen blocks north

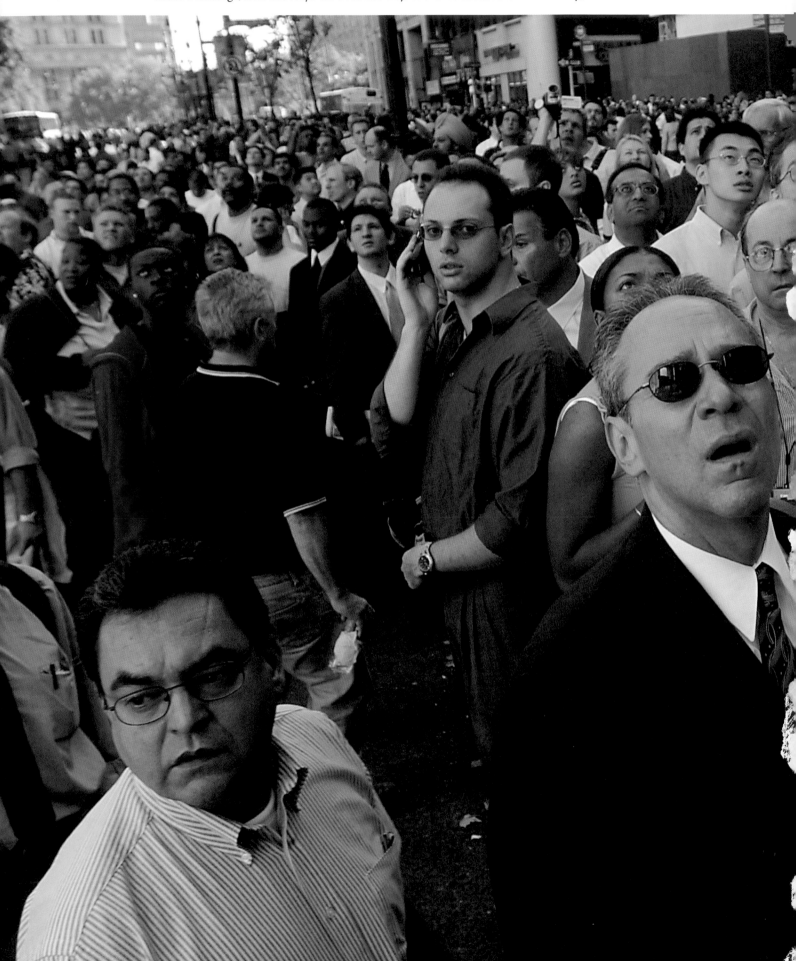

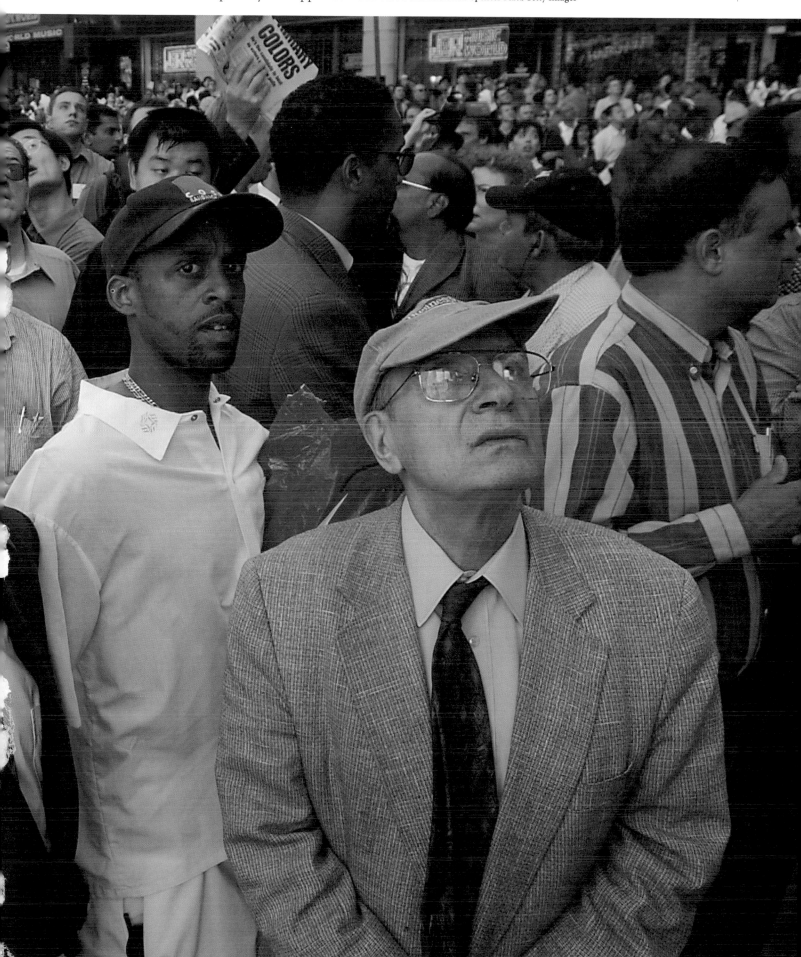

of the Trade Center, to watch the stuff of nightmares written across the sky, as the towers burned and then—inexplicably—disappeared from view. PHOTOGRAPH: Spencer Platt/Getty Images

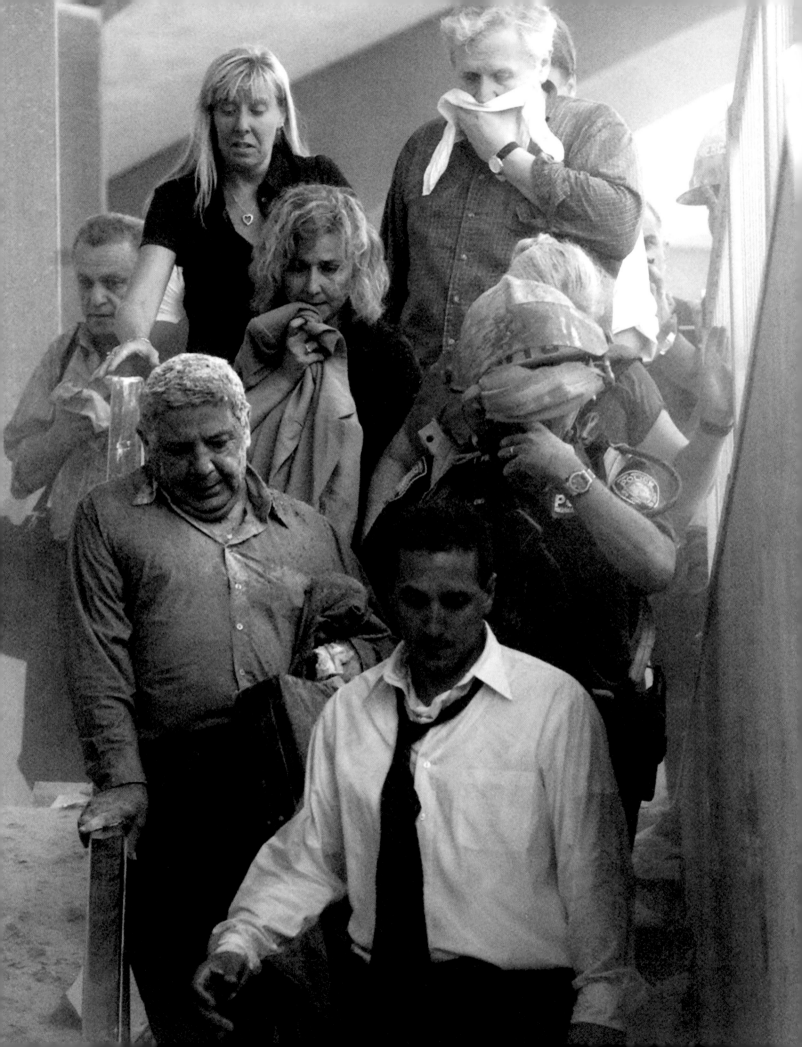

The public address system advised people to remain in their offices, but most took to the stairways, which were eerily quiet and orderly. They filed down to safety—past firemen climbing up. "One fireman stopped to take a breath, and we looked each other in the eye," said Louis Lesce, who escaped from his office on the 86th floor of the North Tower. "He was going to a place that I was damn well trying to get out of. I looked at him thinking, 'What are you doing this for?' He looked at me like he knew very well. 'This is my job.'"

PHOTOGRAPHS: Shannon Stapleton/Reuters/Timepix (opposite); John Labriola/AP Wide World Photos (below)

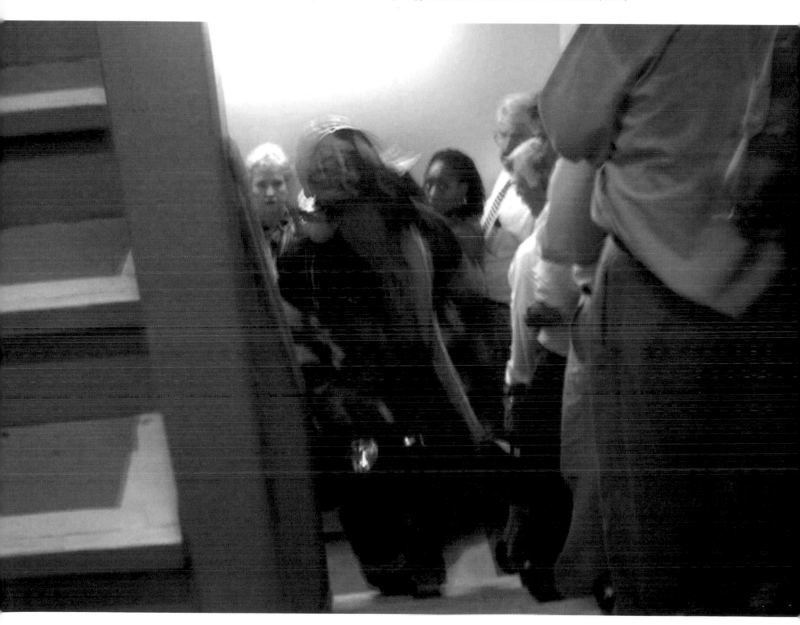

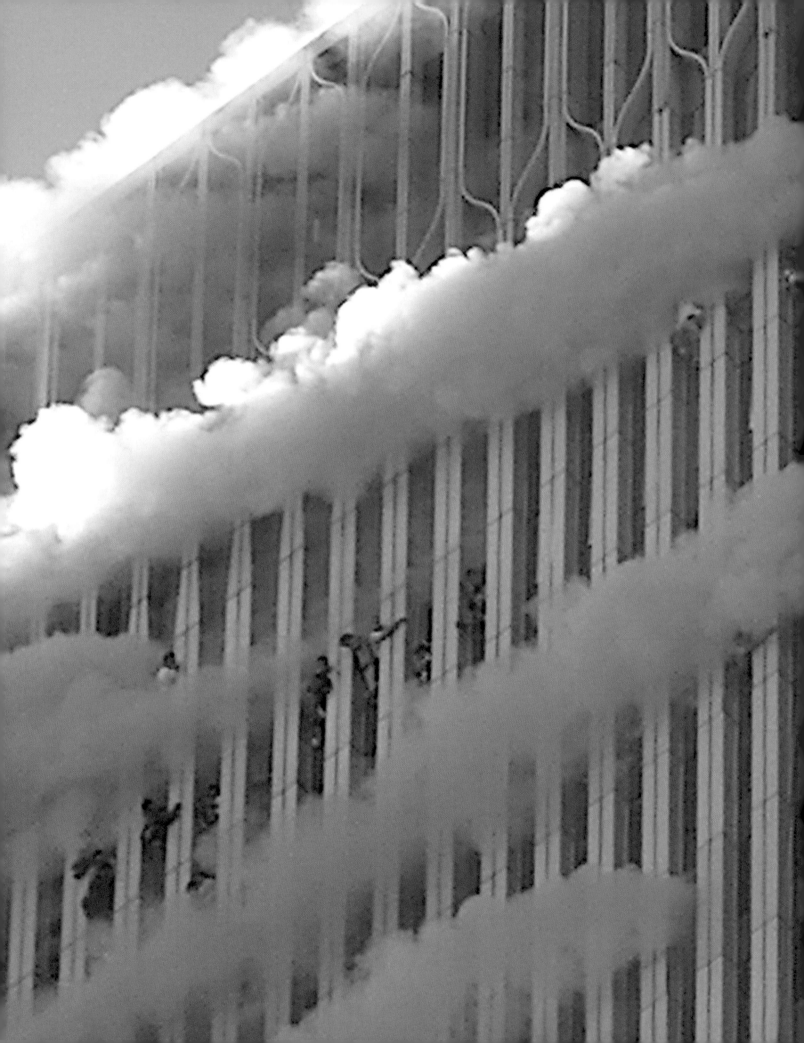

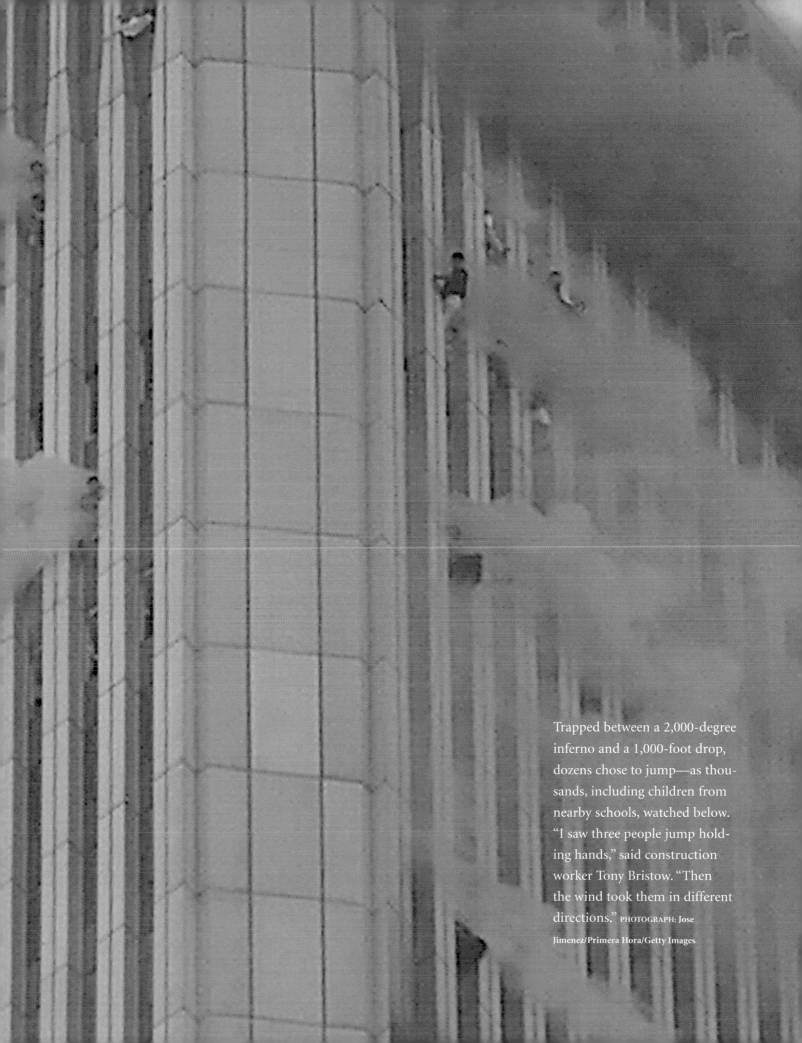

Trapped between a 2,000-degree inferno and a 1,000-foot drop, dozens chose to jump—as thousands, including children from nearby schools, watched below. "I saw three people jump holding hands," said construction worker Tony Bristow. "Then the wind took them in different directions." PHOTOGRAPH: Jose Jimenez/Primera Hora/Getty Images

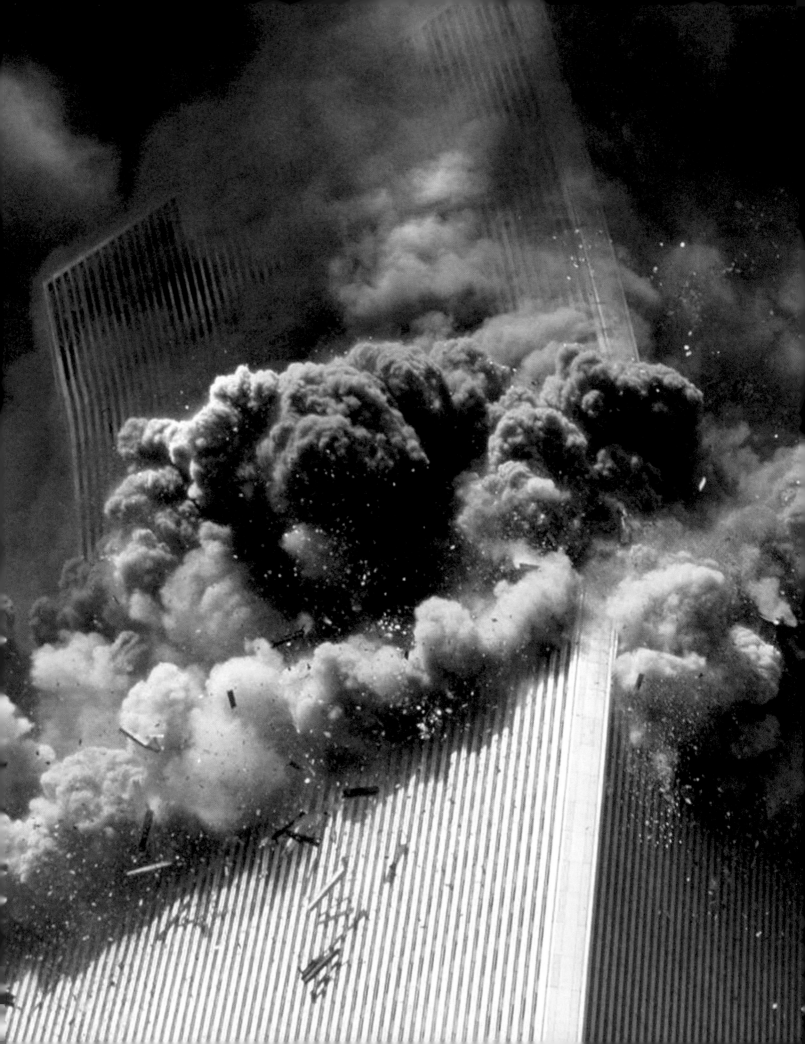

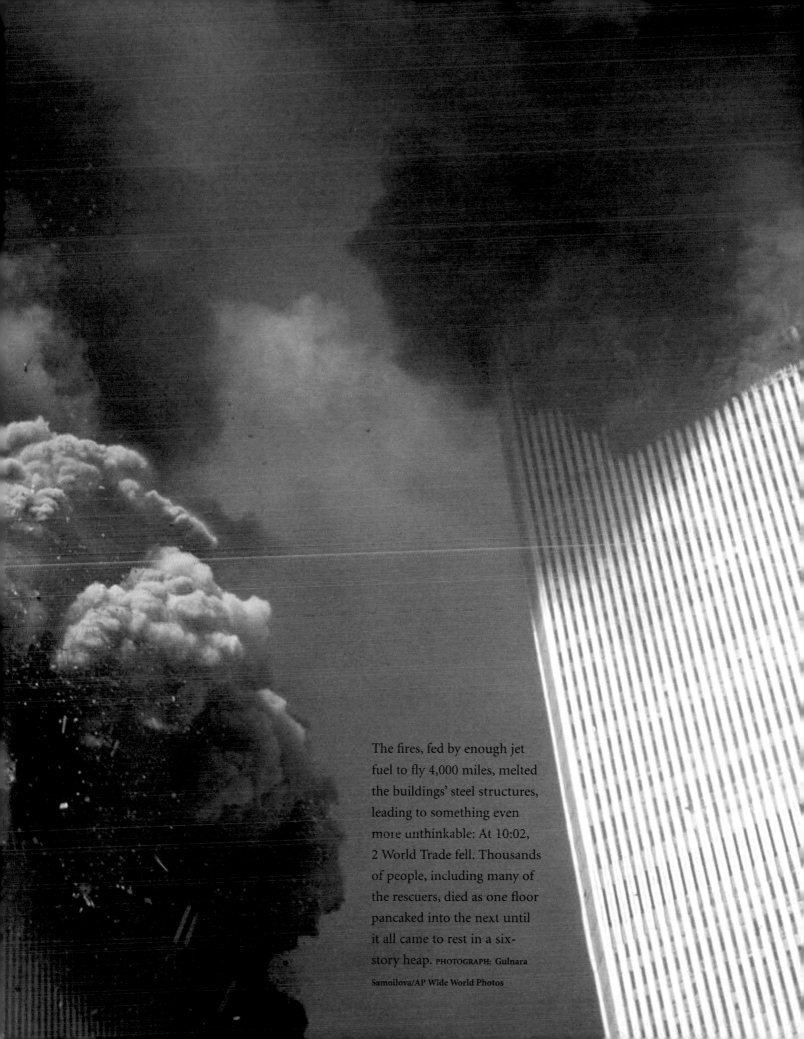

The fires, fed by enough jet fuel to fly 4,000 miles, melted the buildings' steel structures, leading to something even more unthinkable: At 10:02, 2 World Trade fell. Thousands of people, including many of the rescuers, died as one floor pancaked into the next until it all came to rest in a six-story heap. PHOTOGRAPH: Gulnara Samoilova/AP Wide World Photos

When 2 World Trade fell, people blocks away found themselves running for their lives, pursued by an angry, roiling cloud. Filmmaker Tony Bui held a sweater over his mouth as he raced to outrun the mayhem, ducking into the Brooklyn Battery Tunnel. "So much debris and soot and smoke went into the tunnel with us that it was hard to breathe in there," he says. "I thought we were gone. It was like Pompeii."

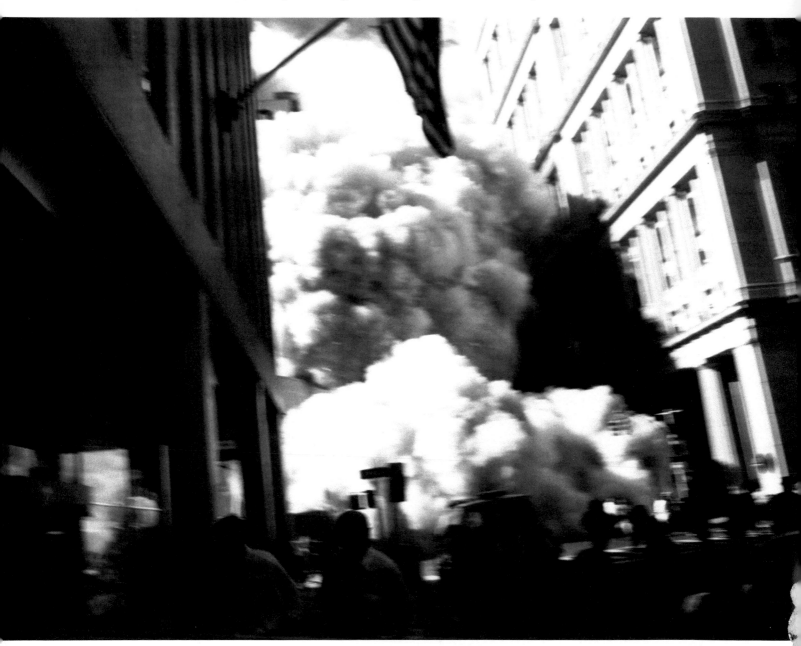

People refused to believe what their eyes had just seen, but when the smoke and debris thinned, there was just one remaining tower. Mike McGuire and five other firefighters from Engine 33 were in the North Tower when the South Tower fell, and they were ordered out. "When we came out of the lobby, everything was white. It looked like it had snowed. I remember looking over my shoulder and saying to someone, 'Where is the other tower?'"

PHOTOGRAPHS: Jerry Arcieri/Corbis SABA (above); Sean Hemmerle (opposite); Robert Stolarik/Gamma (overleaf)

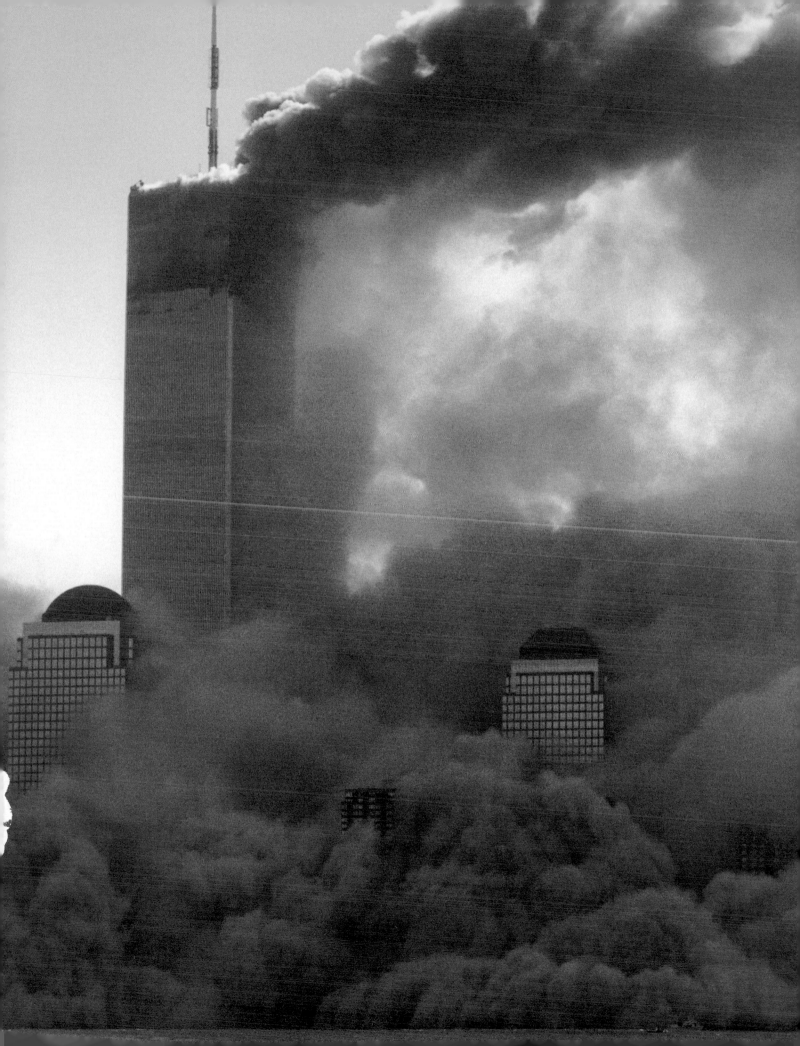

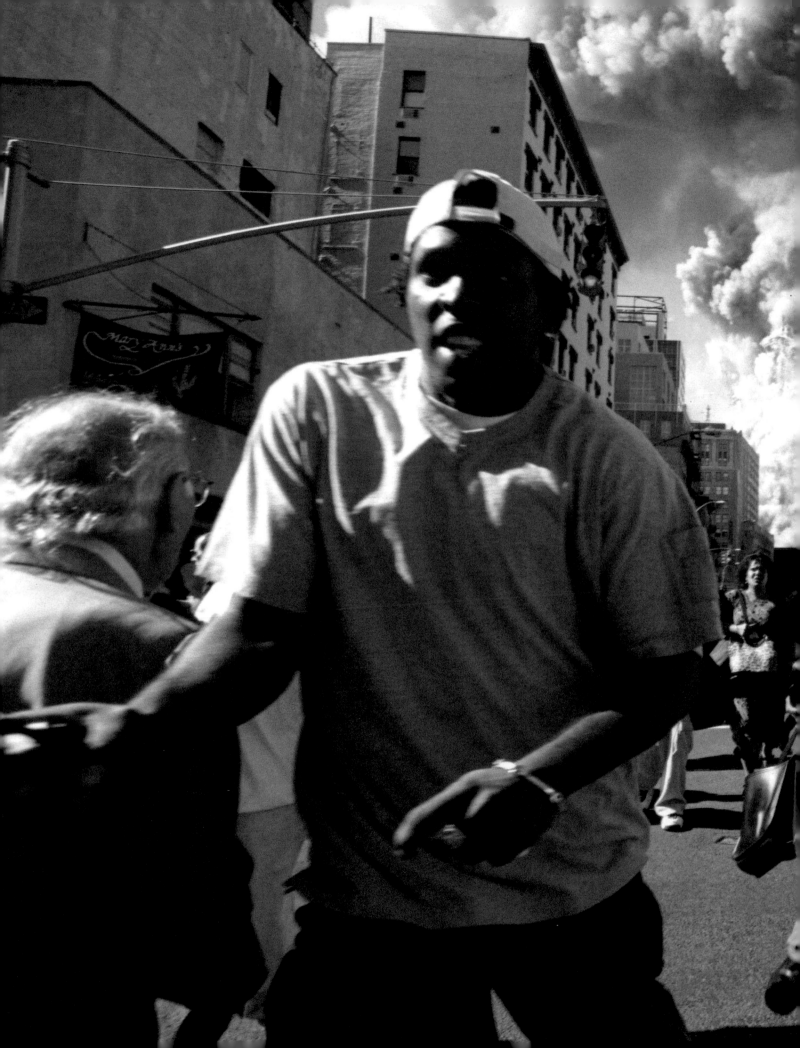

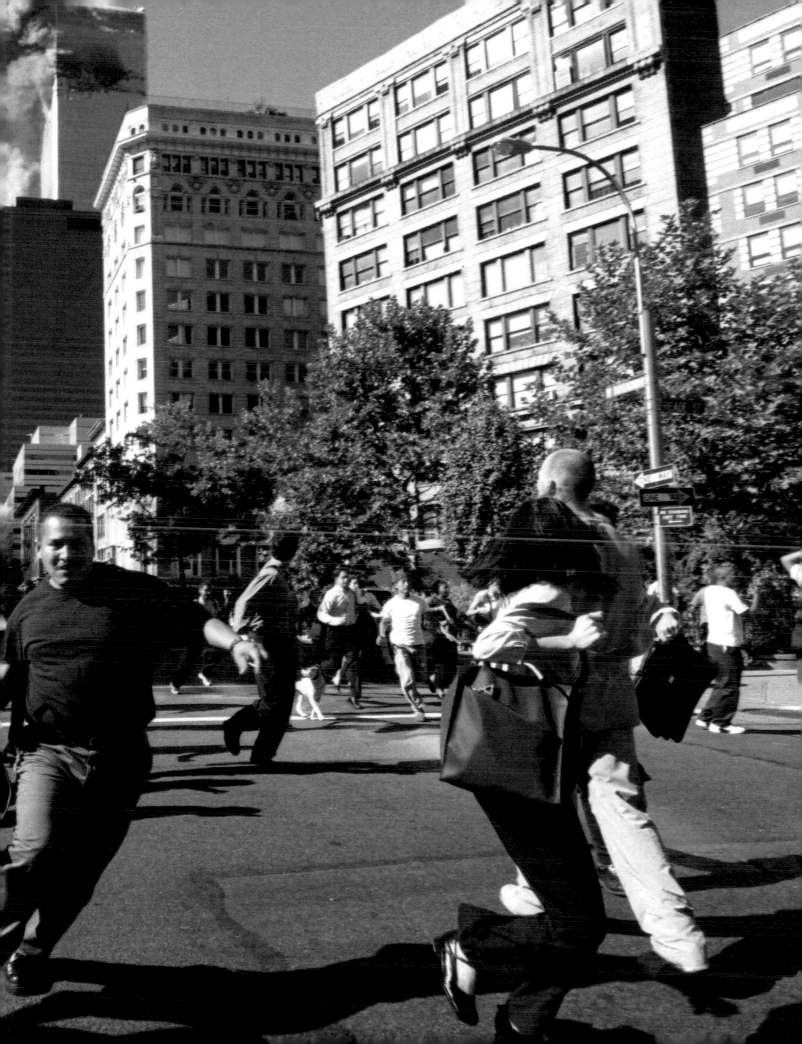

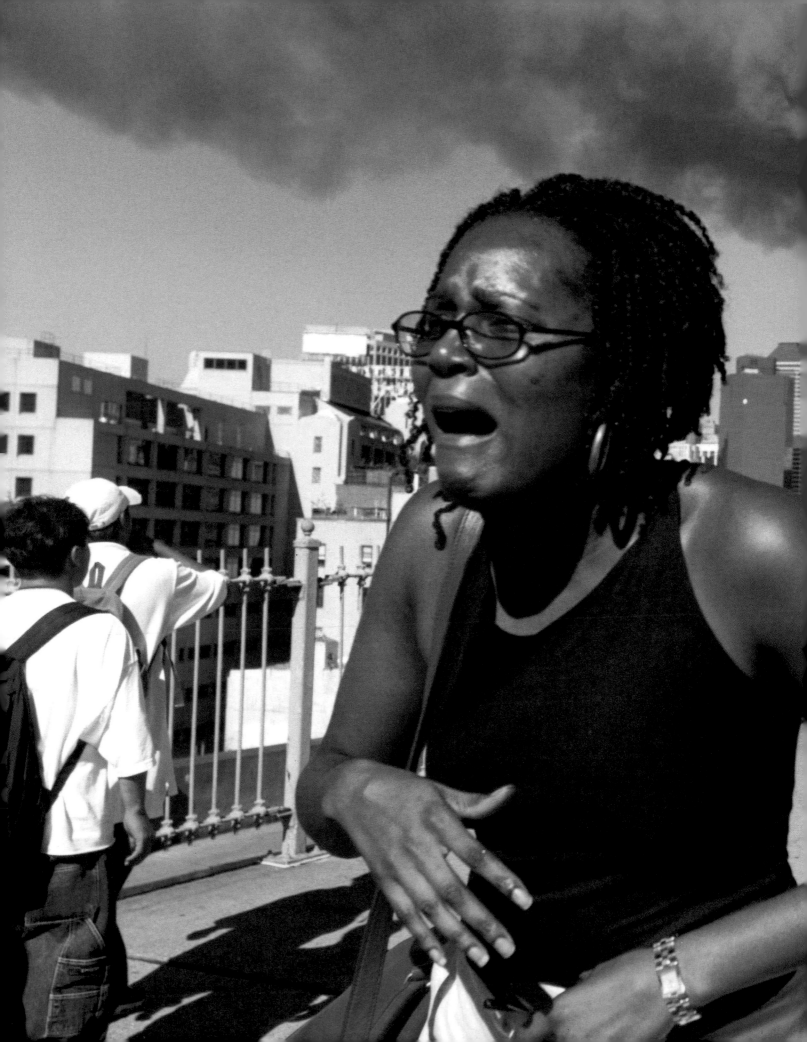

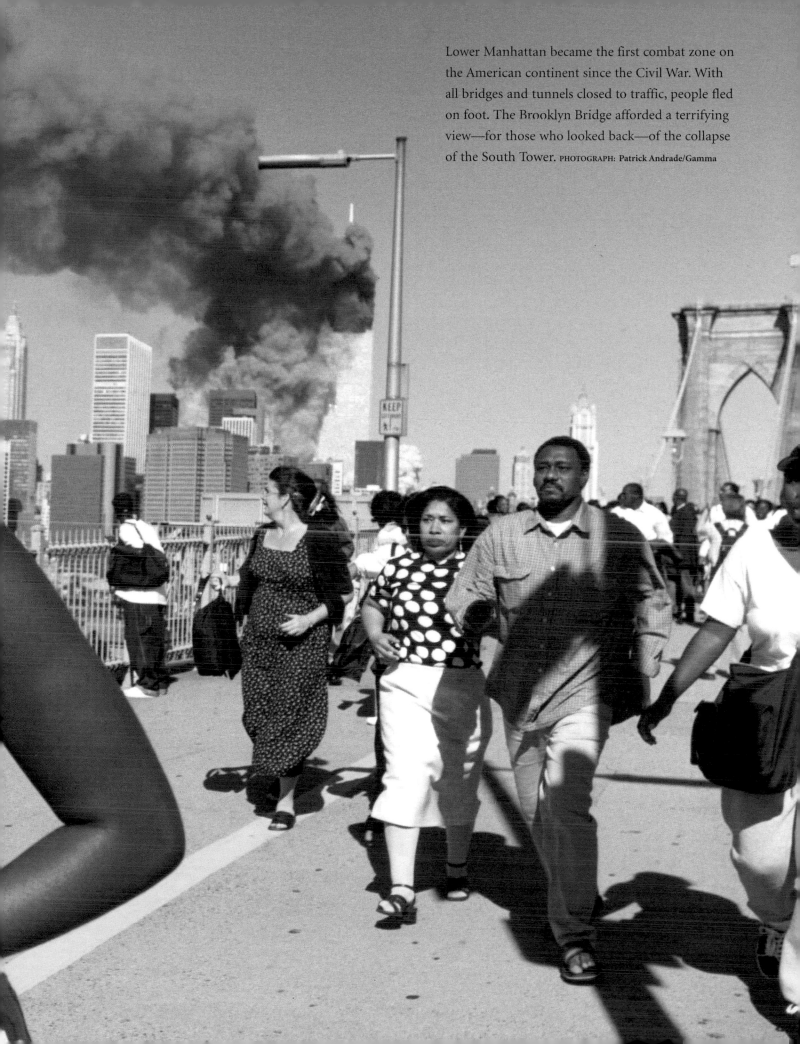

Lower Manhattan became the first combat zone on the American continent since the Civil War. With all bridges and tunnels closed to traffic, people fled on foot. The Brooklyn Bridge afforded a terrifying view—for those who looked back—of the collapse of the South Tower. PHOTOGRAPH: Patrick Andrade/Gamma

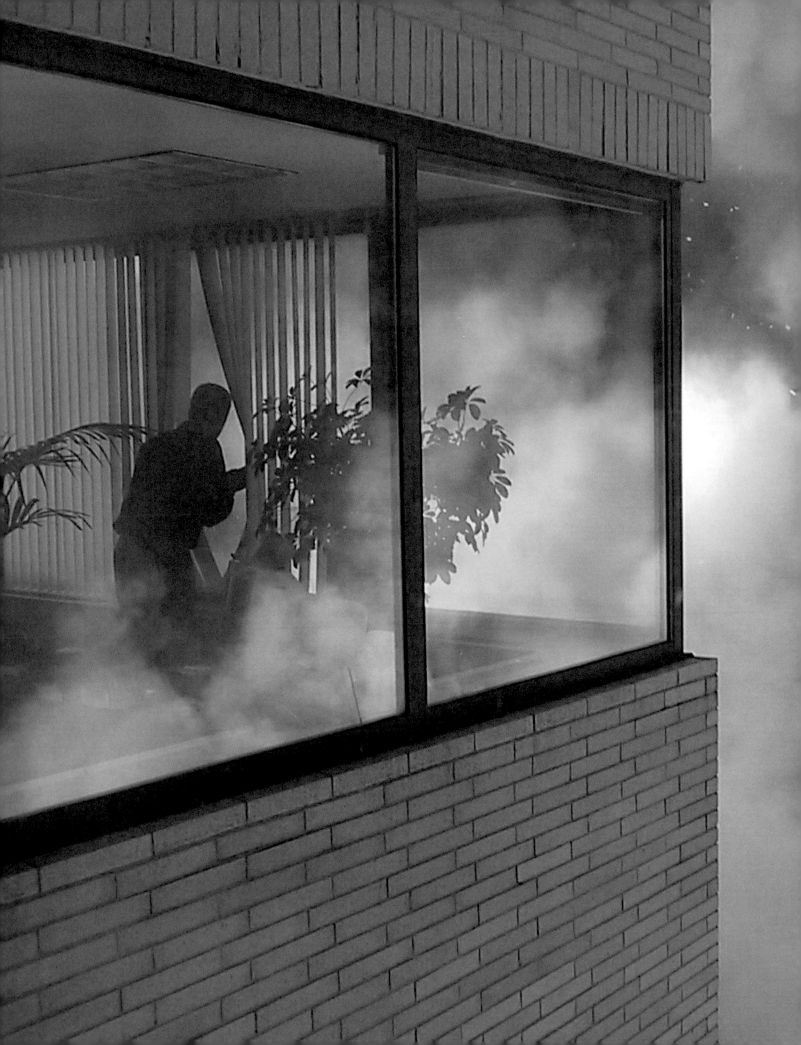

Buildings near the site offered precarious shelter. "I cowered below my desk in fear of debris breaking through our windows," said financial journalist James Cramer, "and wanted to talk to my wife and kids to say—who knows, that I was safe? Was I safe? We couldn't leave after the towers collapsed, the sky totally black, and our building filled with smoke from outside that smelled of the burning plastic of furniture and computers."

PHOTOGRAPHS: Jonathan Demarco/Gamma (left); Kelly Price/Reuters/Timepix (below)

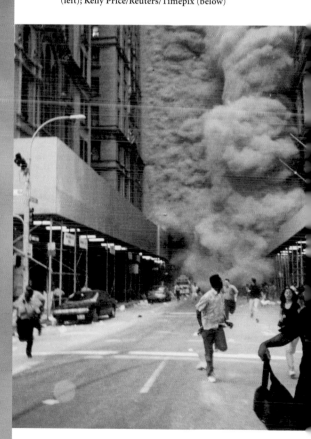

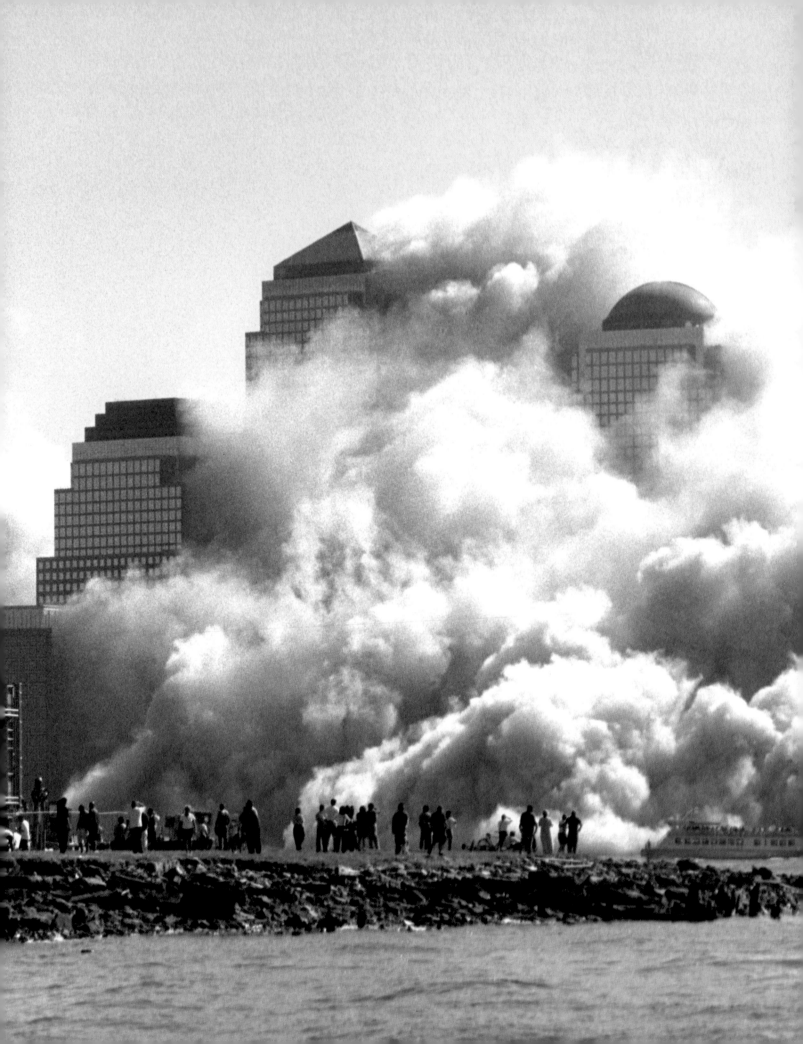

One World Trade disappeared from the skyline a half hour after its sibling. The implosion created a miasma so thick and impenetrable that the rest of downtown New York seemed lost with it. Mayor Rudolph Giuliani, who was trapped for a time in the mayhem, warned later that day, "The number of casualties will be more than any of us can bear ultimately." PHOTOGRAPH: Sean Hemmerle

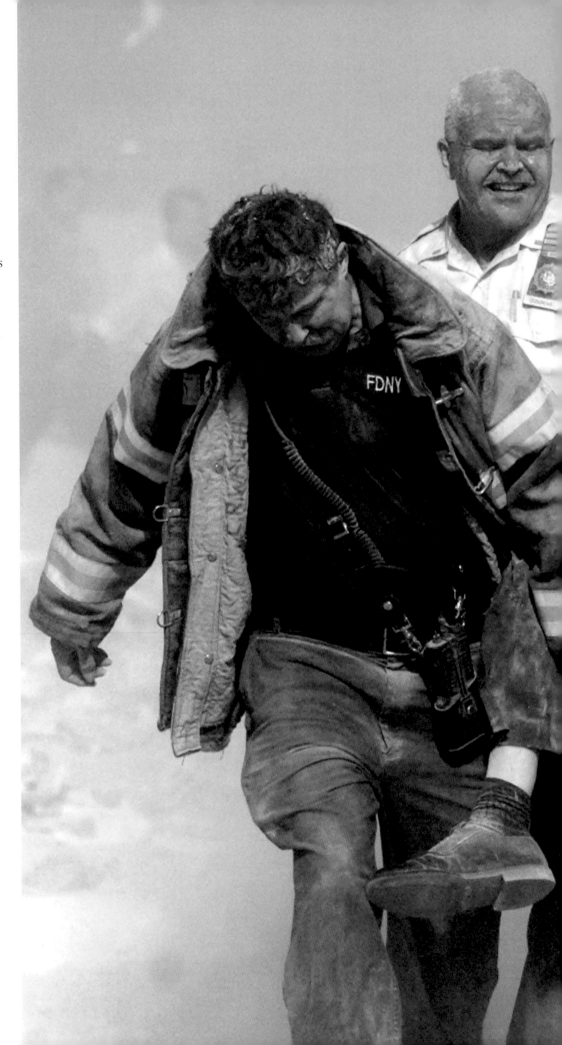

One of the first known casualties was Father Mychal Judge, the beloved Fire Department chaplain, who was killed by debris while administering last rites to a firefighter who had been struck by a body falling from the towers. A grief-stricken cortege of rescue workers carried the chaplain's body several blocks to St. Peter's Church, where it was placed on the altar.

"He was where the action was, he was praying, talking to God, helping someone," said the Reverend Michael Duffy at Judge's funeral. "Can you honestly think of a better way to die? Three hundred firemen are still buried there. It would have been impossible for him to minister to all of them in this life. In the next life he'll greet them with that big Irish smile and say, 'Welcome. Let me take you to our father.'" PHOTOGRAPH: Shannon Stapleton/Reuters/Timepix

34

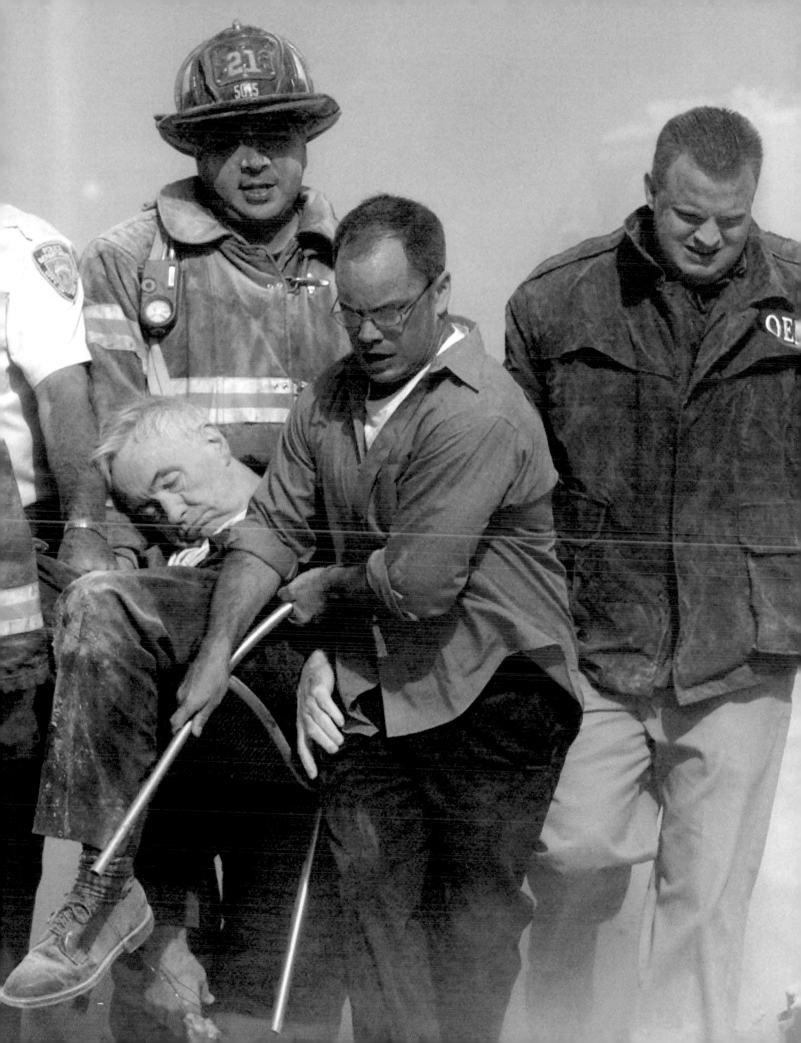

Shaken office workers who were fortunate enough to escape injury made their way out of the danger zone through a moonscape of ash, battered vehicles, and paper blown skyward by the implosion. "It was Mount St. Helens," said Dave Macri, a trader at the New York Stock Exchange. "Salvador Dalí in real life. It was like the moon or something, dead silent. The soot was so thick you could barely hear the sirens."

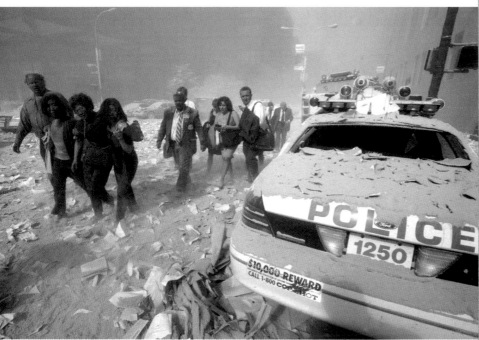

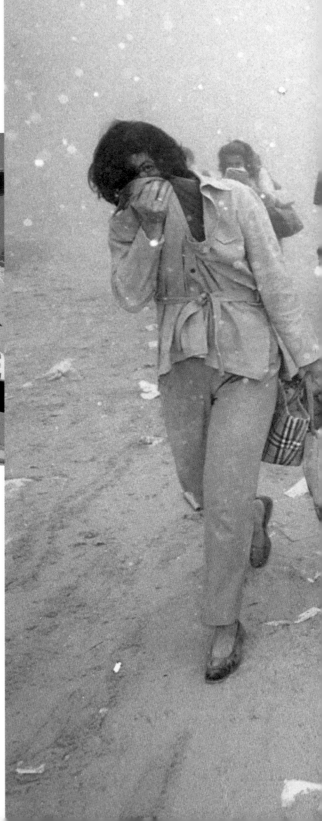

Marco Haber, a tech writer for financial services company Marsh & McLennan who had been late to his office on the 97th floor of the North Tower, recalled: "It was raining little balls of concrete. I was choking on the dust. The first paper that I saw close up—I saw Marsh right there, on the letterhead." A week later, 300 of the company's 1,700 employees were still missing. PHOTOGRAPHS: Robert Stolarik/Gamma (above); Mary Altaffer/Woodfin Camp & Assoc. (right)

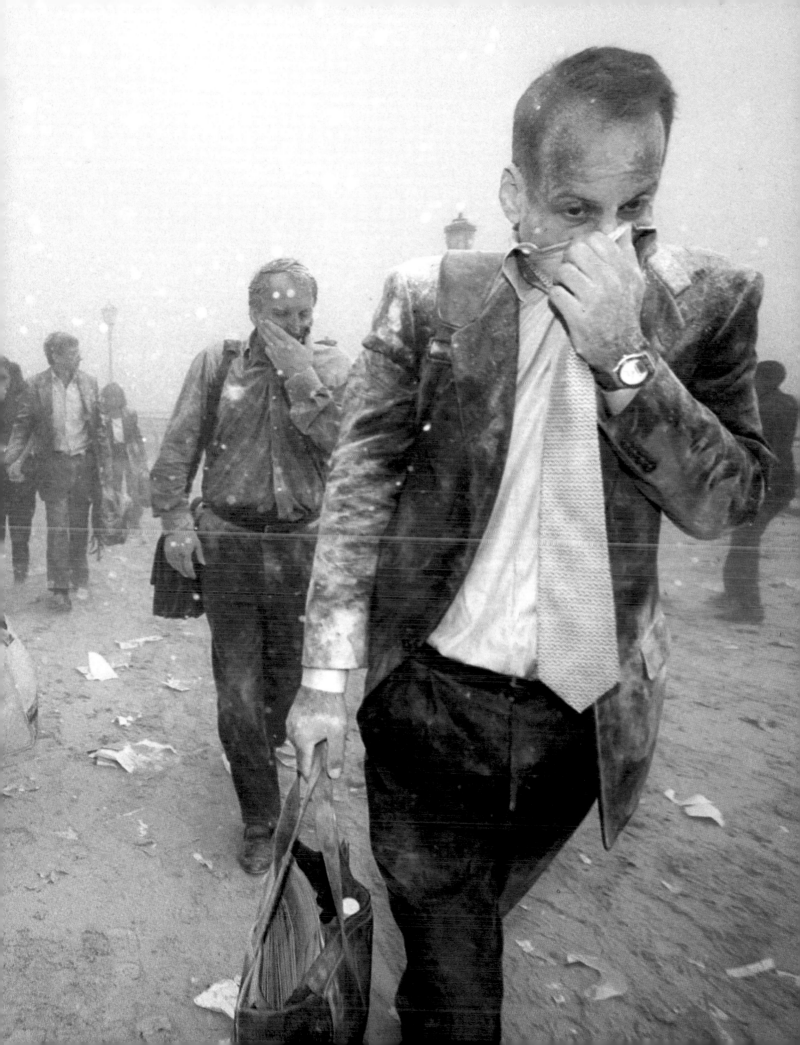

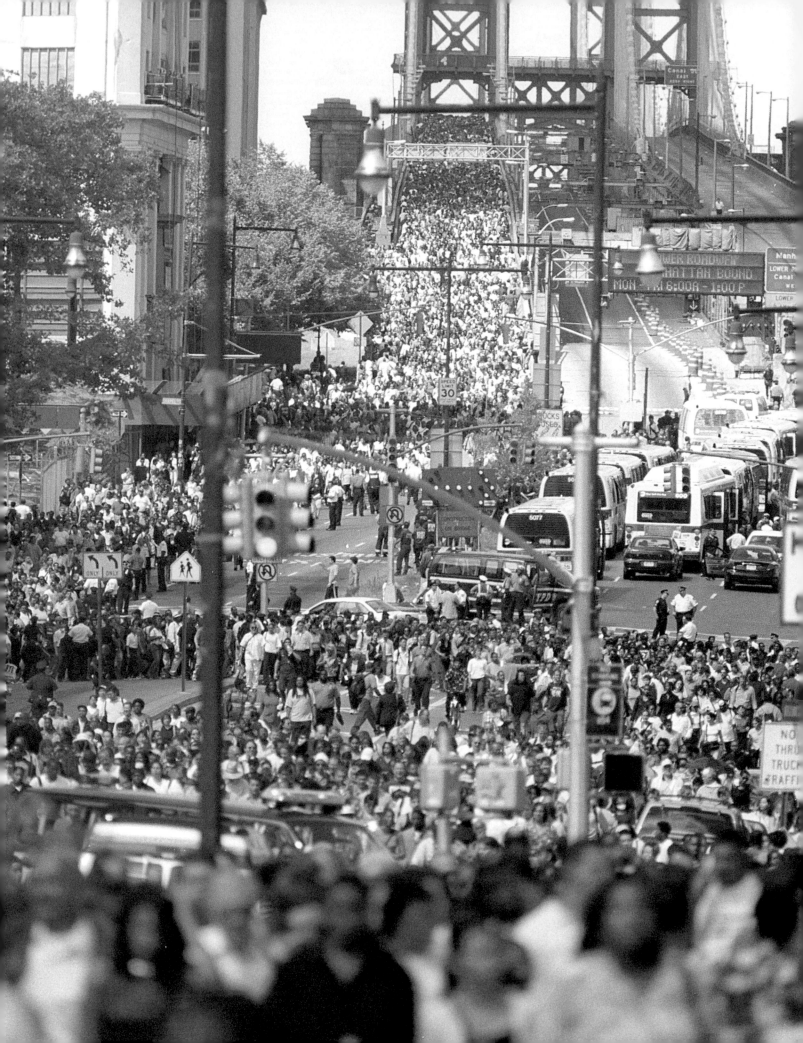

"It looks like the entire city is walking home," said WINS reporter Steve Kastenbaum. And it was. With Lower Manhattan in chaos, people flooded uptown and over the bridges to Brooklyn, to families grateful they were safe. Other families waited in vain for husbands and wives, sons and daughters, less lucky, but no less loved.

PHOTOGRAPHS: Jonathan Barth/World Picture News (opposite); Patrick Andrade/Gamma (below)

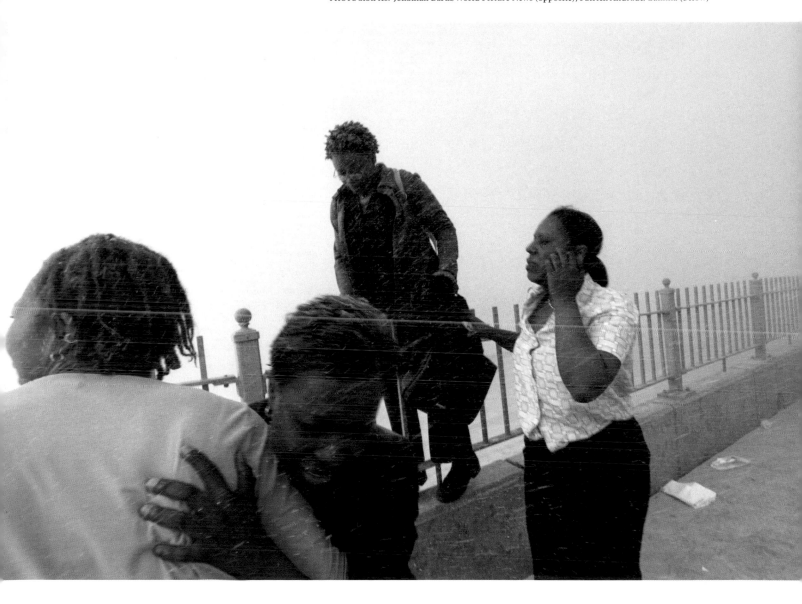

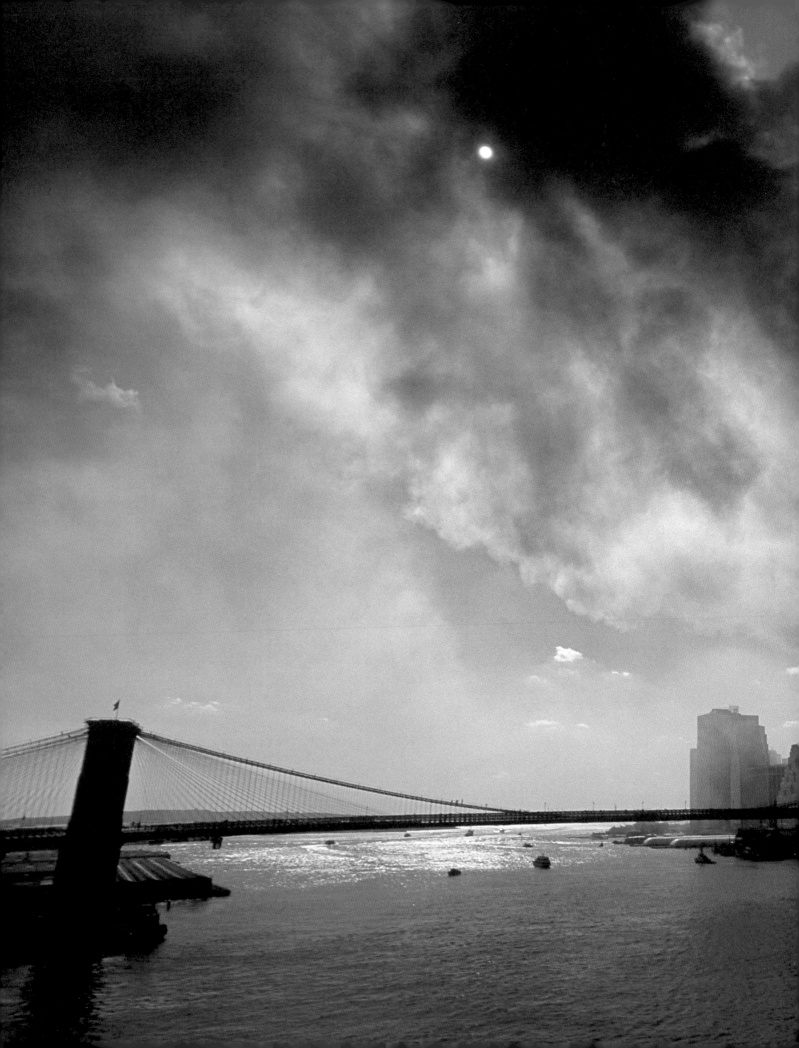

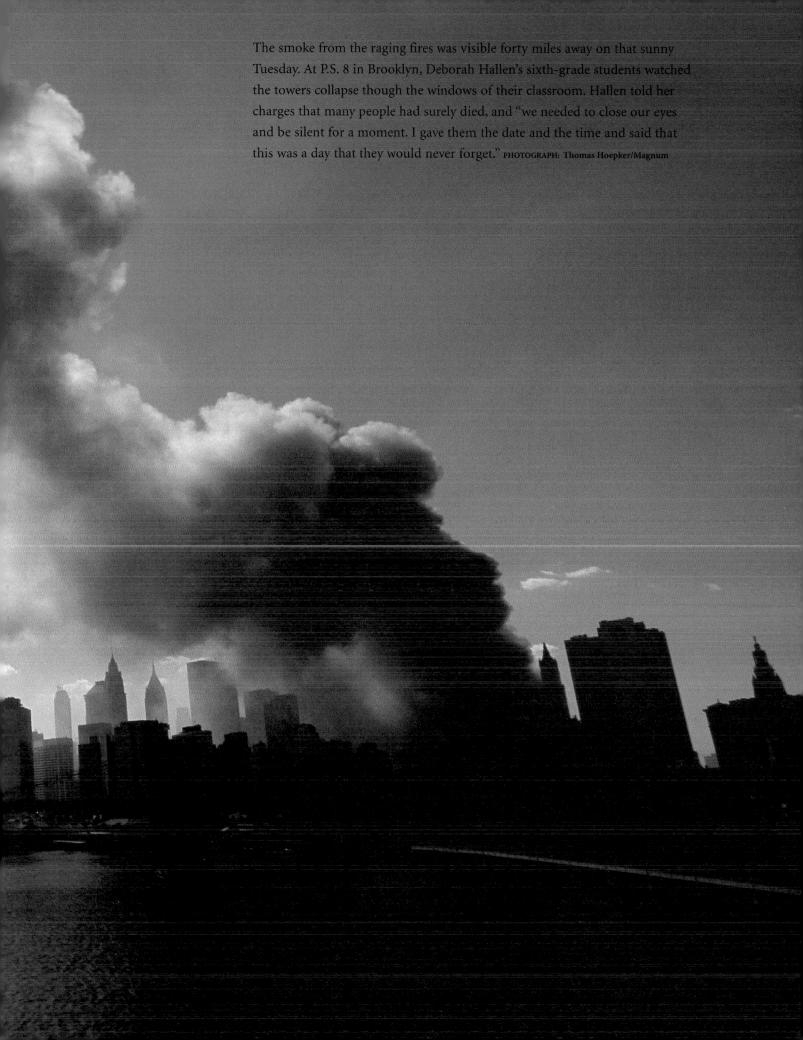

The smoke from the raging fires was visible forty miles away on that sunny Tuesday. At P.S. 8 in Brooklyn, Deborah Hallen's sixth-grade students watched the towers collapse though the windows of their classroom. Hallen told her charges that many people had surely died, and "we needed to close our eyes and be silent for a moment. I gave them the date and the time and said that this was a day that they would never forget." PHOTOGRAPH: Thomas Hoepker/Magnum

With black smoke turning day to night, firefighters fanned out to search for their brothers and other victims. "We've seen the worst of what humanity can do," said Linda Blackman,

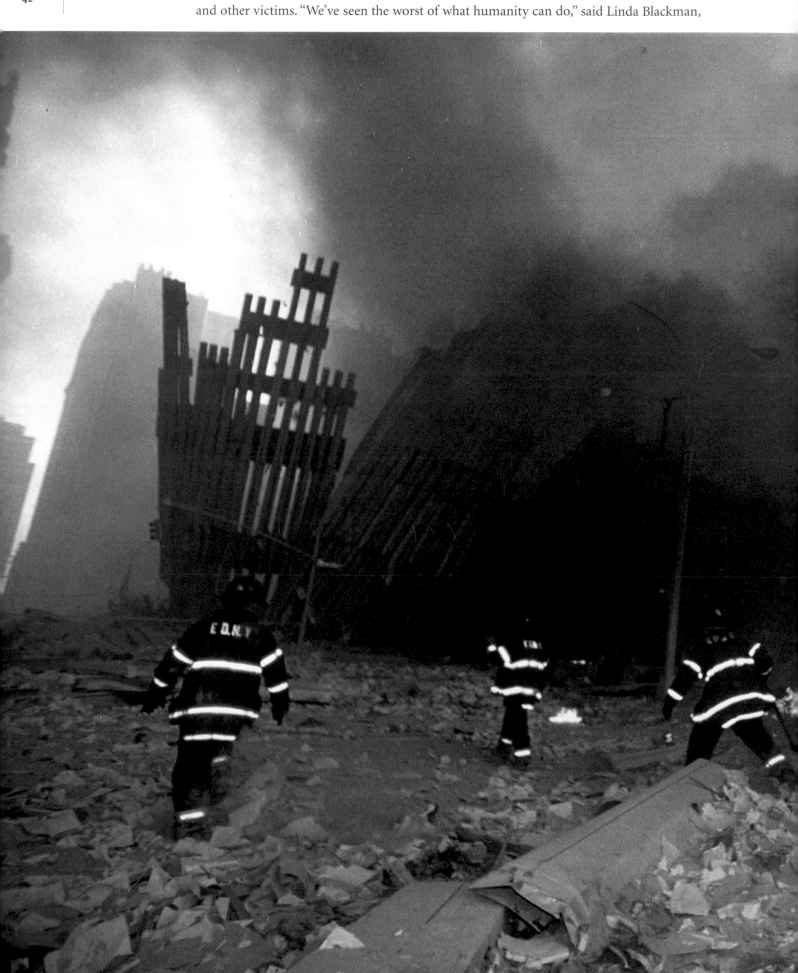

a volunteer delivering supplies to rescue workers, "but now we're seeing the best. I'll stay here until they throw me out or I pass out." PHOTOGRAPH: Mary Altaffer/Woodfin Camp & Assoc.

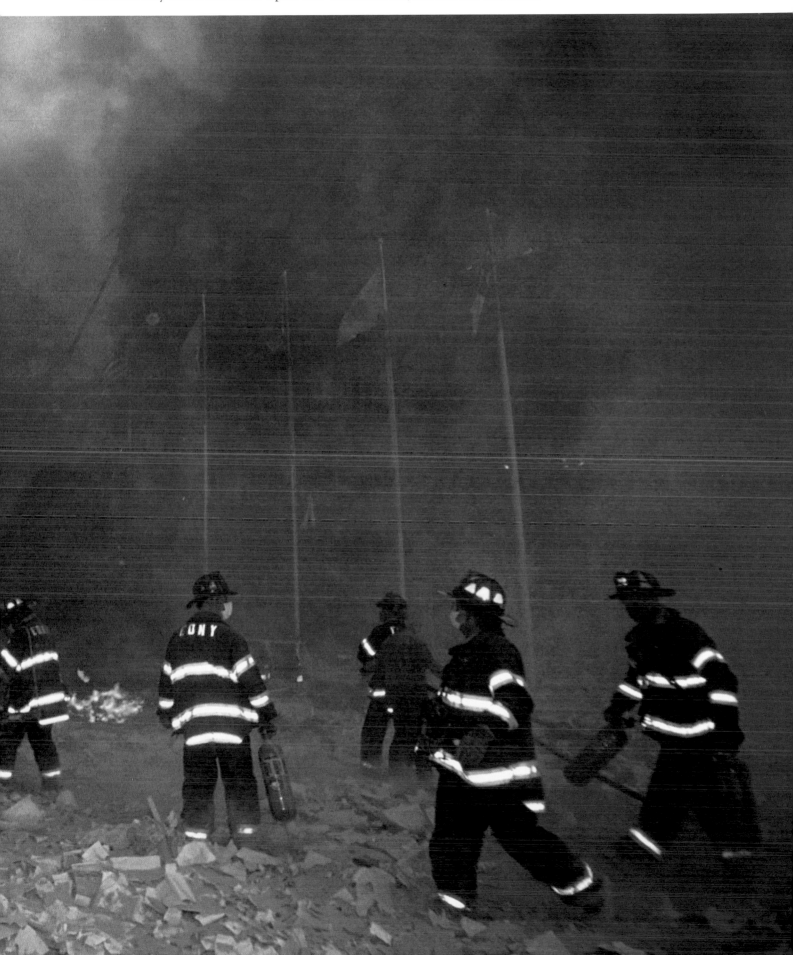

The former epicenter of American economic might became Ground Zero, a disaster area encircled by rescue units who surely knew, before they could admit it, that there was no hope for survivors. PHOTOGRAPHS: Keith Bedford/Gamma (below); Michael Parmelee (opposite)

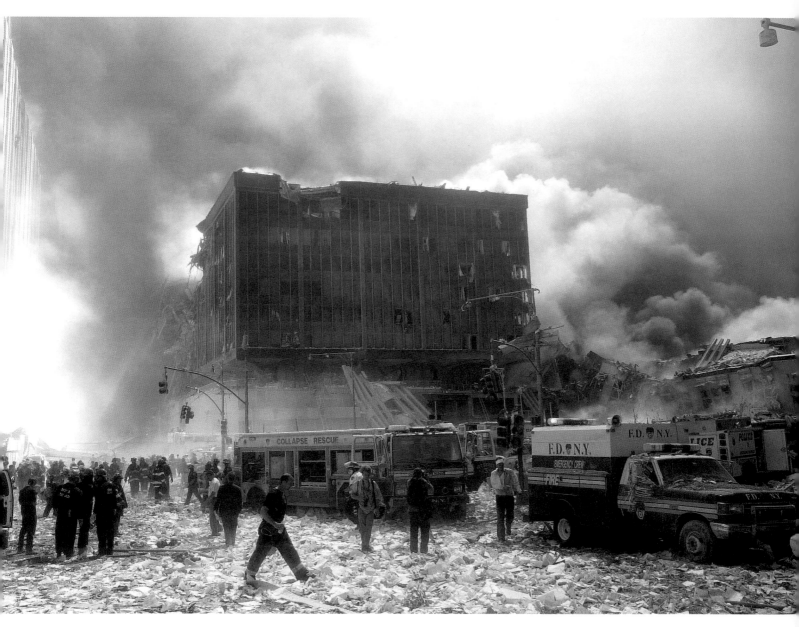

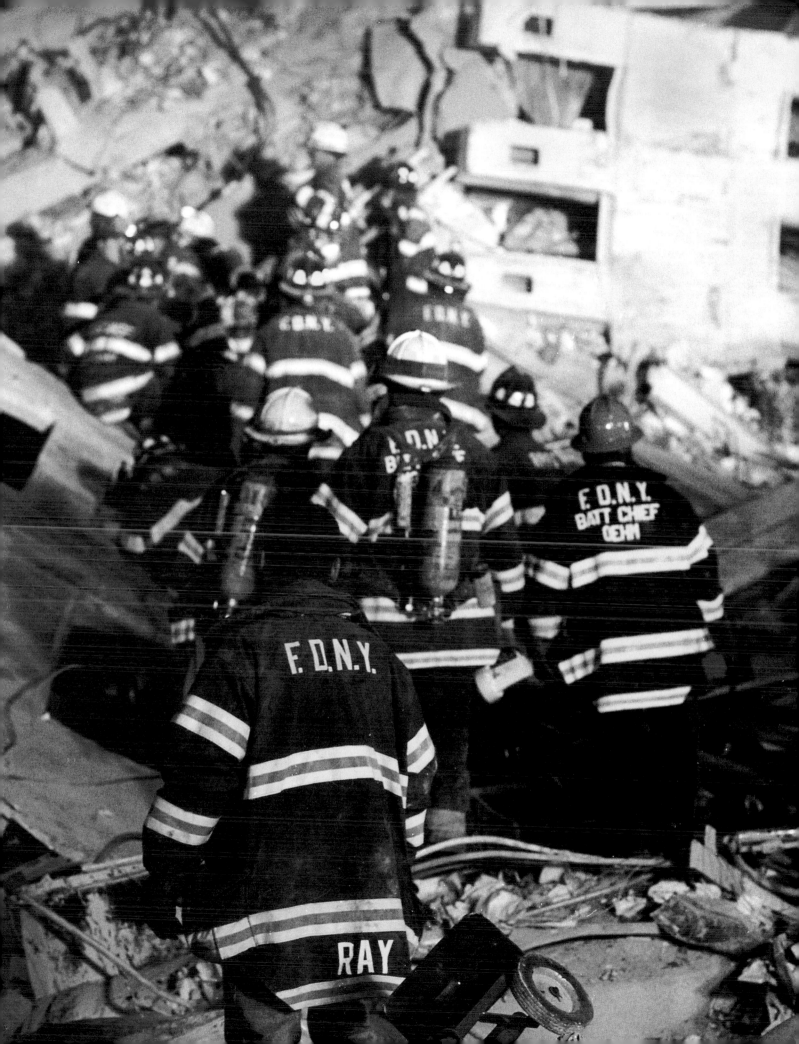

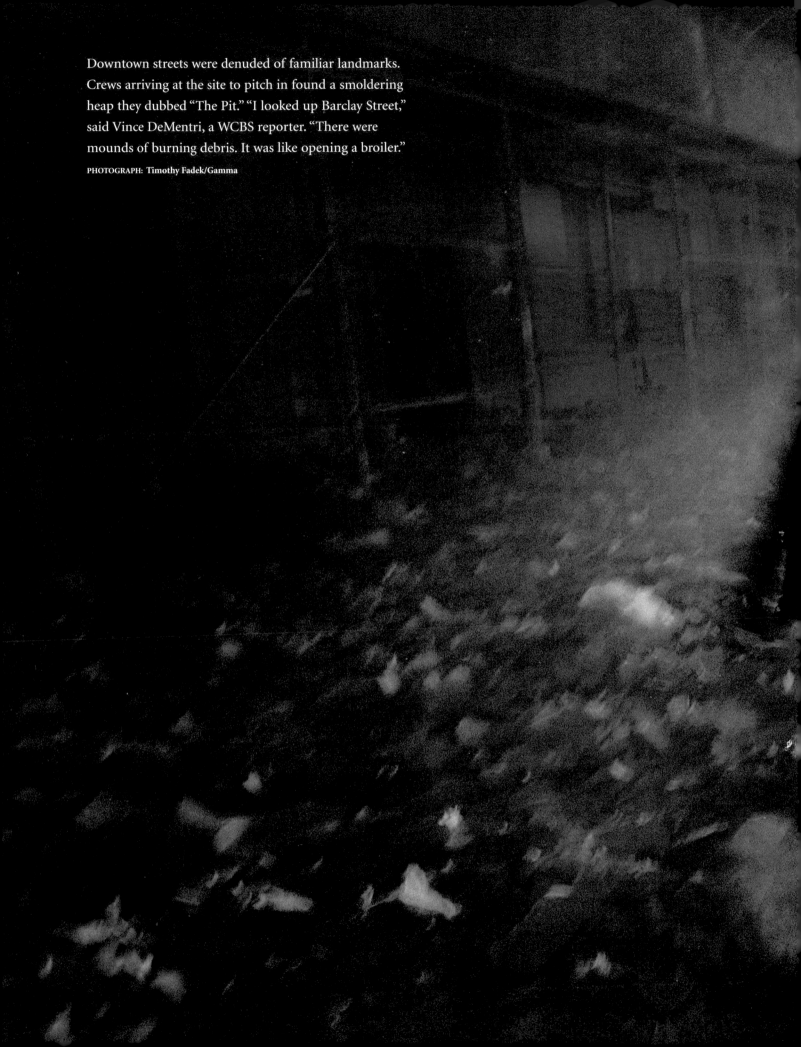

Downtown streets were denuded of familiar landmarks. Crews arriving at the site to pitch in found a smoldering heap they dubbed "The Pit." "I looked up Barclay Street," said Vince DeMentri, a WCBS reporter. "There were mounds of burning debris. It was like opening a broiler."

PHOTOGRAPH: Timothy Fadek/Gamma

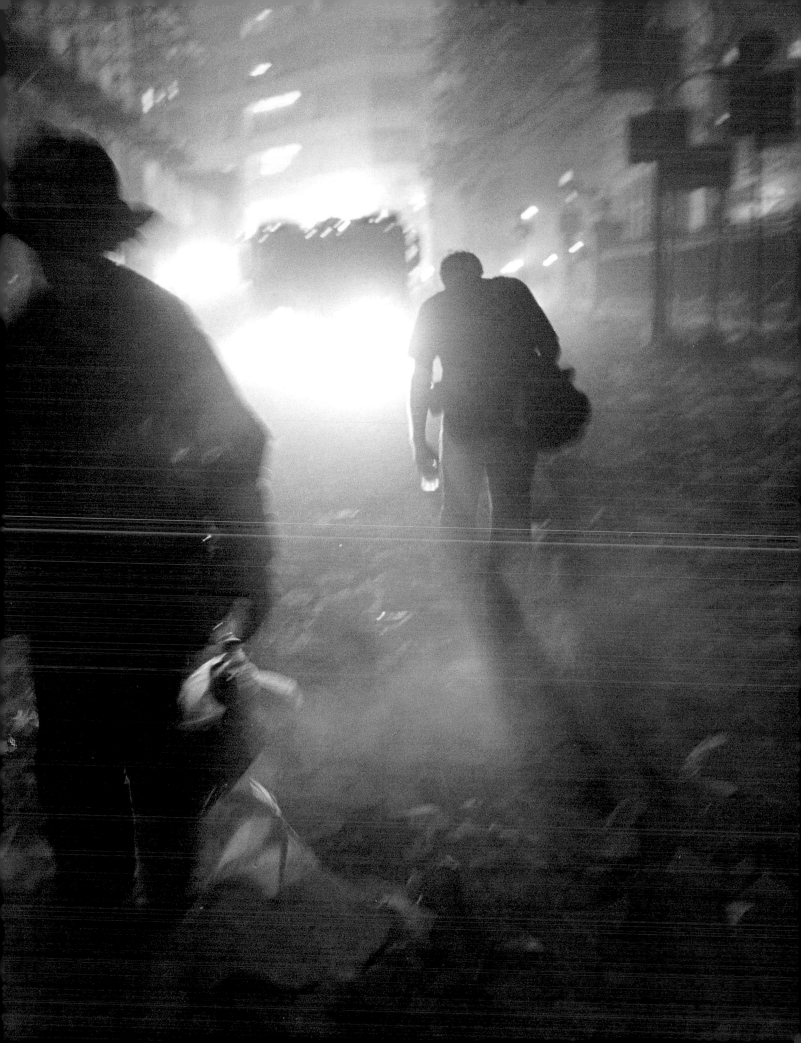

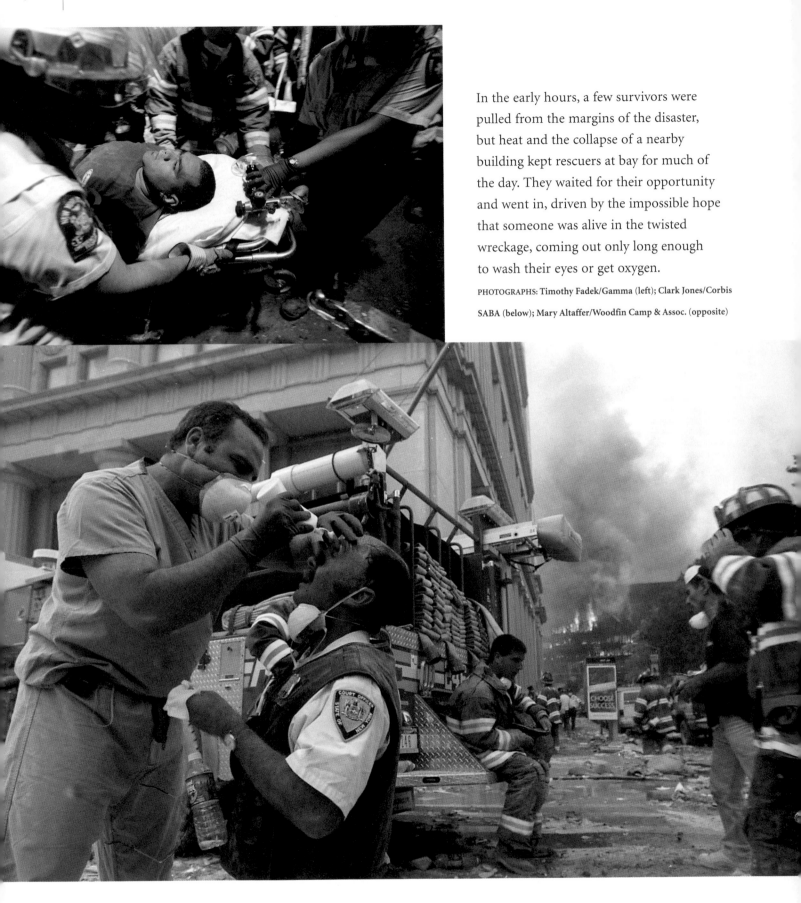

In the early hours, a few survivors were pulled from the margins of the disaster, but heat and the collapse of a nearby building kept rescuers at bay for much of the day. They waited for their opportunity and went in, driven by the impossible hope that someone was alive in the twisted wreckage, coming out only long enough to wash their eyes or get oxygen.

PHOTOGRAPHS: Timothy Fadek/Gamma (left); Clark Jones/Corbis SABA (below); Mary Altaffer/Woodfin Camp & Assoc. (opposite)

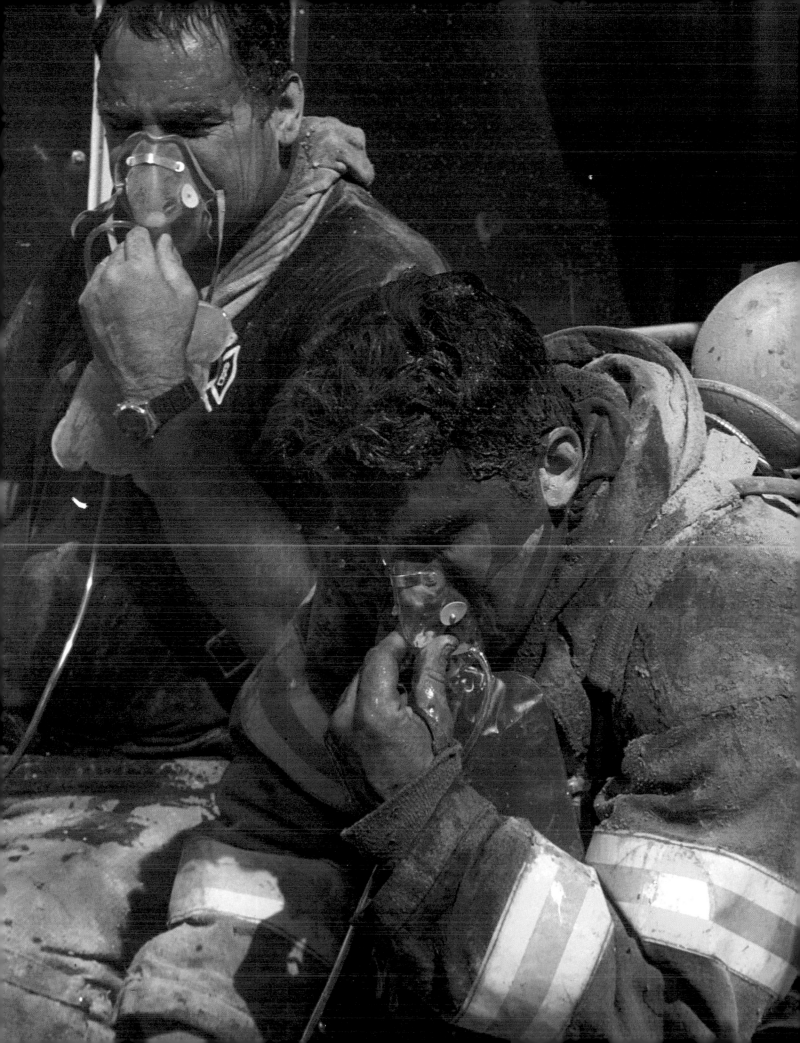

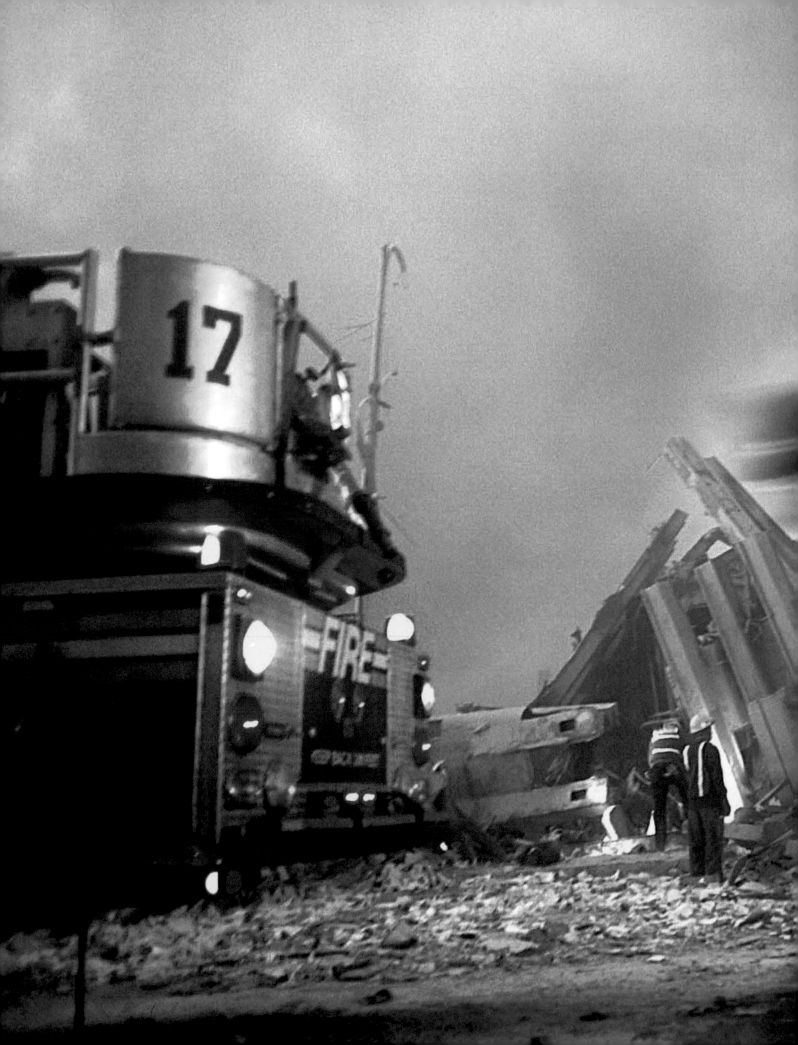

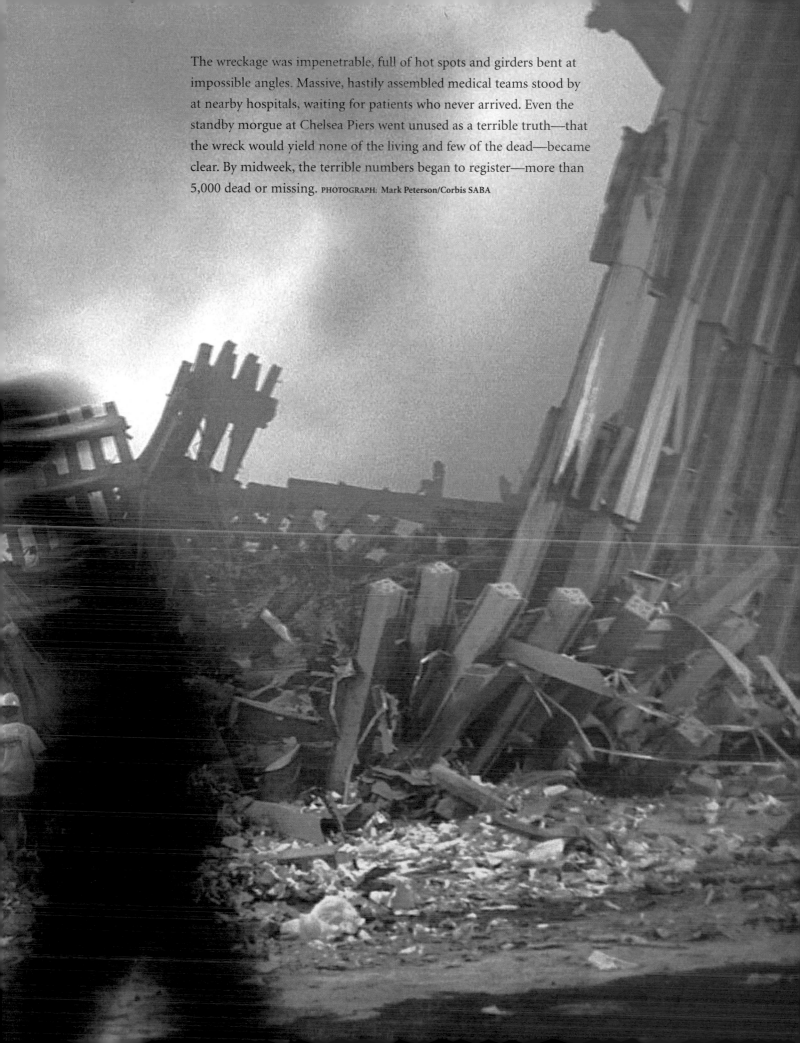

The wreckage was impenetrable, full of hot spots and girders bent at impossible angles. Massive, hastily assembled medical teams stood by at nearby hospitals, waiting for patients who never arrived. Even the standby morgue at Chelsea Piers went unused as a terrible truth—that the wreck would yield none of the living and few of the dead—became clear. By midweek, the terrible numbers began to register—more than 5,000 dead or missing. PHOTOGRAPH: Mark Peterson/Corbis SABA

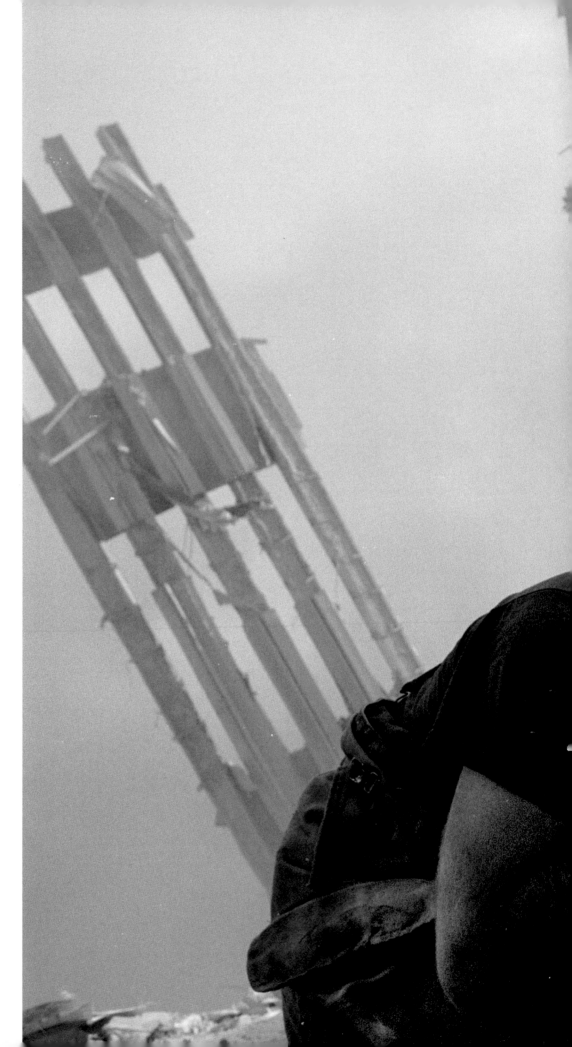

A fireman stopped to clear his vision at a working hydrant. "When Tower Two came down," another said, "we just started digging. We keep on going 'cause that's what we do."

PHOTOGRAPH: Yoni Brook/Gamma

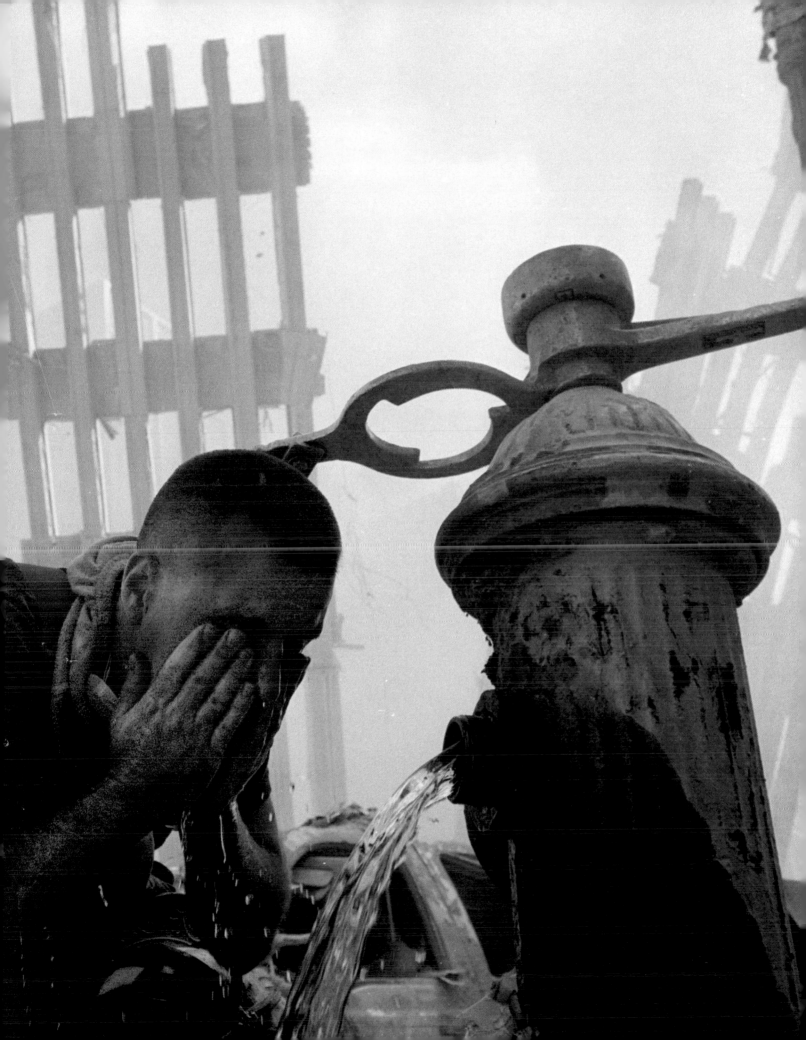

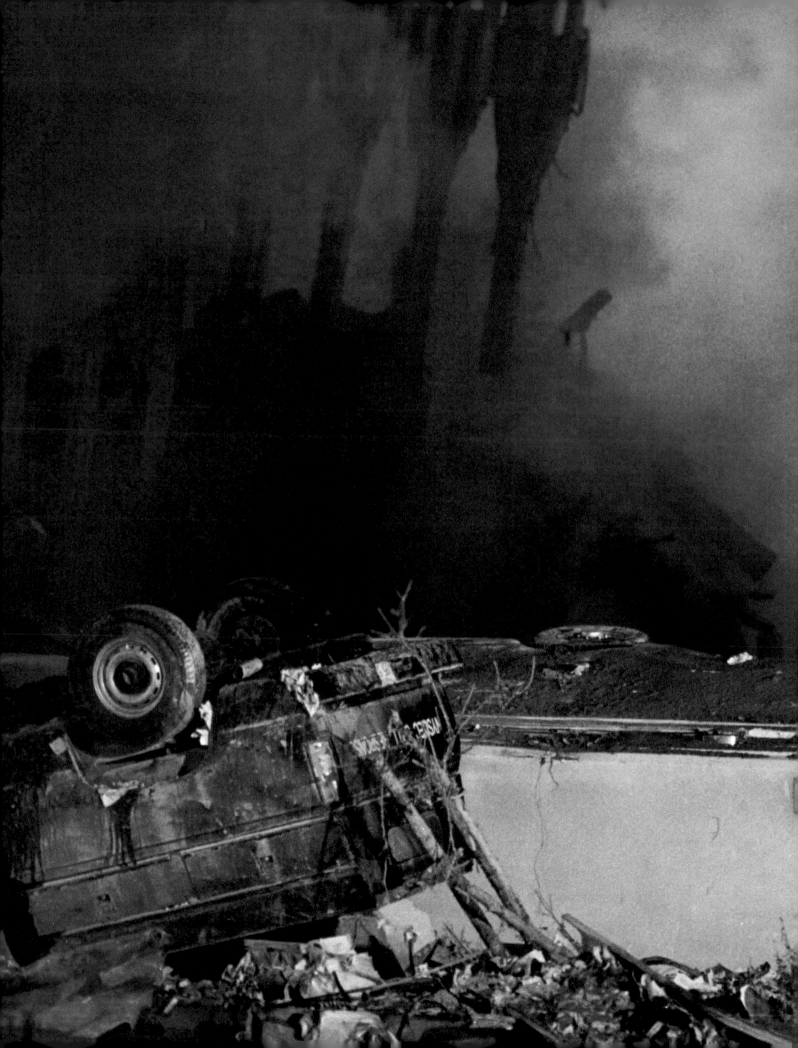

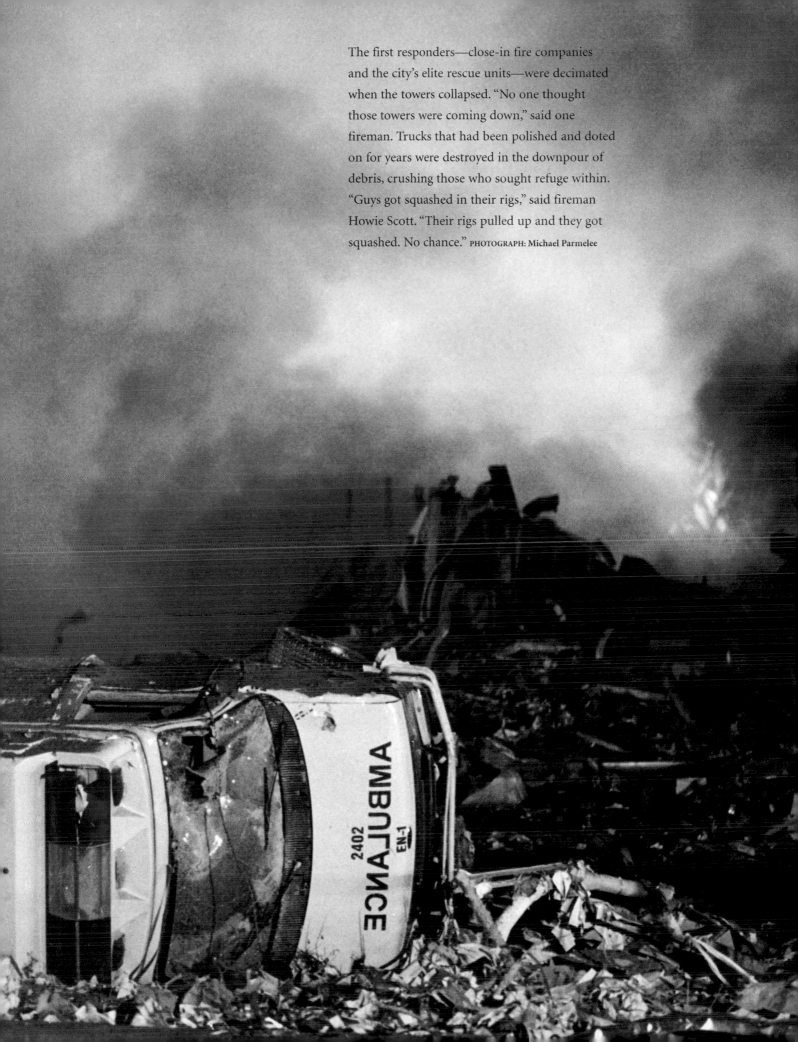

The first responders—close-in fire companies and the city's elite rescue units—were decimated when the towers collapsed. "No one thought those towers were coming down," said one fireman. Trucks that had been polished and doted on for years were destroyed in the downpour of debris, crushing those who sought refuge within. "Guys got squashed in their rigs," said fireman Howie Scott. "Their rigs pulled up and they got squashed. No chance." PHOTOGRAPH: Michael Parmelee

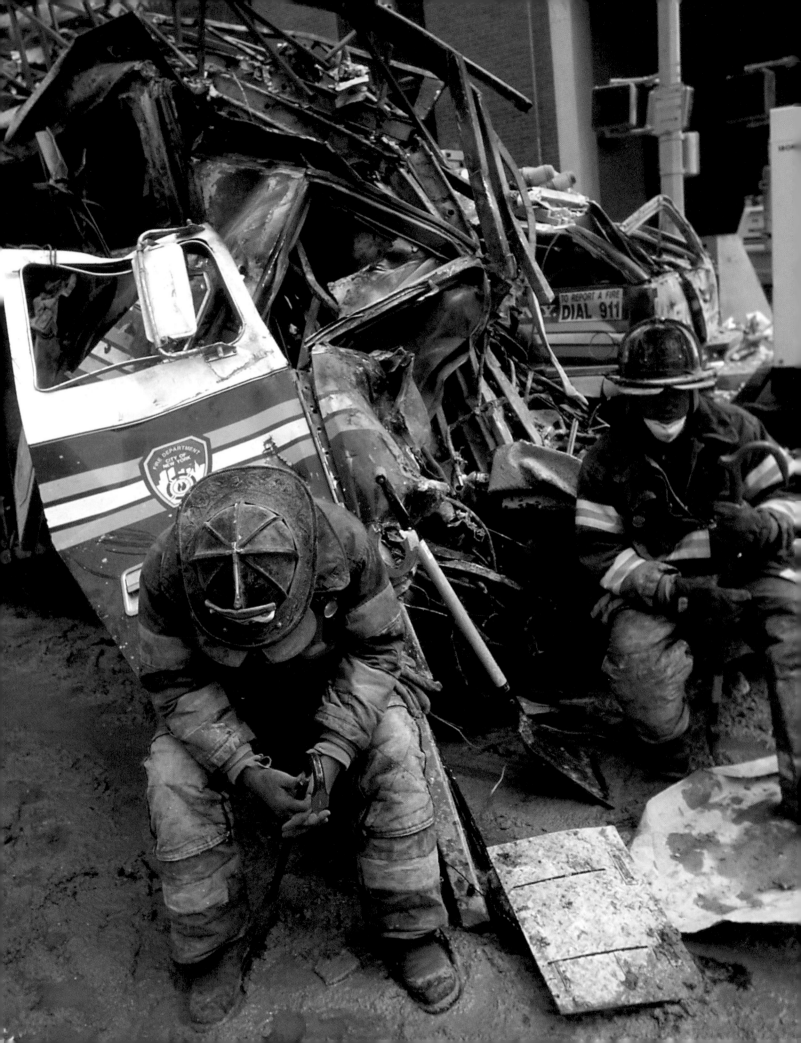

On September 11 the F.D.N.Y. lost 343 of the roughly 400 firefighters who answered the call—among them a quarter of its trained rescue personnel. In the aftermath of the tragedy, exhausted survivors and fresh reinforcements alike had to battle both fire and despair.

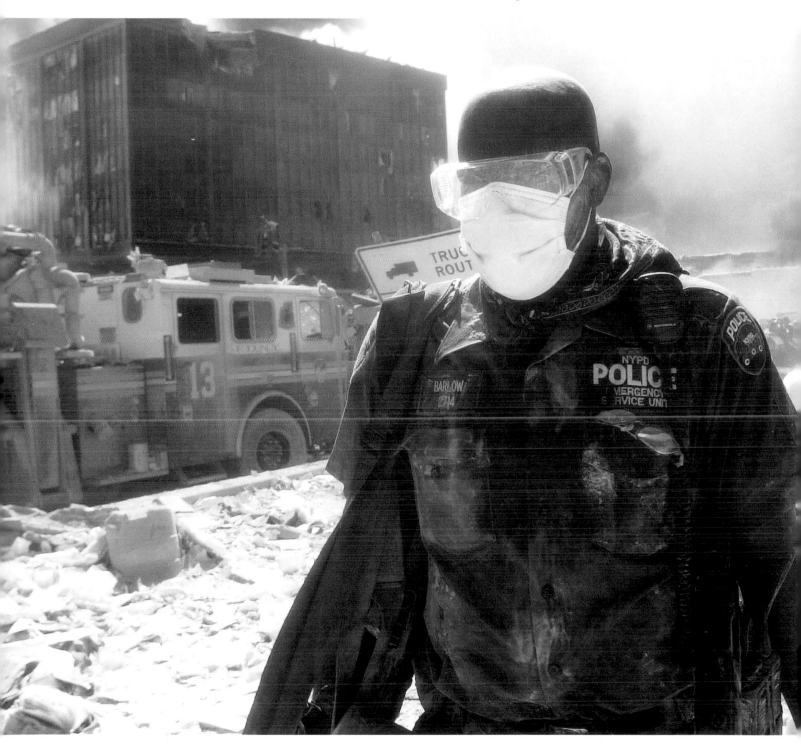

The New York Police Department lost twenty-three police officers. The Port Authority Police, charged with fire and rescue duties for their agency, which was headquartered in 1 World Trade, was also hard-hit, with forty-two officers counted among the missing.

PHOTOGRAPHS: James Leynse/Corbis SABA (opposite); Keith Bedford/Gamma (above)

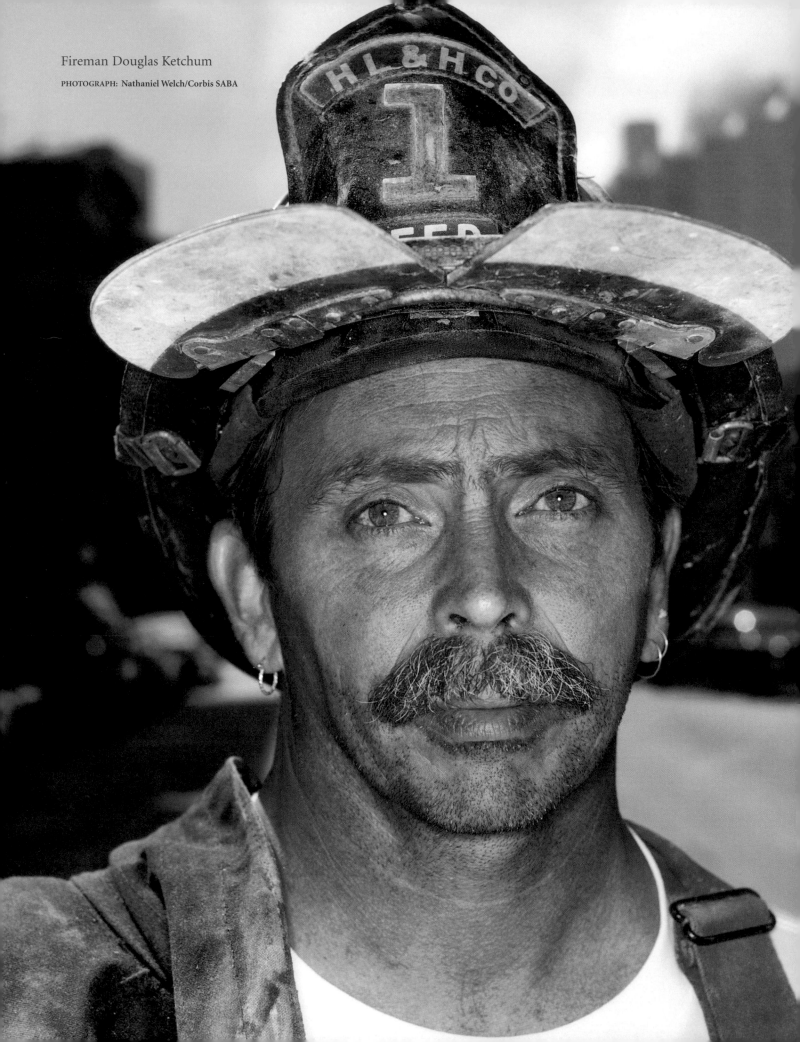

Fireman Douglas Ketchum

PHOTOGRAPH: Nathaniel Welch/Corbis SABA

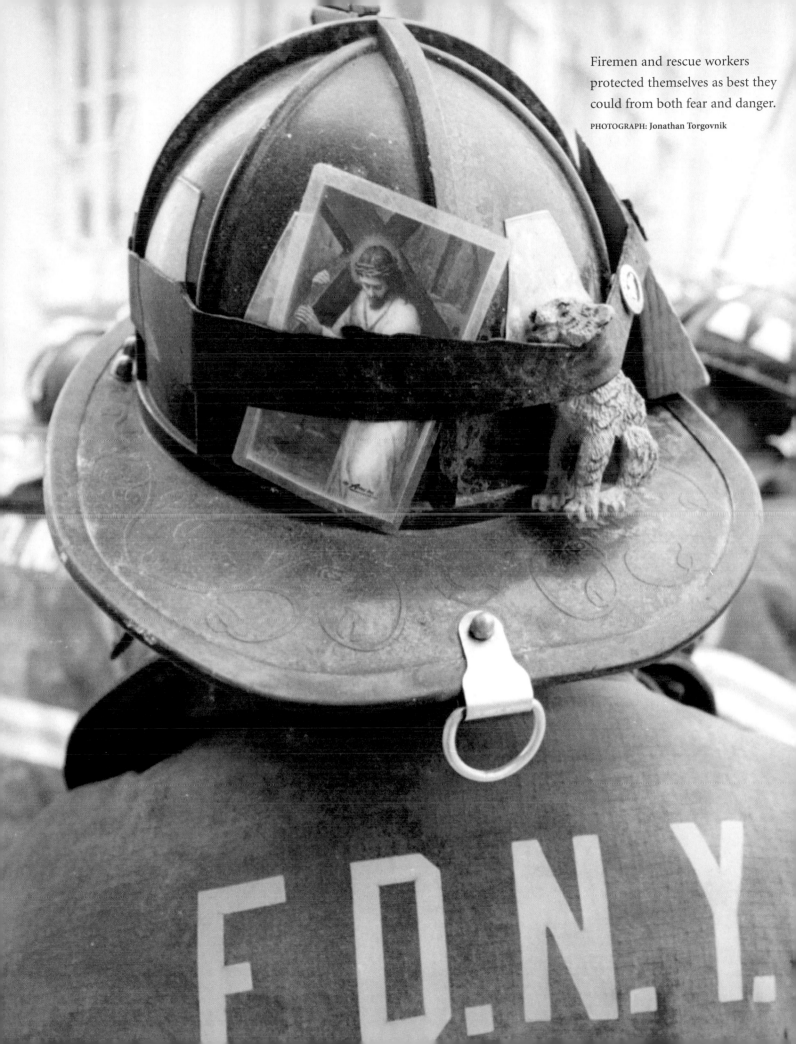

Firemen and rescue workers protected themselves as best they could from both fear and danger.
PHOTOGRAPH: Jonathan Torgovnik

The fire melted steel and
pulverized concrete, but it
spared paper: Memos, files,
letters, family pictures, and
other artifacts of business
as usual fluttered on the wind
as far away as Brooklyn. A
blizzard of paper and debris
from the towers blanketed
the cemetery of the landmark
Trinity Church. PHOTOGRAPH:

Zana Briski/Contact Press

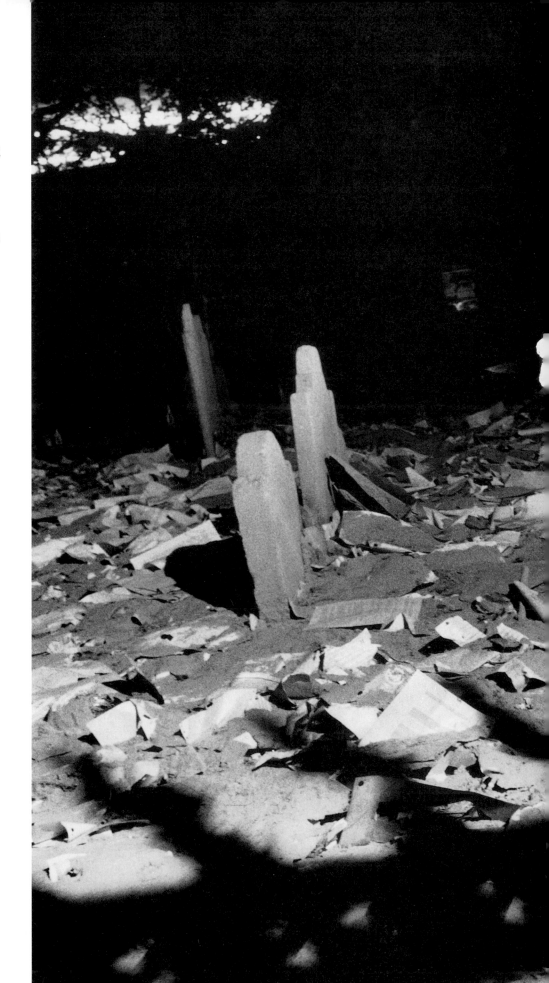

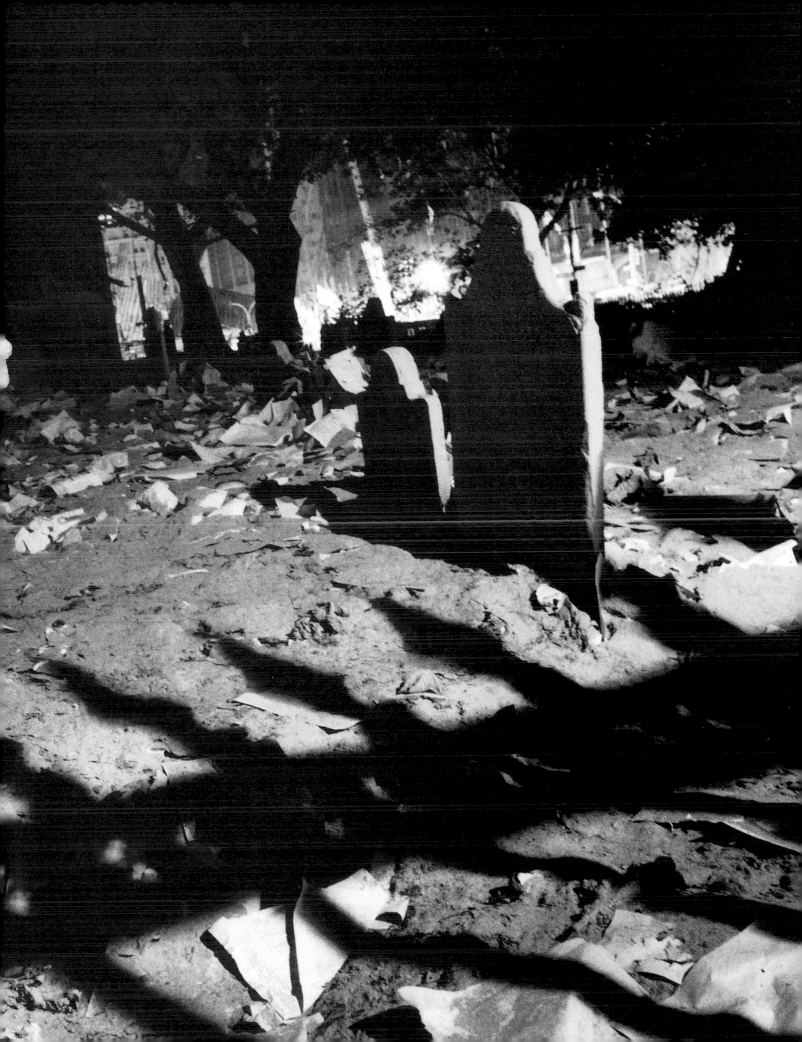

In the shattered Winter Garden at the nearby
World Financial Center, palm trees formerly under
glass towered incongruously. And at a normally
busy lunch spot in the Trade Center Plaza, midday
found empty chairs at empty tables in a sea of dust
and paper. PHOTOGRAPHS: Spencer Platt/Getty Images (below);
Timothy Fadek/Gamma (right)

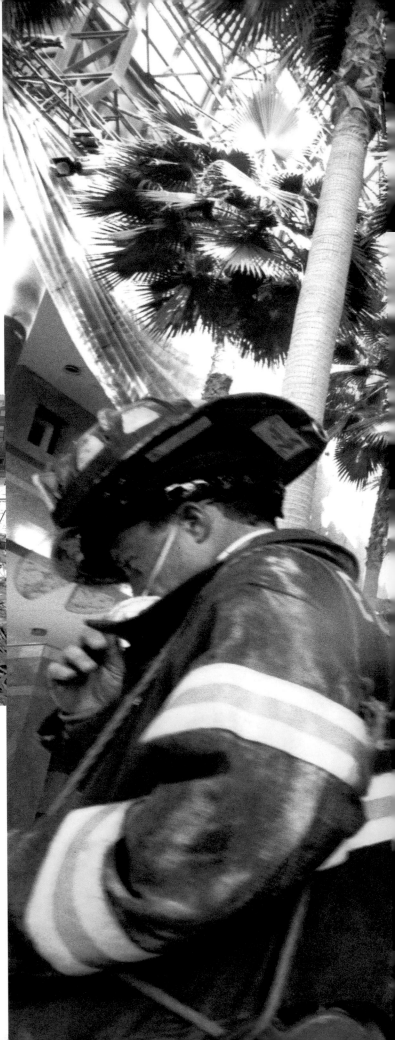

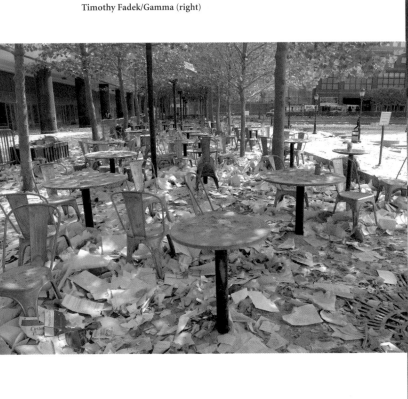

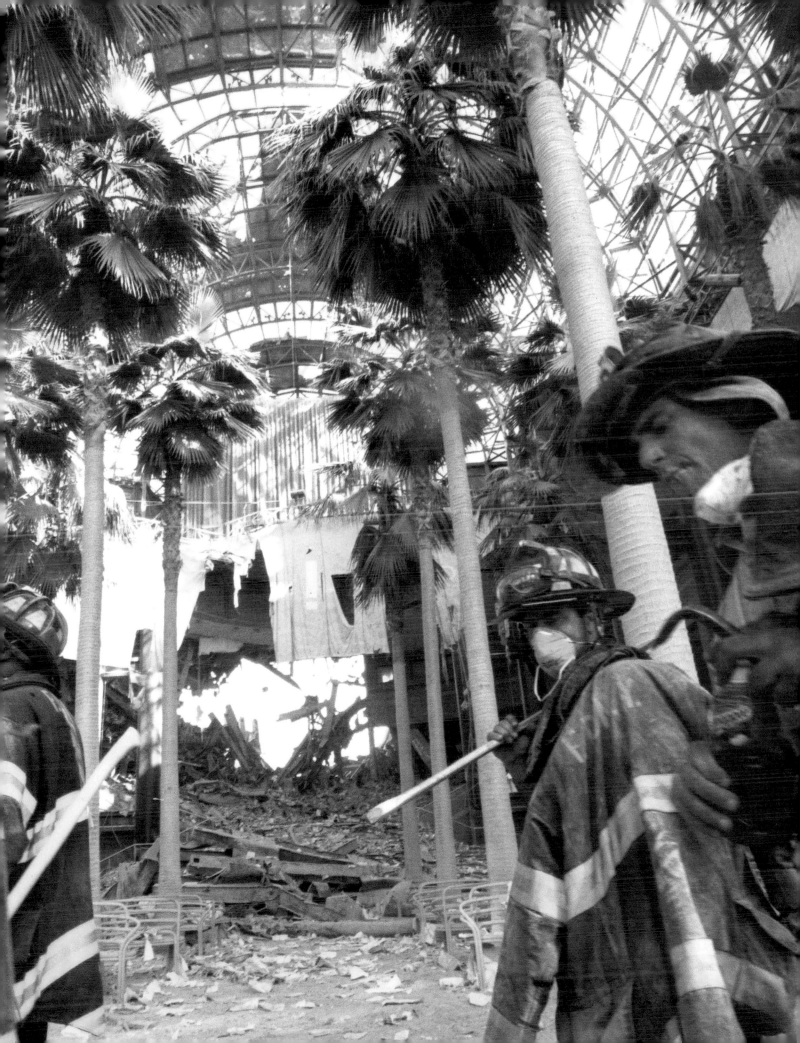

In what became known as the Frozen Zone, a messenger's bike remained anchored to a post, buried under a snowfall no one could have predicted. A workout room was once undoubtedly prized for its view of the towering behemoths across the street. PHOTOGRAPHS: Graham Morrison/Gamma (below); Patrick Andrade/Gamma (right)

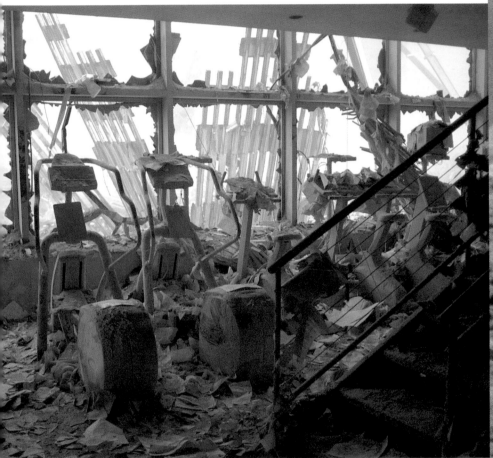

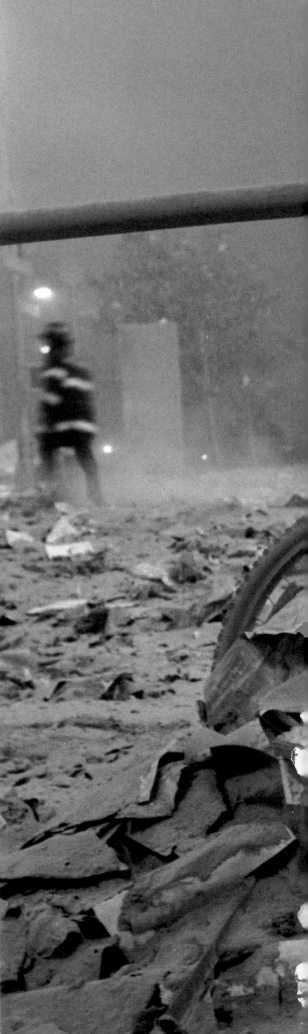

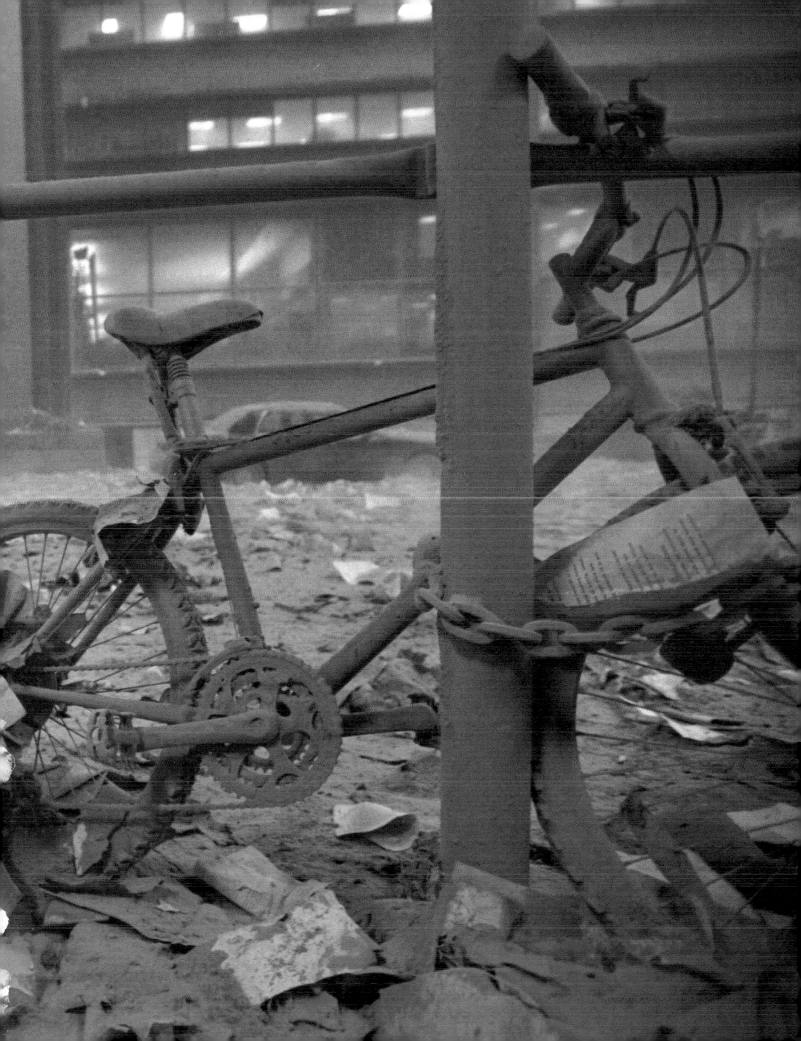

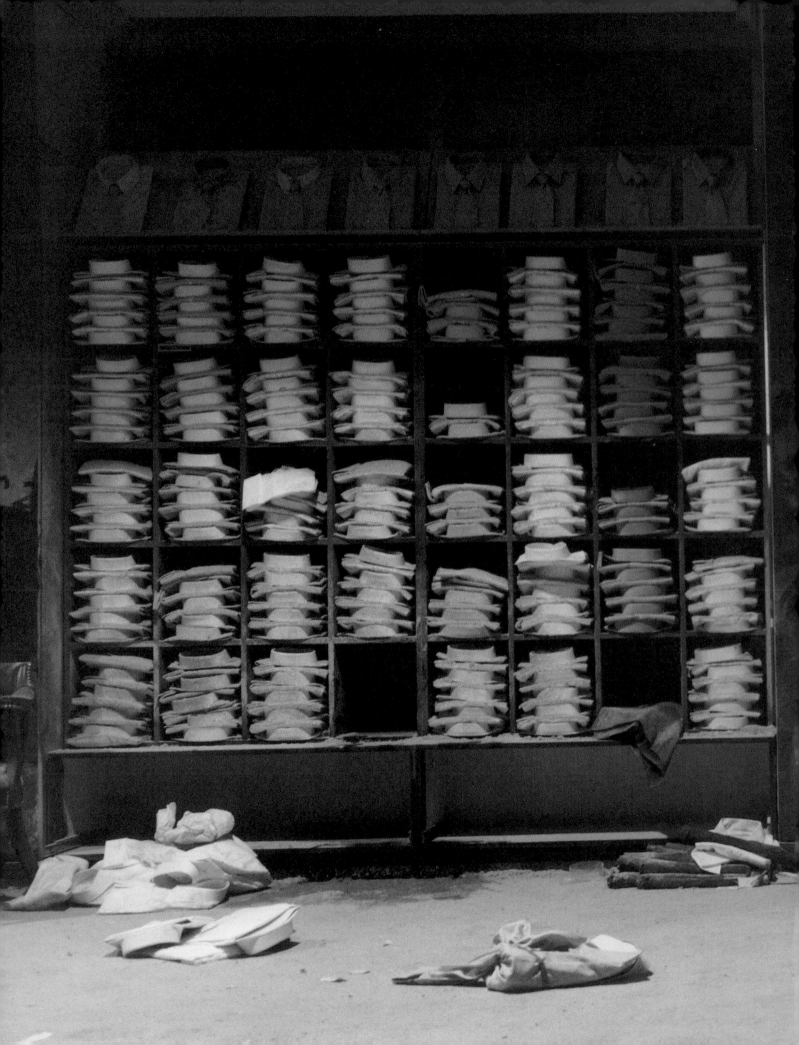

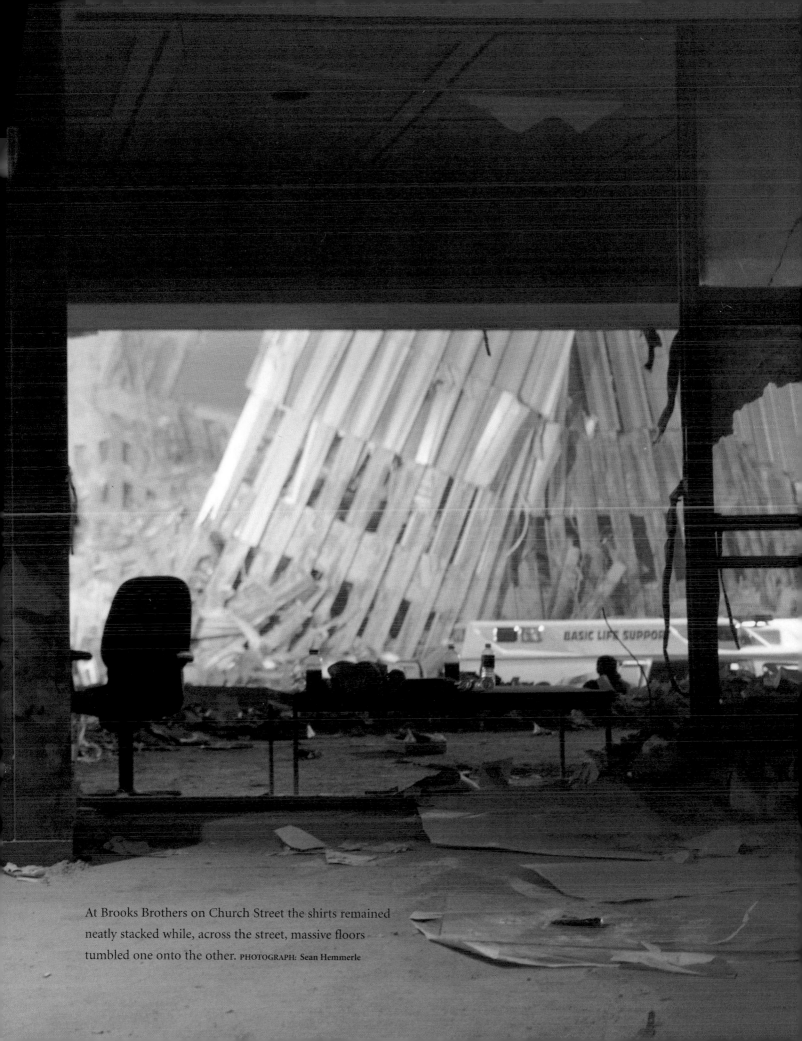

At Brooks Brothers on Church Street the shirts remained
neatly stacked while, across the street, massive floors
tumbled one onto the other. PHOTOGRAPH: Sean Hemmerle

68

"The dust shall sing like a bird, as the grains blow, as your death grows, through our heart" —Dylan Thomas. Messages of defiance, love, sorrow, and resolve were etched in the dust throughout downtown, while a tree was festooned with shoes.

PHOTOGRAPHS: Mark Peterson/Corbis SABA (below);

James Leynse/Corbis SABA (right)

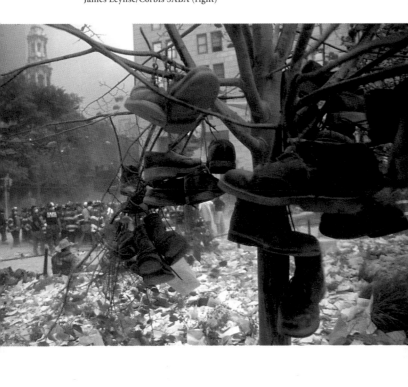

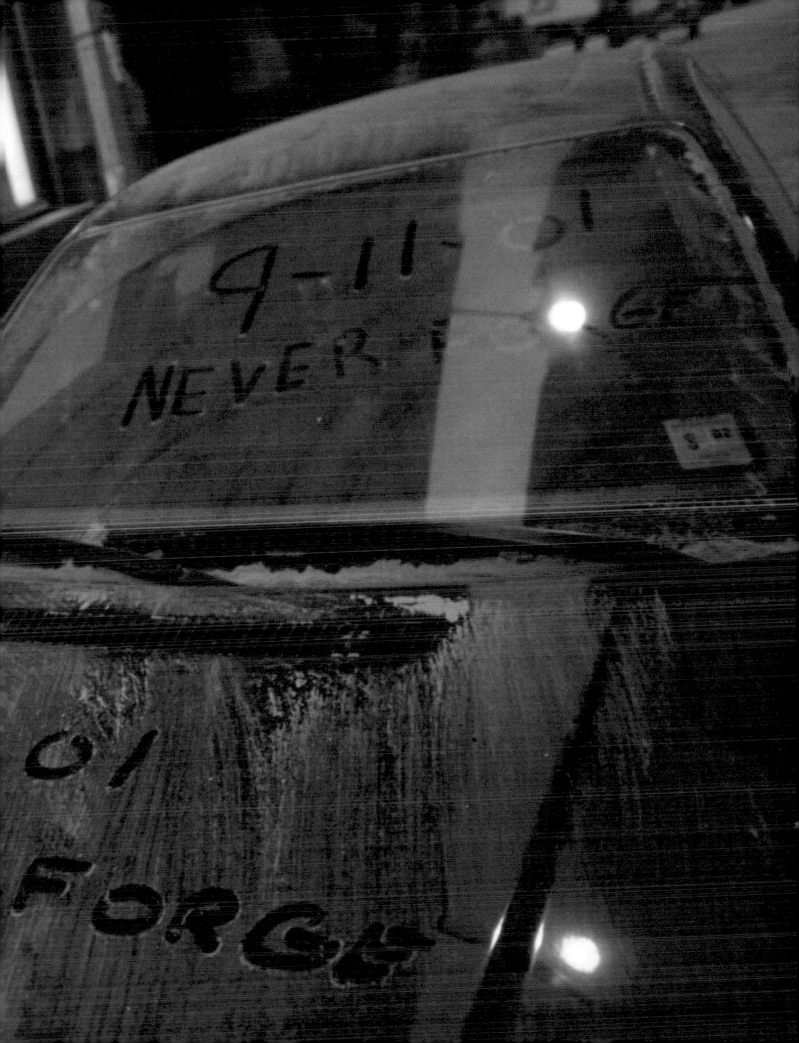

The man and his moment will be remembered long after the hole in the skyline is filled. Rudolph Giuliani, a lame duck who was limping toward the end of his controversial second term, became a mayor for all of America. He had helped the citizenry of New York finally feel safe, but his greatest gift was his ability to press on even when they weren't.

In the week after the attack, the mayor, often accompanied by New York Governor George Pataki, brought many national and international leaders to Ground Zero to read its lesson in the twisted steel, including United Nations Secretary General Kofi Annan. Two weeks later, Annan, in turn, had Giuliani at the UN, where the mayor read a lesson of his own: "The evidence of terrorism's brutality and inhumanity . . . is lying beneath the rubble of the World Trade Center less than two miles from where we meet today. Look at that destruction, that massive, senseless, cruel loss of human life, and then I ask you to look in your hearts and recognize that there is no room for neutrality on the issue of terrorism."

PHOTOGRAPH: Timothy A. Clary/AFP

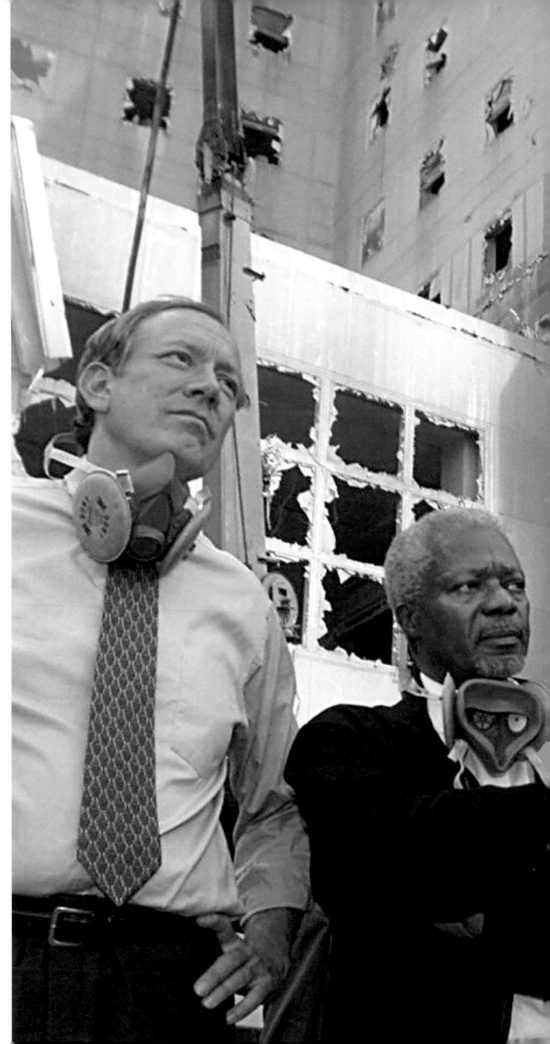

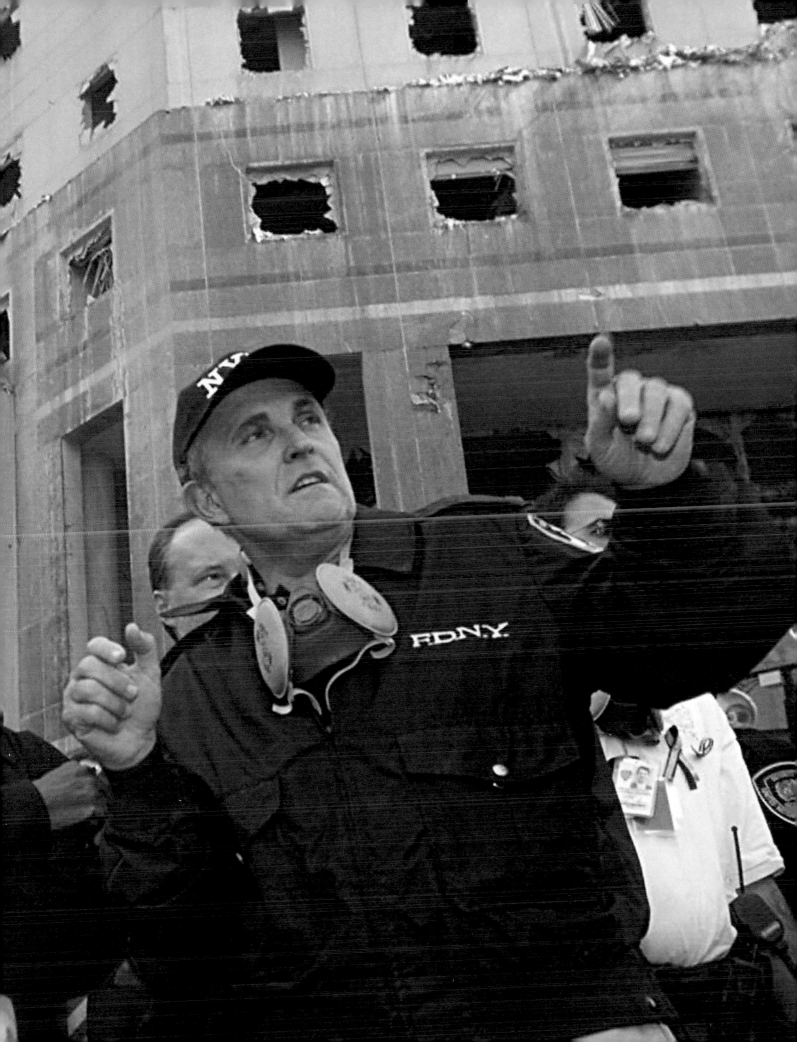

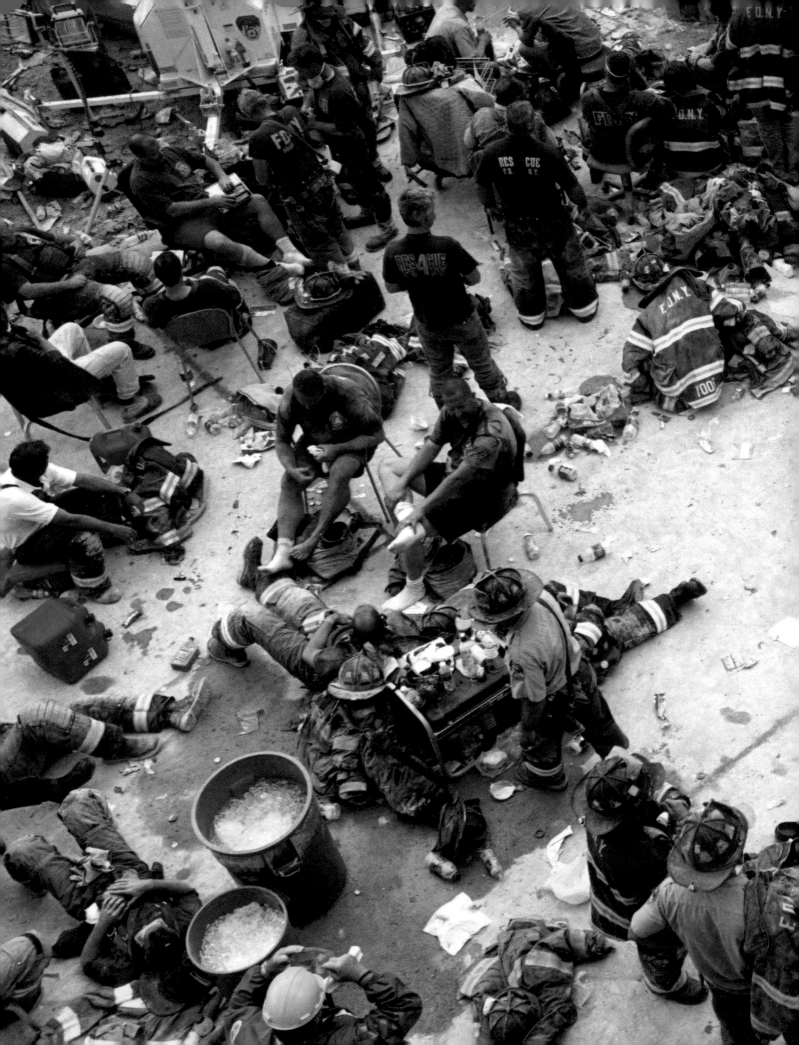

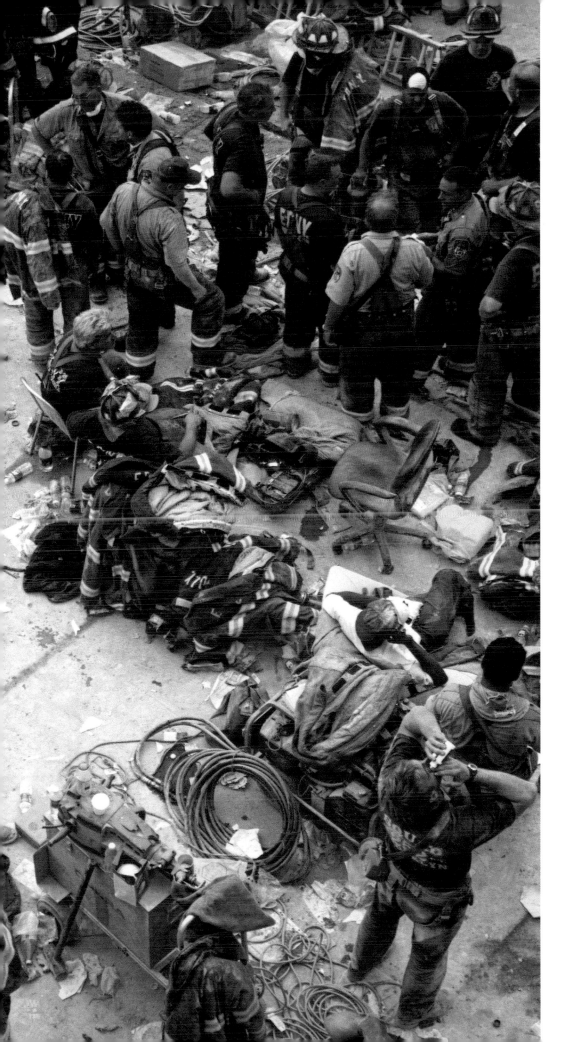

Ground Zero became a city within a city, governed by its own rules. Men worked until they dropped, grabbing drinks and food from the volunteers walking through. There was more talk of blisters than bravery, although there were plenty of both to go around. PHOTOGRAPH: Timothy Fadek/Gamma

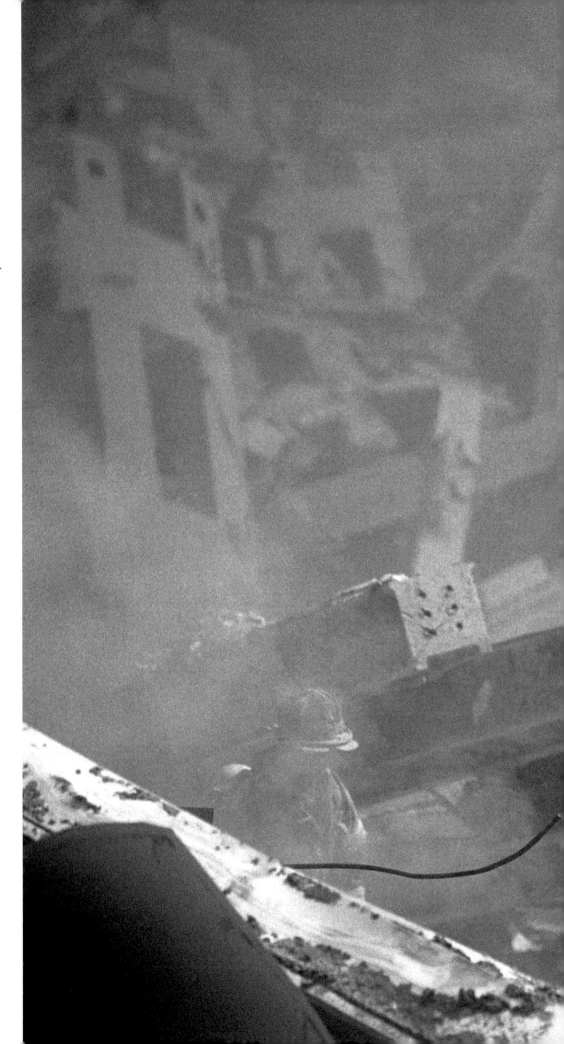

Firefighters ascended the mountain of sorrow at their own peril. Seemingly solid mounds of wreckage were actually perched above four- and-five story drops. Several men working on the recovery effort slid into holes, creating false rumors of new survivors when they were pulled from the depths.

PHOTOGRAPH: Richard B. Levine

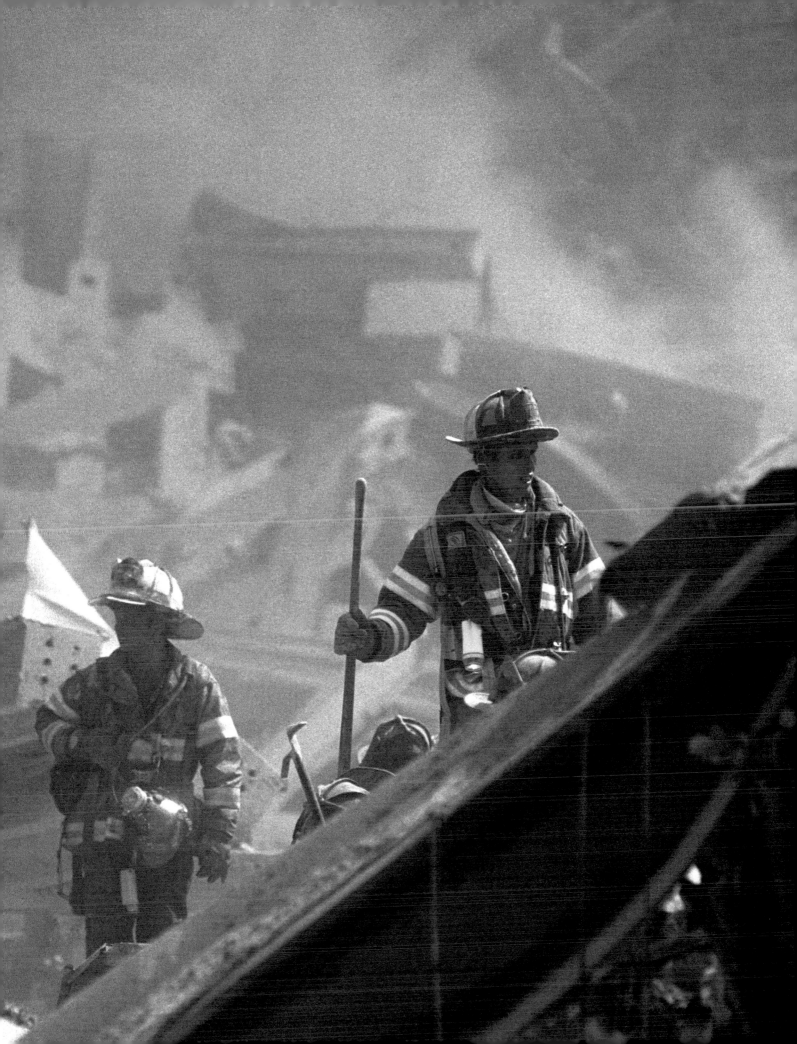

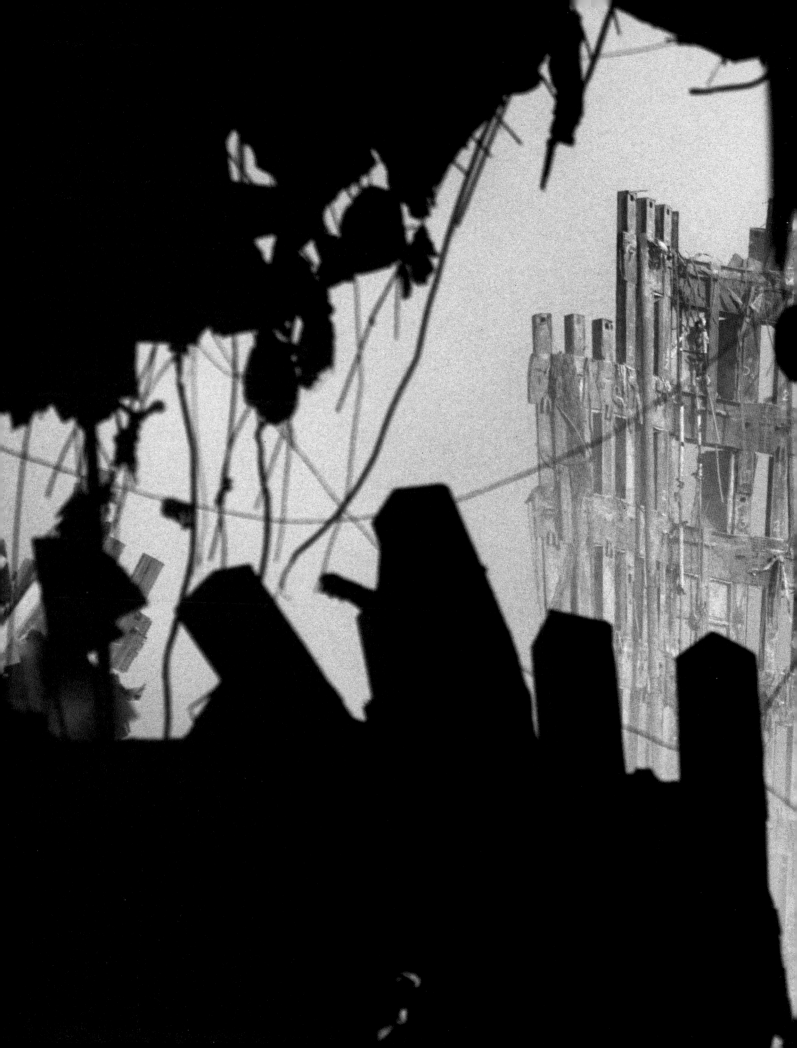

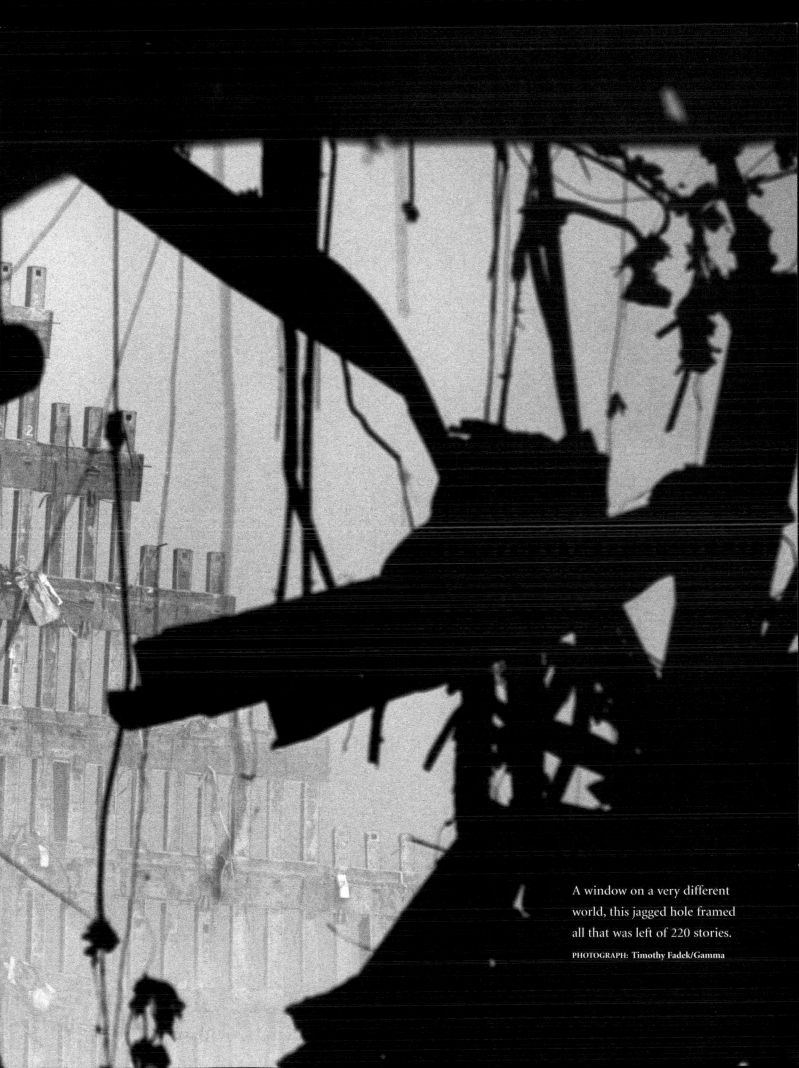

A window on a very different
world, this jagged hole framed
all that was left of 220 stories.
PHOTOGRAPH: Timothy Fadek/Gamma

After carefully picking away the smaller debris by hand, workers brought in torches to cut away massive girders felled like a forest of trees. By Friday, September 14, 9,000 tons of debris had been removed—1,500 truckloads—but almost 1.2 million tons remained on the sixteen-acre site. PHOTOGRAPHS: Yoni Brook/Gamma (below); Marcos Townsend/AFP (opposite)

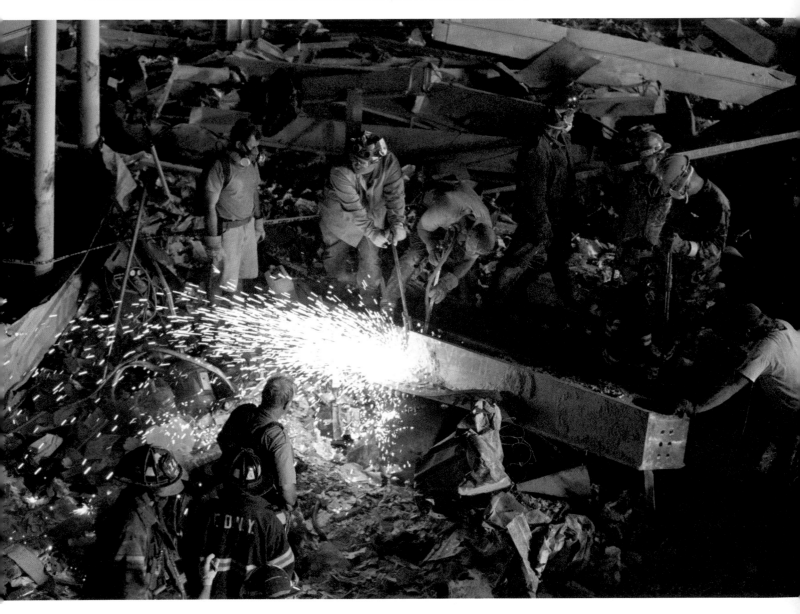

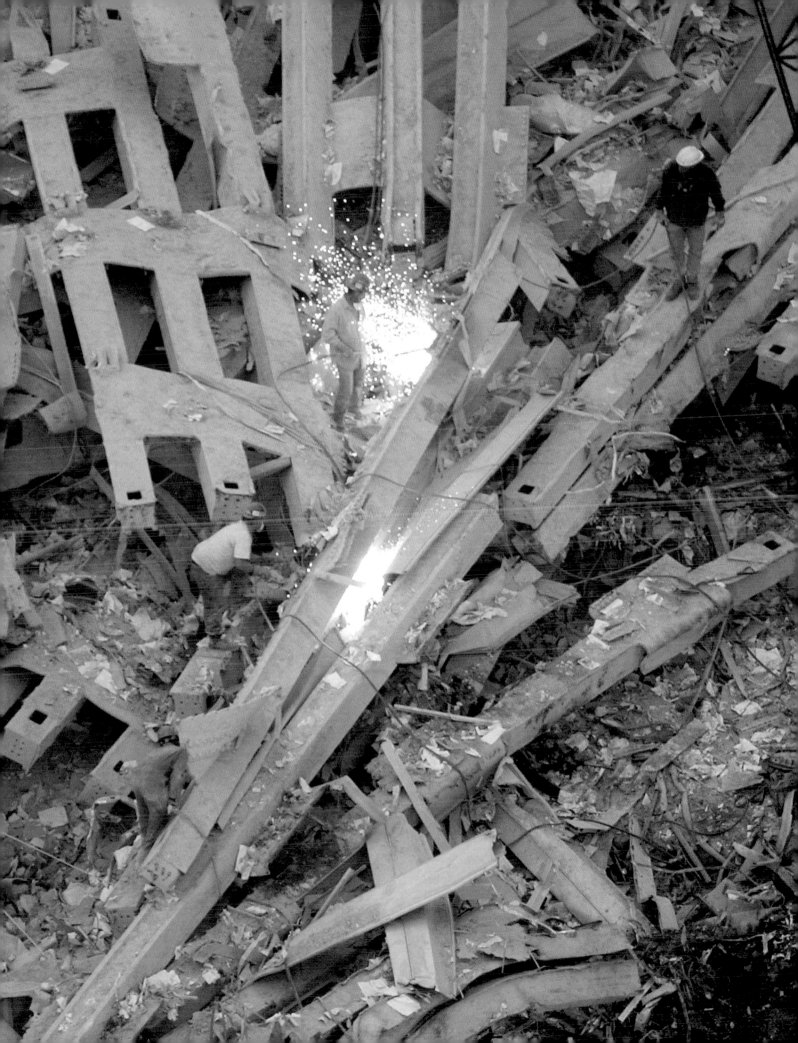

"After four days, we were in there looking for miracles, but we found bodies instead," said Lt. George Farinacci of Ladder 148 in Brooklyn, who took this photograph from inside six stories of rubble near the site of a stairway in 1 World Trade—the "attack stairway" that firefighters had climbed to fight the blaze. Although a few men from Ladder 6 somehow emerged from a pocket in the stairs on the first day, many others did not. "You want to find a void of live, breathing friends," he added. "But at least by recovering some of the bodies, we were able to give the families some closure."

PHOTOGRAPH: George Farinacci

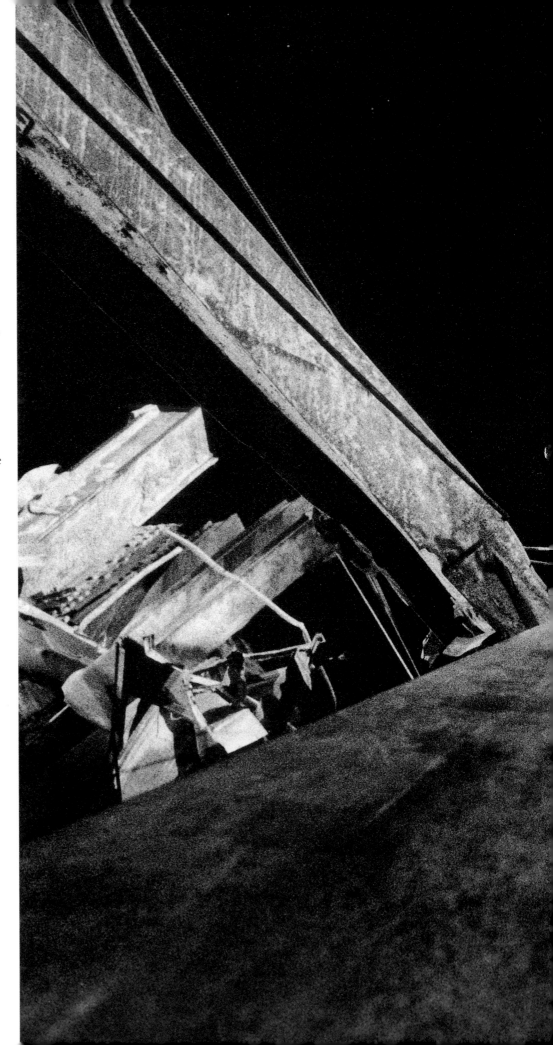

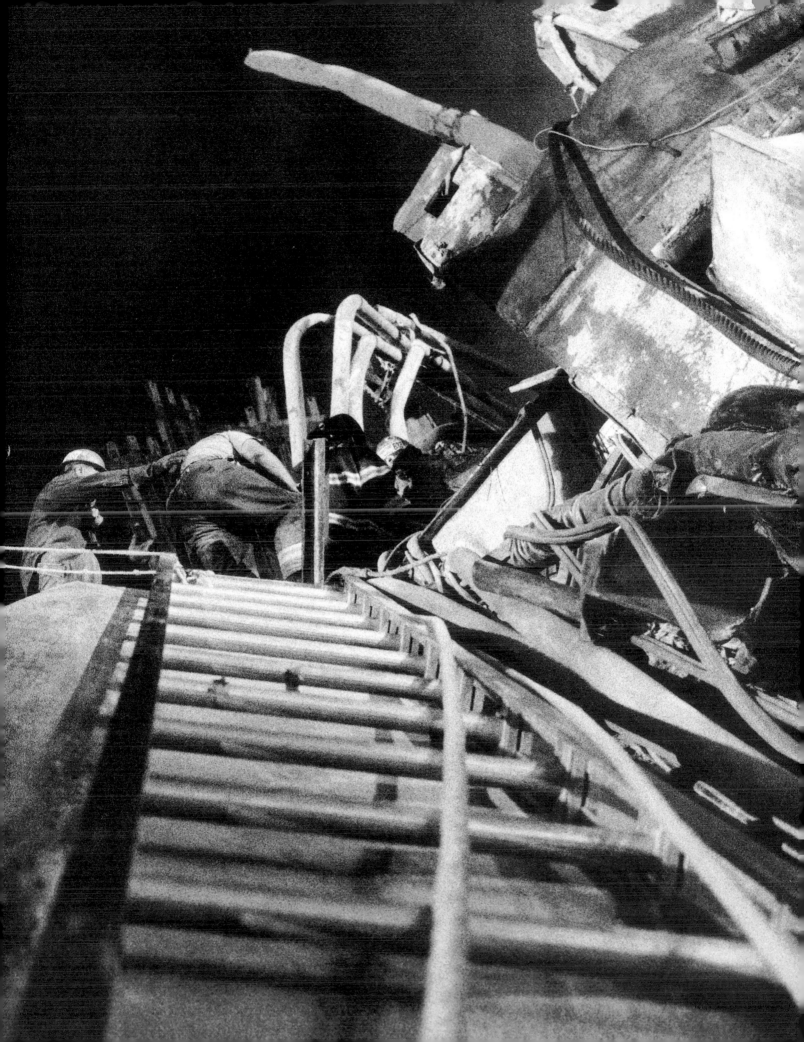

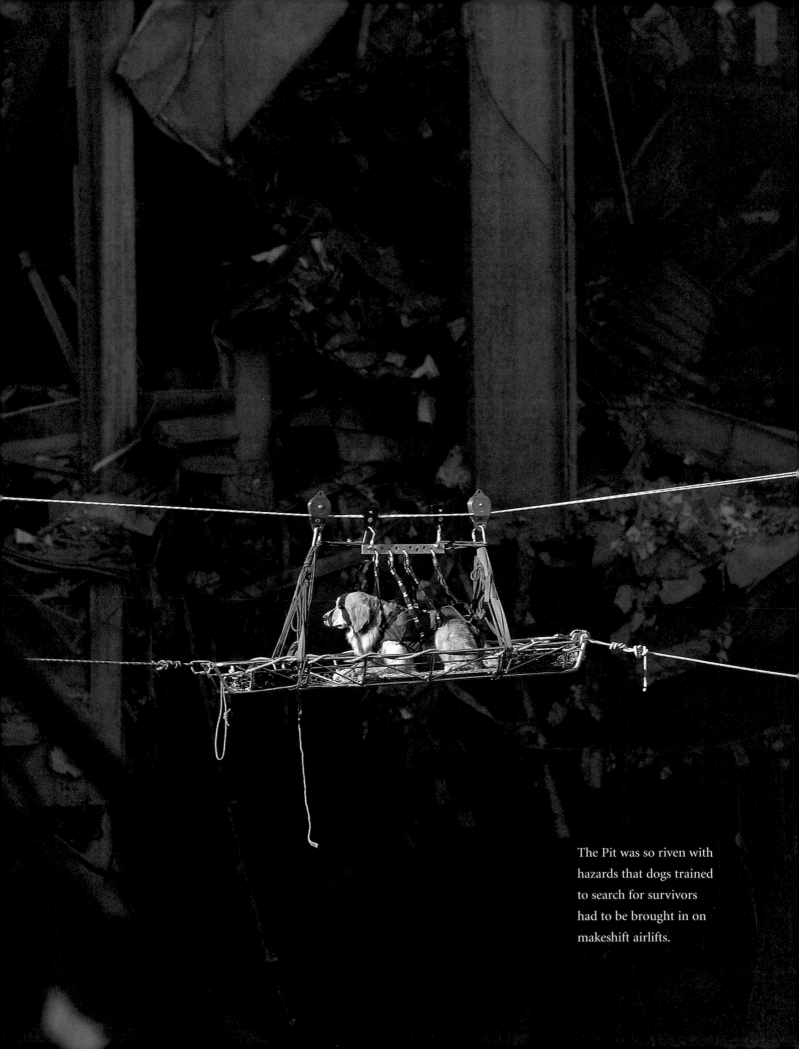

The Pit was so riven with
hazards that dogs trained
to search for survivors
had to be brought in on
makeshift airlifts.

Rescue workers formed a bucket brigade to remove rubble, hoping to find identifiable remains or personal belongings that could be returned to families. "What you've got," said carpenter Robert Doremus, "is daisy chains of guys—hundreds of guys—pulling stuff out, handing it off the old-fashioned way, the way they used to bring water into a fire."

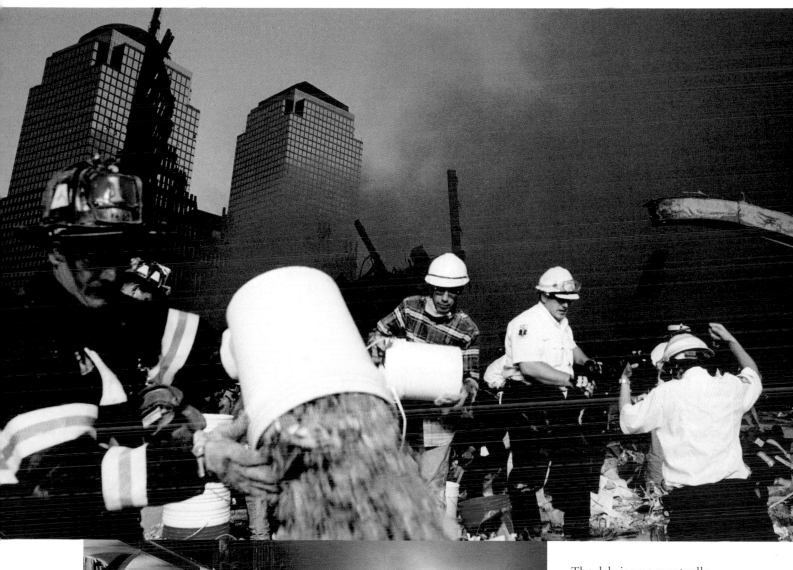

The debris was eventually loaded into dump trucks for the slow trip to Staten Island's Fresh Kills landfill, which was reopened to serve as a sorting ground and disposal site. City officials estimated that it would take at least a year to clean up Ground Zero.

PHOTOGRAPHS: Gamma (opposite); Yoni Brook/Gamma (above); Stuart Ramson/AP Wide World Photos (left)

The search for survivors went on 24/7, with huge movie lights giving the site a cinematic cast, even though the devastation was all too real. PHOTOGRAPH: Patrick Andrade/Gamma

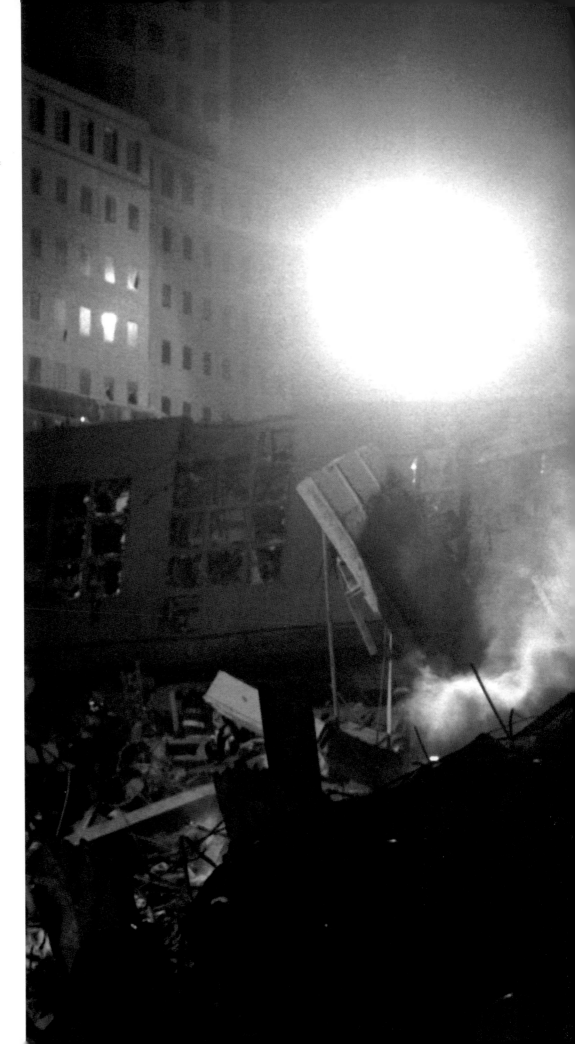

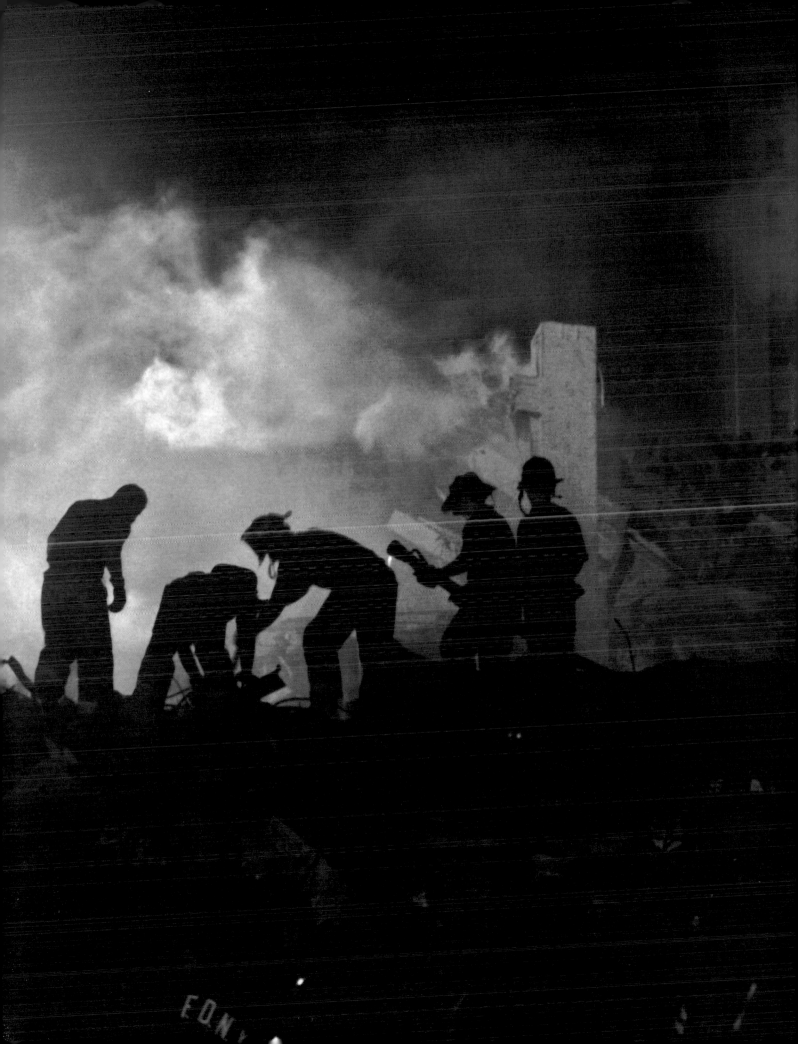

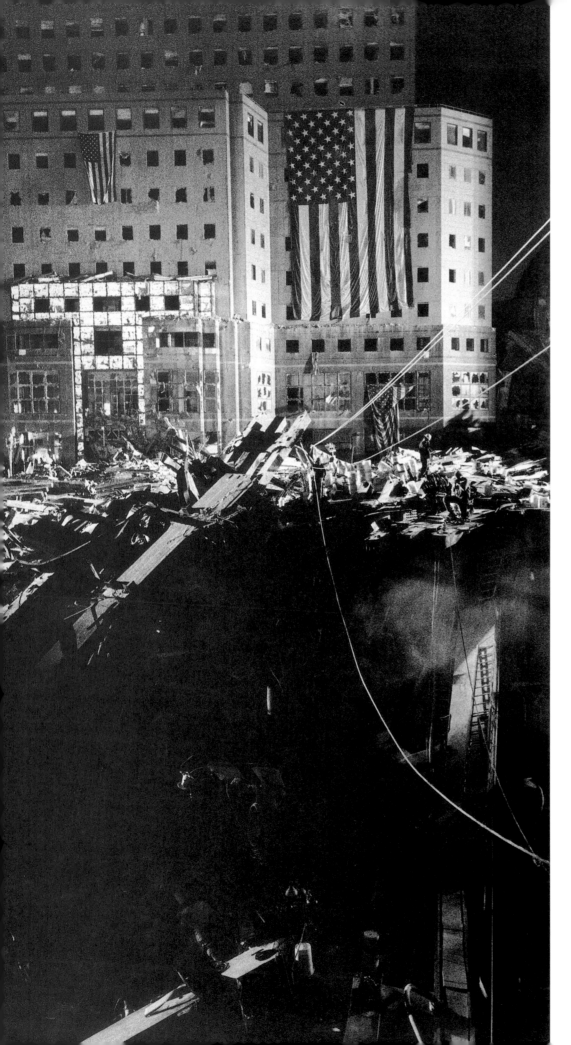

The flag of the United States became the emblem of strength amidst the ruins. On Wednesday, September 12, firefighters uncovered the TV tower that had once topped 1 World Trade and raised the colors halfway up to remember the dead and embolden the living. The echo of Iwo Jima was not lost on a country seeking its confidence. "My mother and father . . . could tell you where they were when Pearl Harbor happened," said Mayor Giuliani. "Everybody's going to be able to tell you where they were when the World Trade Center was attacked." The mayor will be able to tell anyone who asks that he was right in the middle of it, spreading a certainty that New York would survive and prosper anew.

Flags on the shattered façade of 2 World Financial Center helped sustain the men and women involved in the rescue effort as they dug deeper into the gaping maw of devastation. PHOTOGRAPHS: George Farinacci (left); Stephen Shames/Matrix (opposite)

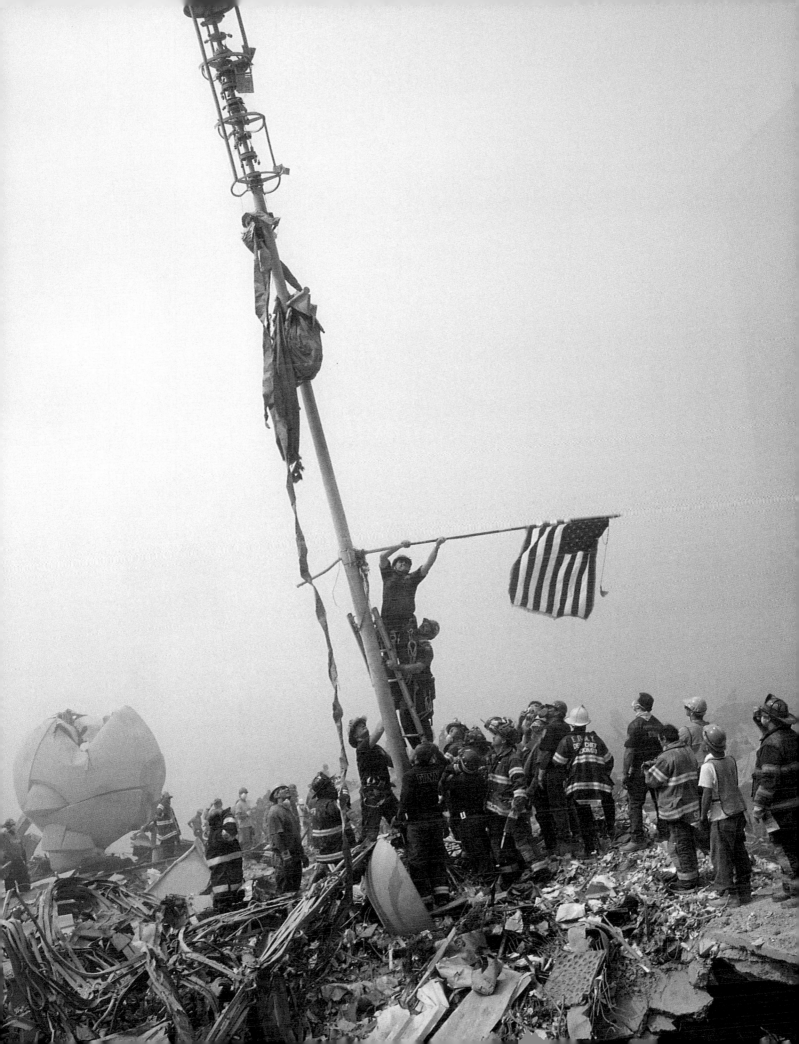

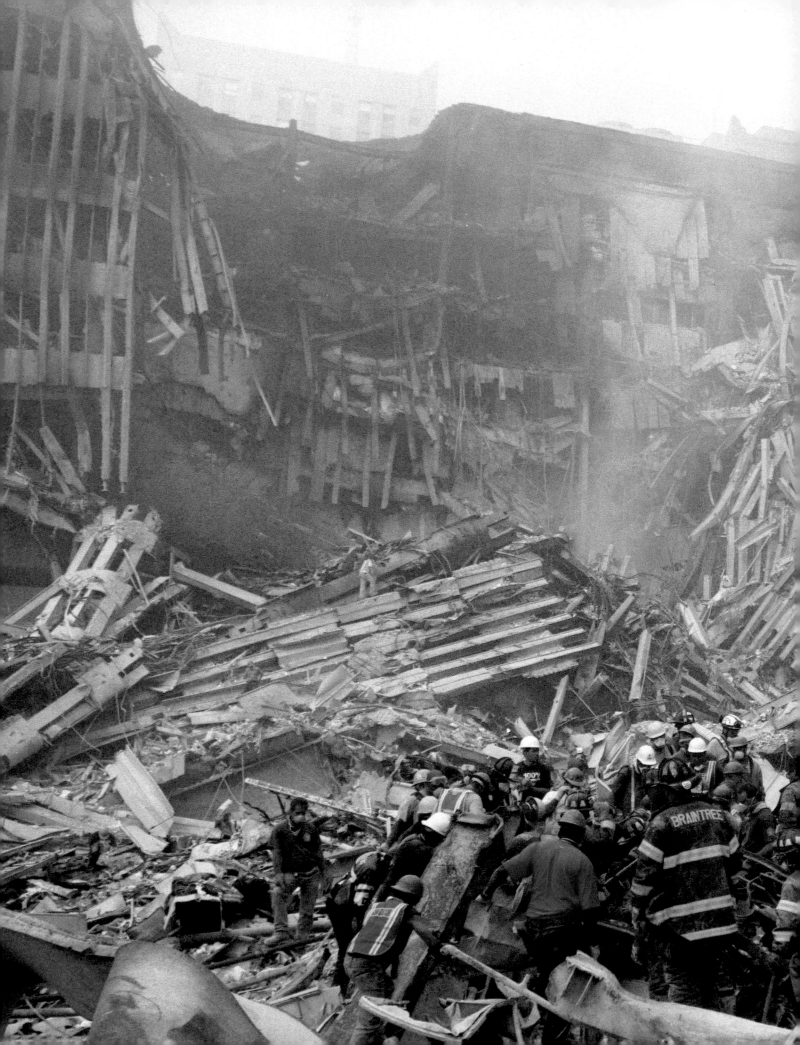

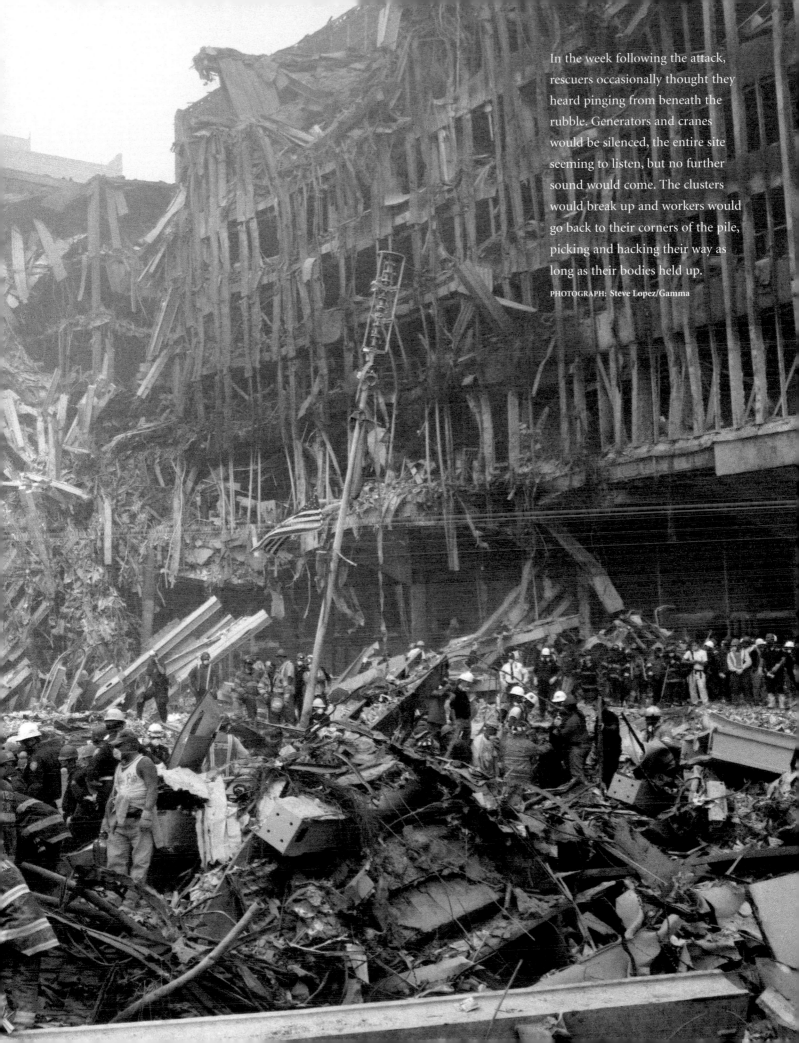

In the week following the attack, rescuers occasionally thought they heard pinging from beneath the rubble. Generators and cranes would be silenced, the entire site seeming to listen, but no further sound would come. The clusters would break up and workers would go back to their corners of the pile, picking and hacking their way as long as their bodies held up.

PHOTOGRAPH: Steve Lopez/Gamma

On Friday, September 14, President Bush visited the site, standing atop a charred fire truck with a bullhorn to thank the men and women who arrived on Tuesday to help—and never left. After some of the workers shouted that they couldn't hear the President, he took the opportunity to send some other messages as well. "I can hear you. The rest of the world hears you, and the people who knocked these buildings down will hear all of us soon."

That same day, Congress unanimously approved a $40 billion emergency aid package for relief and counterterrorism measures. Speaking of the President, whose support for the bill was unequivo-cal, New York Senator Chuck Schumer said, "I would bet this is the first time he's bonded with New York. . . . I think it's a metaphor for America. There's no hostility. There's no wariness. It's a rare moment." PHOTOGRAPH: Win McNamee/Reuters/Timepix

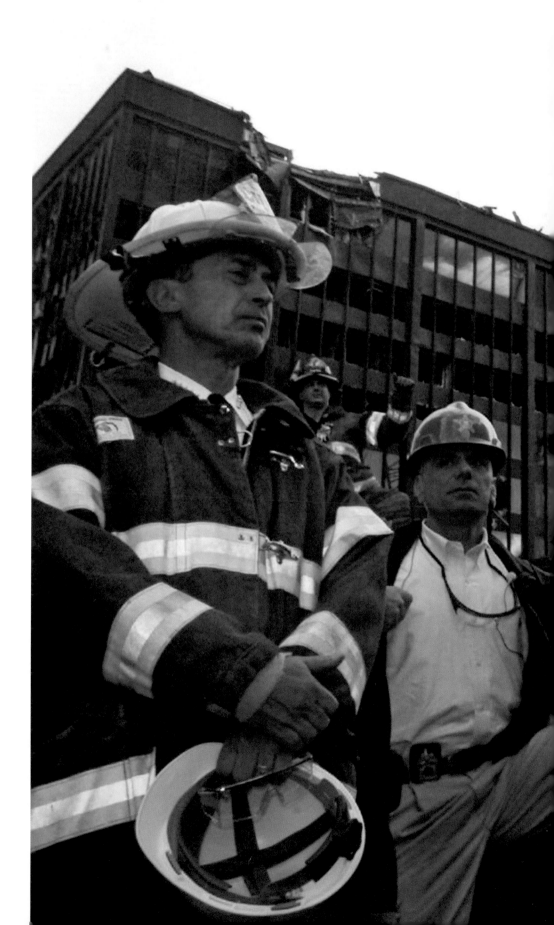

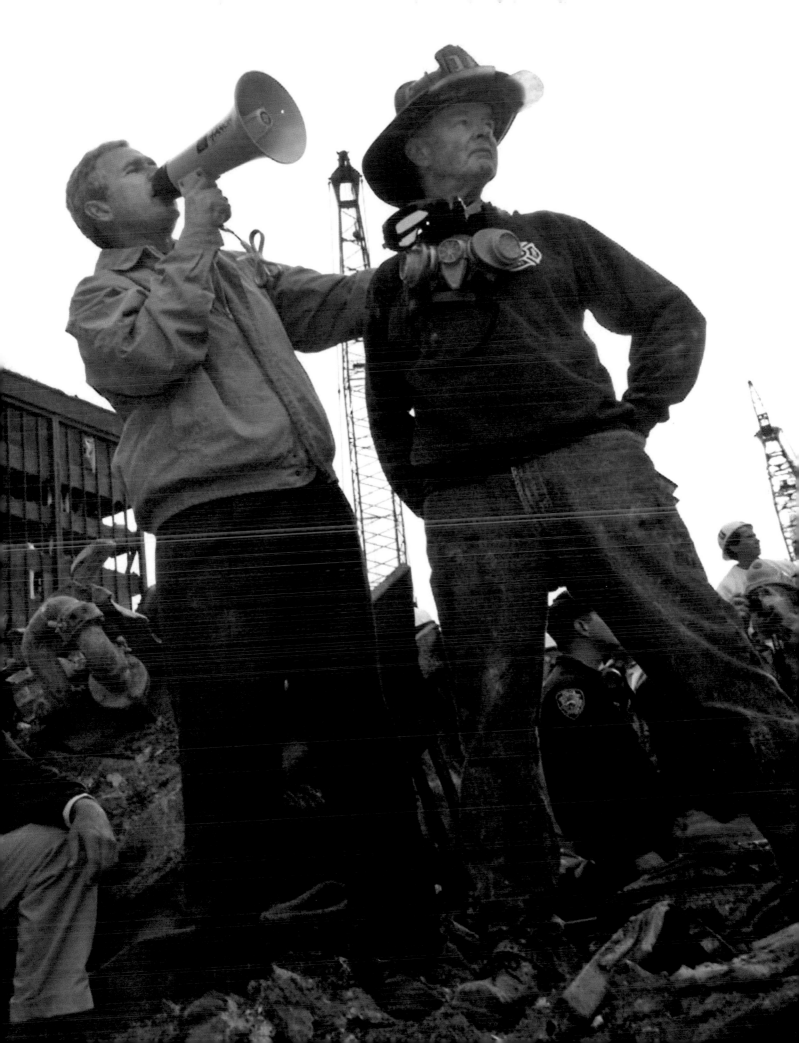

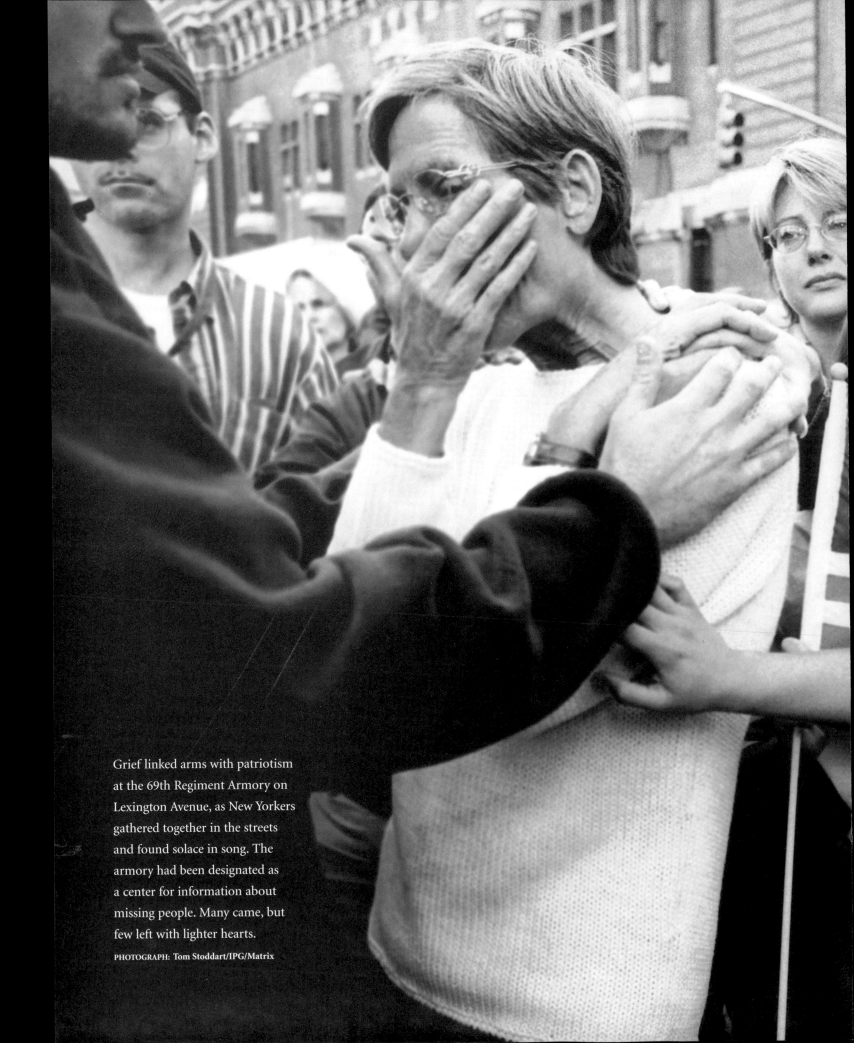

Grief linked arms with patriotism at the 69th Regiment Armory on Lexington Avenue, as New Yorkers gathered together in the streets and found solace in song. The armory had been designated as a center for information about missing people. Many came, but few left with lighter hearts.

PHOTOGRAPH: Tom Stoddart/IPG/Matrix

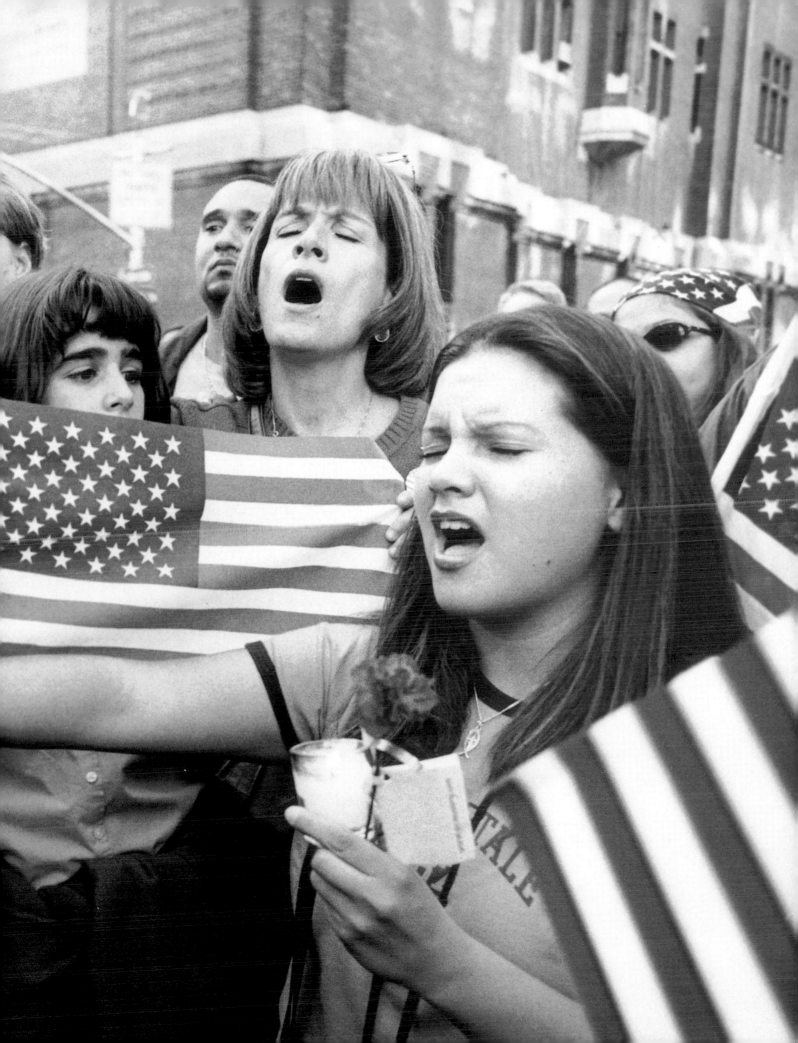

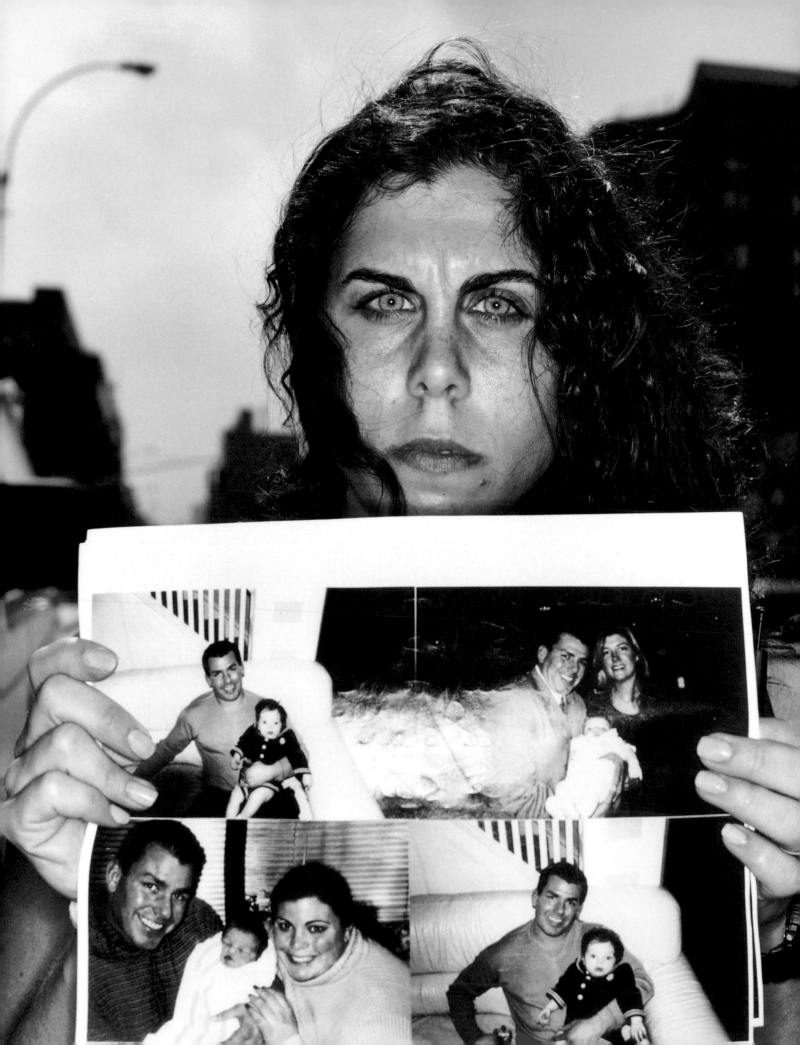

Ingrid Smith holds onto hope and a poster depicting her missing brother-in-law. Left with no trace of their loved ones, Smith and thousands of others commandeered copy machines and then hit the streets, papering the city with images of the lost. As the hours became days, and the days became weeks, the posters themselves became totems of the city's bereftness, testaments to the enduring love of family and friends.

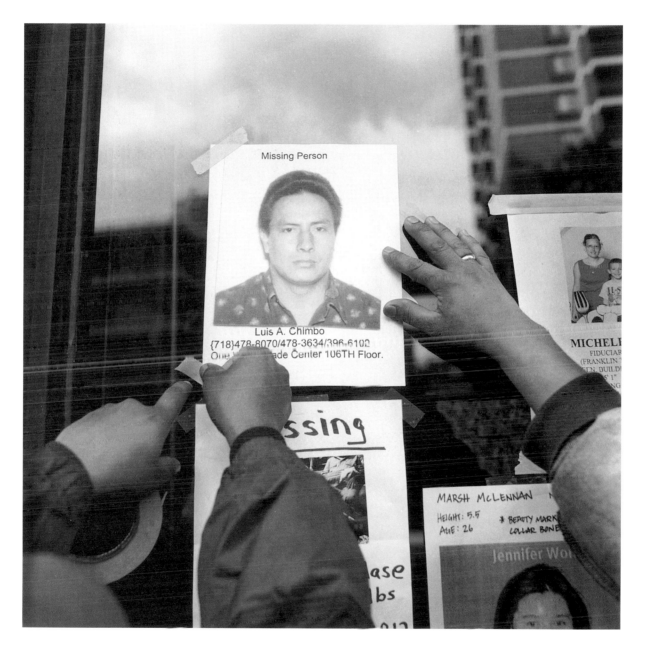

Financial firms most New Yorkers had never heard of became household names, echoed on poster after poster. Cantor Fitzgerald, bond traders on the 101st through 105th floors of the North Tower, was mortally wounded, losing more than 600 of its 1,000 New York employees and leaving 1,500 children grieving for a parent. Its chairman, Howard Lutnick, not known on the Street for a soft heart, said, "We have a new class of partners here—these families. I have to take care of these families." PHOTOGRAPHS: Nathaniel Welch/Corbis SABA (opposite); Brian Finke (above)

On September 11, death crossed the rivers and the seas from Manhattan. Every borough of the city was scathed; of the lost firefighters, seventy-eight came from Staten Island. "You could knock on every door and you'd find someone who knows someone in the Trade Center or who was on a truck," said Ron Barranco, a paramedic who lives in Staten Island. "I know thirty guys—fifteen from my community.'" Some towns in New Jersey, Westchester, Connecticut, and Long Island lost more sons and daughters at the Trade Center than they had in World War II or Vietnam. And among the missing were people from eighty nations. PHOTOGRAPH:

Jonathan Torgovnik

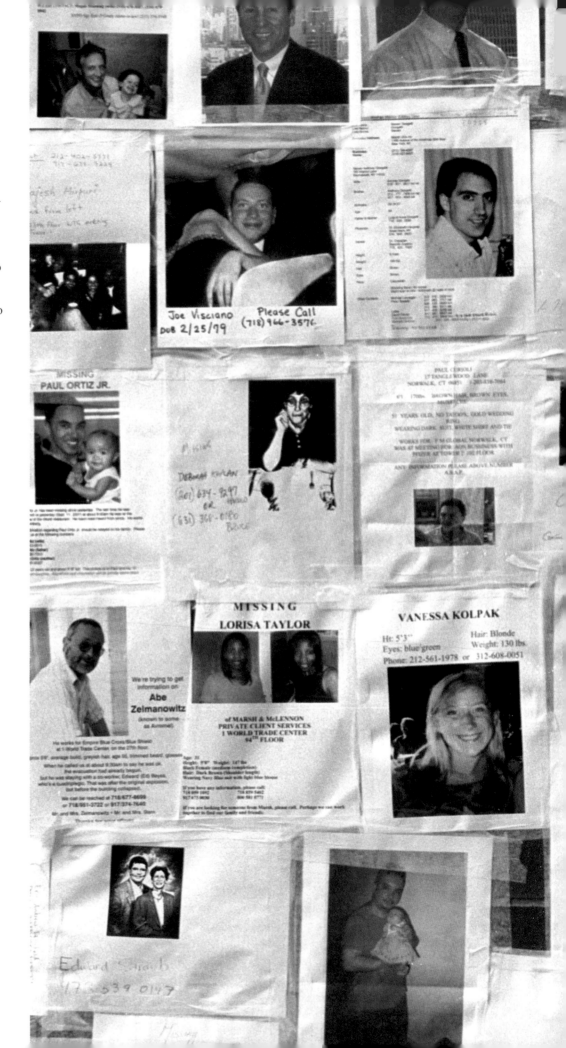

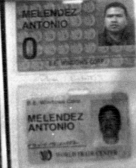

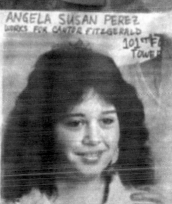
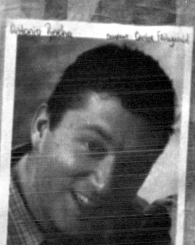

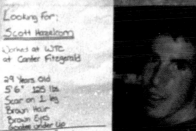

Children were among the first artists to be inspired by the tragedy: Rafael Texidor's "New York Under Attack" was one of hundreds of drawings posted at firehouses and at impromptu memorials around the city. Parents and educators did their best to struggle past their own feelings of vulnerability to assure their children that they were safe. PHOTOGRAPHS: Brian Finke (opposite); Tom Stoddart/IPG/Matrix (below)

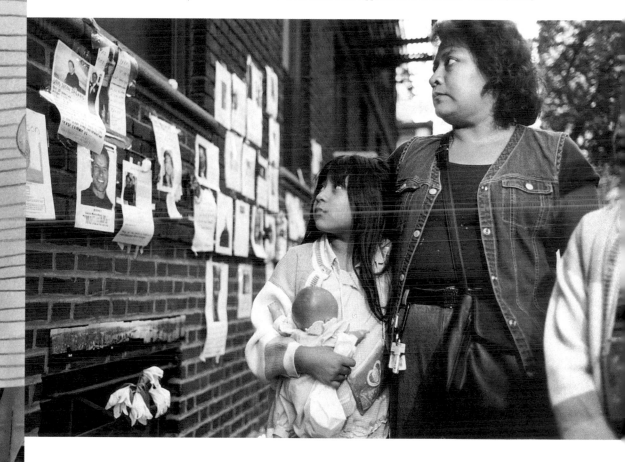

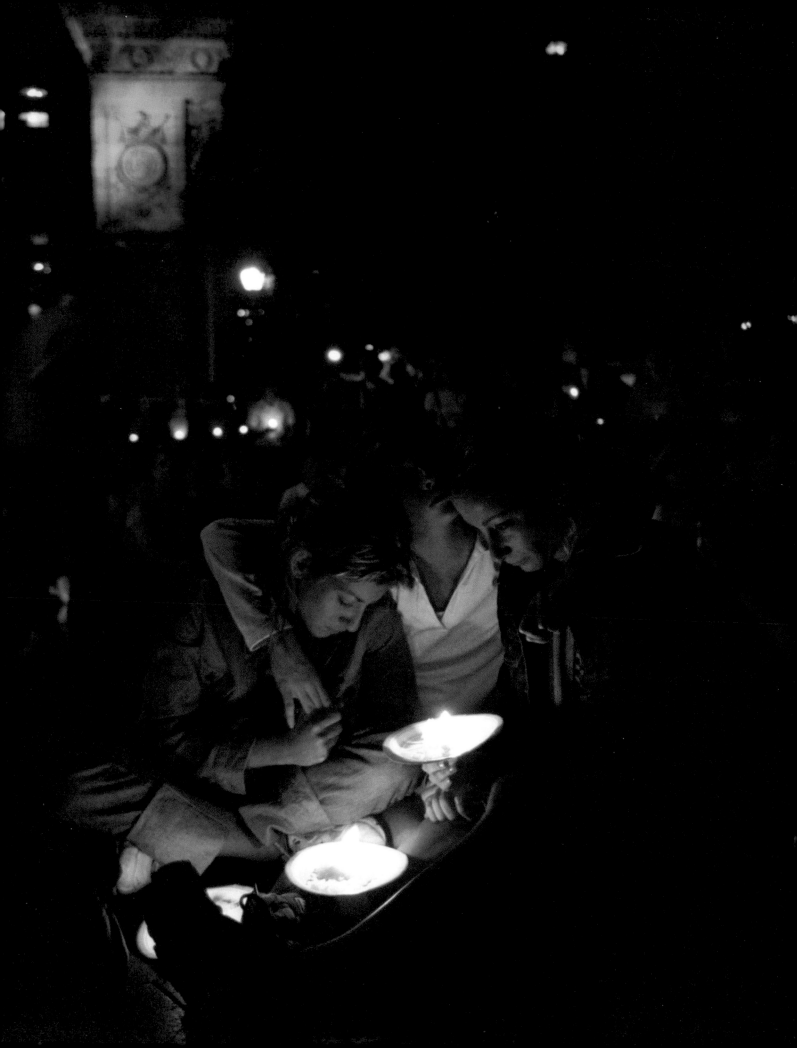

The first candle was lit soon after the attack and the flame was passed from Washington Square to the Brooklyn Promenade and back to Union Square, the flickering light chasing back the darkness in the city's midst and illuminating the American flags that were suddenly everywhere.

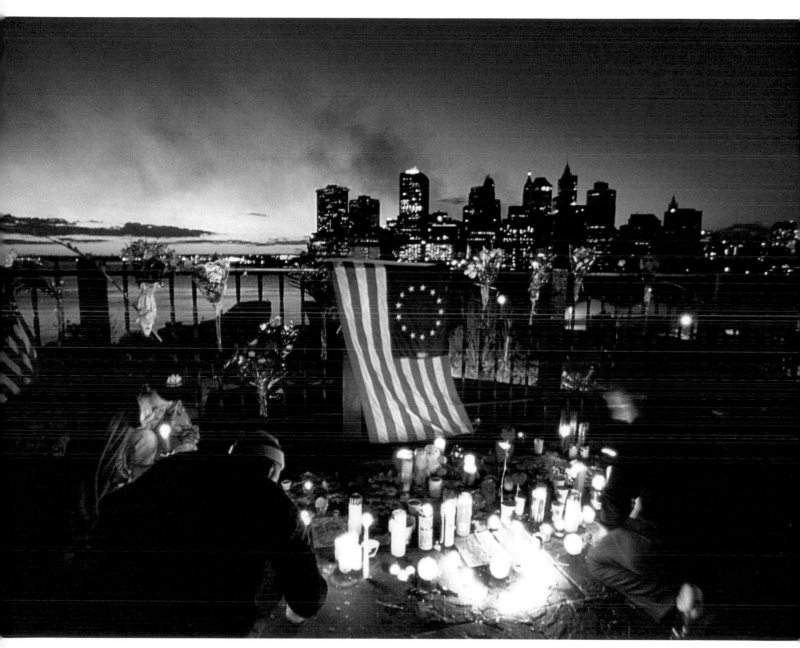

Rabbi Peter Rubinstein of Midtown's Central Synagogue found a homely metaphor to explain the impulse that brought New Yorkers together: "Those of us who ride the subways hold onto poles when they're crowded. We see other hands holding the poles—all the colors, all the nationalities. That's the city. You rumble along, swaying, and there are sudden stops. You're all holding tighter now, to keep from falling. We're all holding tight now, together, because that pole is our foundation."

PHOTOGRAPHS: Clark Jones/Corbis SABA (opposite); Michel Setboun/Gamma (above); Mark Peterson/Corbis SABA (overleaf)

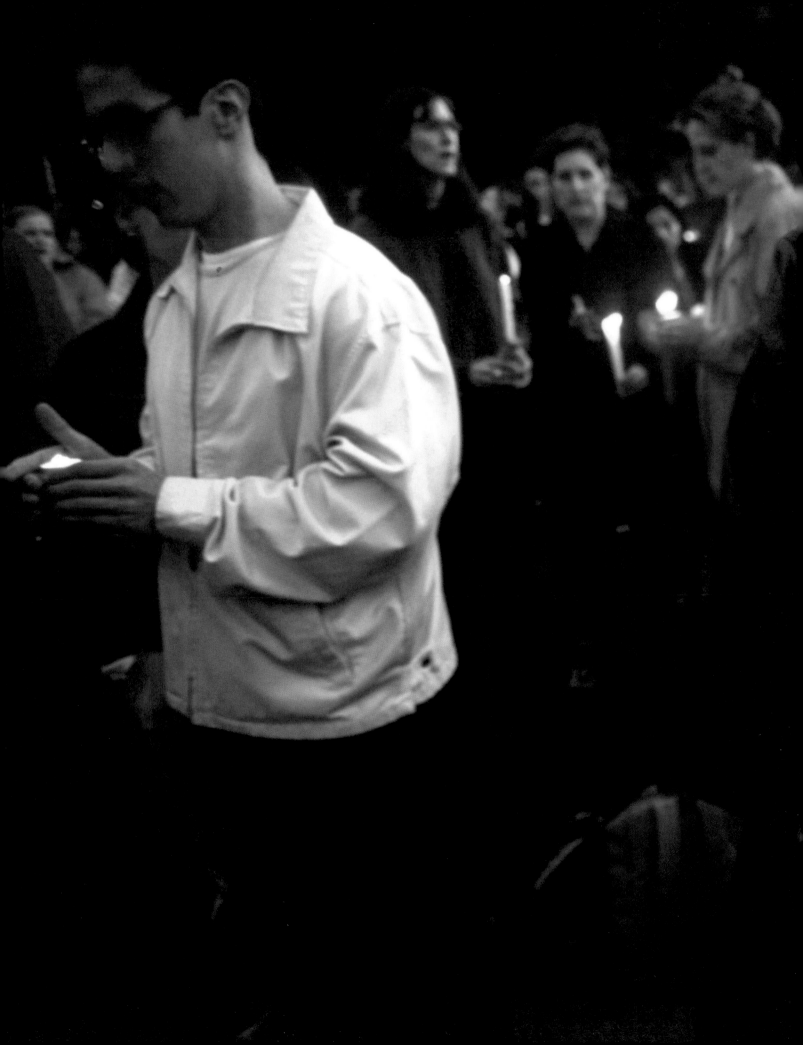

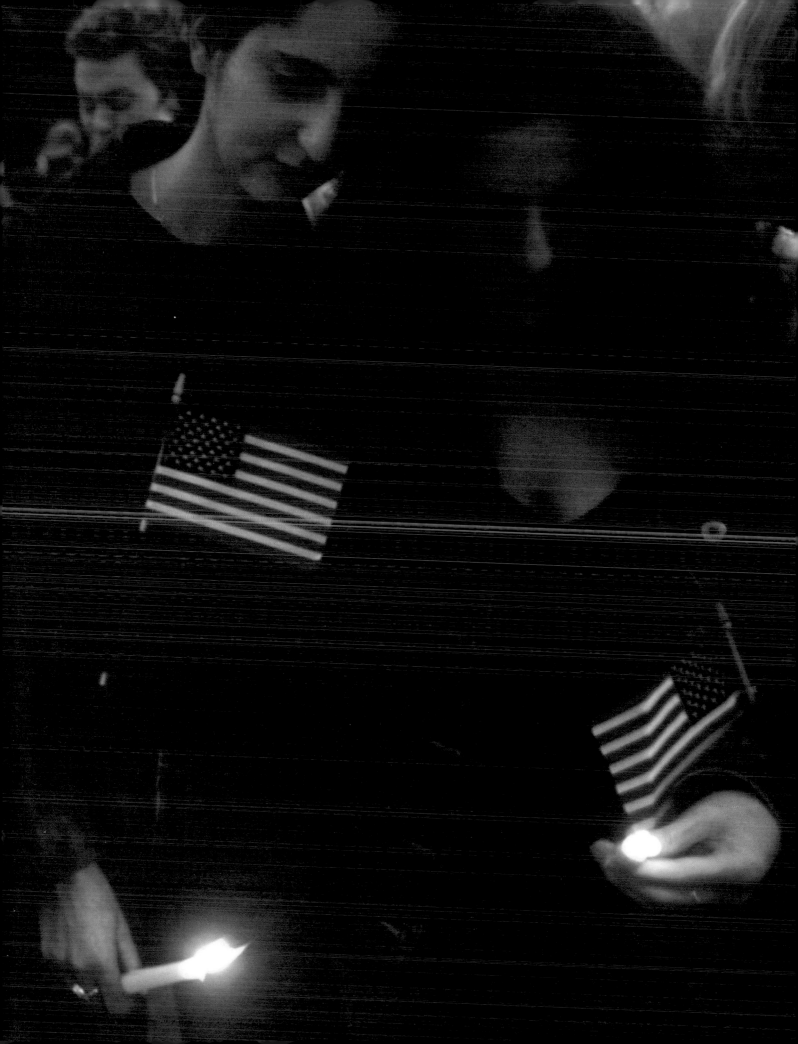

Union Square became a locus of grief and solace. On Tuesday afternoon, a nineteen-year-old student named Jordan Schuster unrolled a large piece of butcher paper for people to write on and by Saturday the fences were covered with messages and the ground with candles and personal offerings. PHOTOGRAPHS: John Reardon/IPG/Matrix

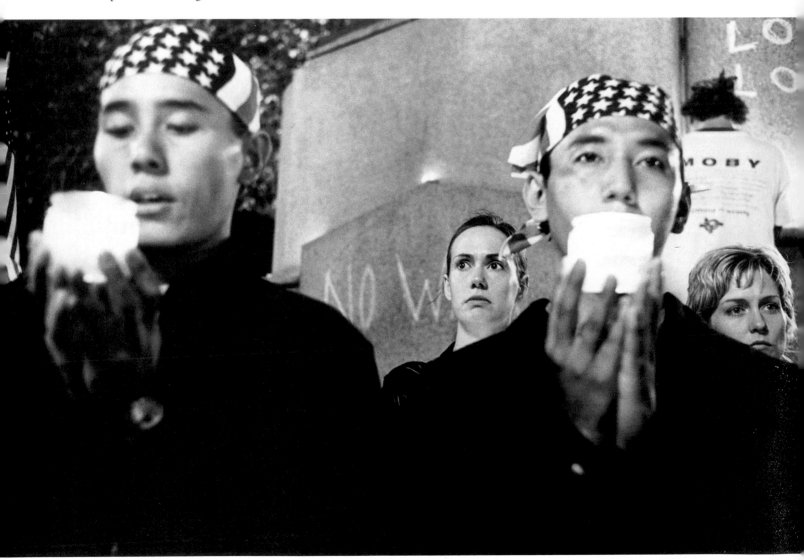

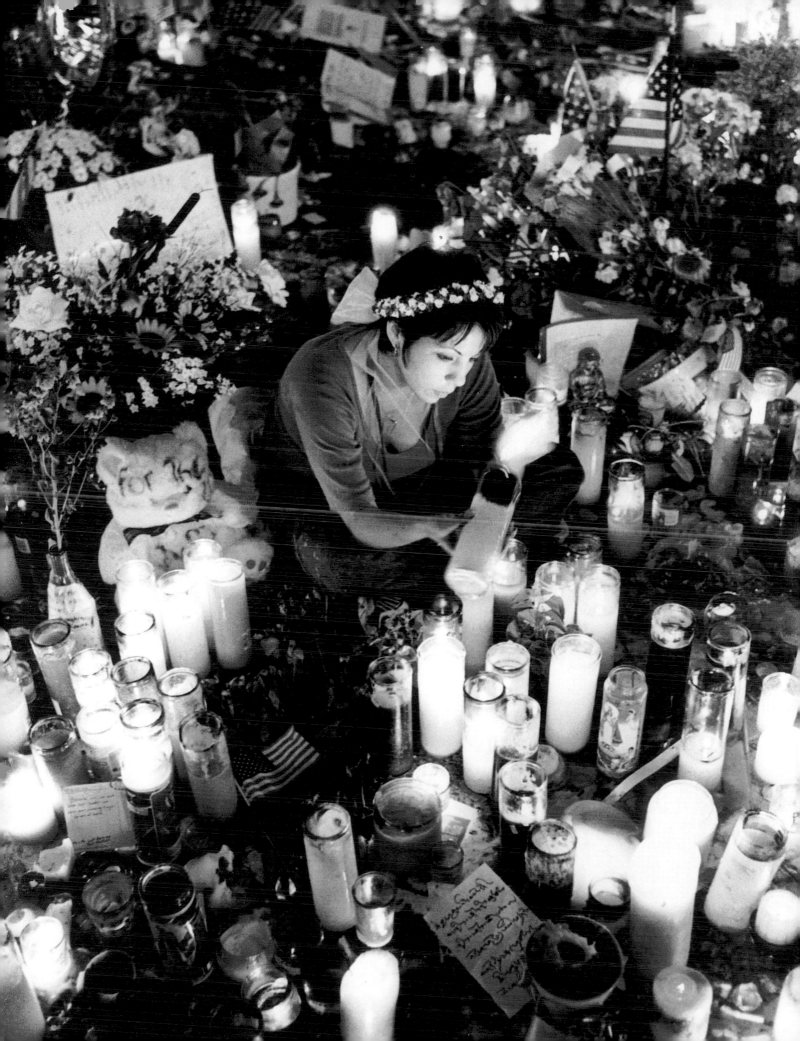

The National Guard patrolled the barricades of the financial district, but gun-toting soldiers were also popping up on uptown corners that usually host people weighed down by shopping bags. Activated guardsmen jammed into a coffee shop called Eat Here Now looking for a bite between shifts. A cheery, busy man with a thick Middle Eastern accent brusquely explained that there was "no toast, only rolls." Why? "Soldier food, army food. War is here. Don't complain." Meanwhile, going back to work became a patriotic duty. PHOTOGRAPHS: John Reardon/IPG/Matrix

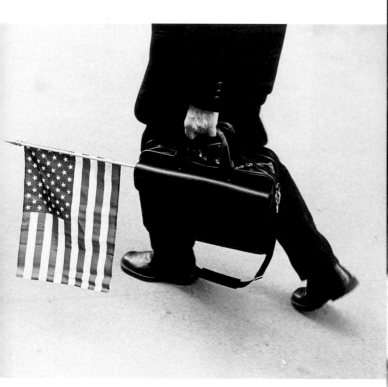

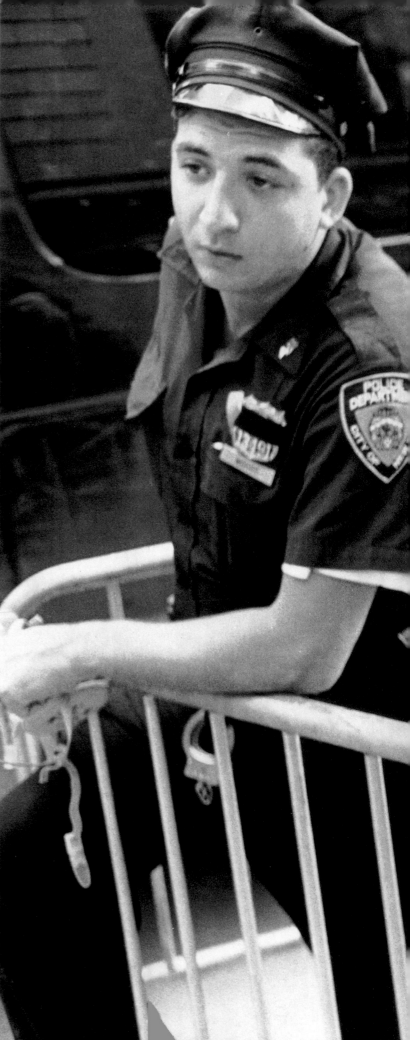

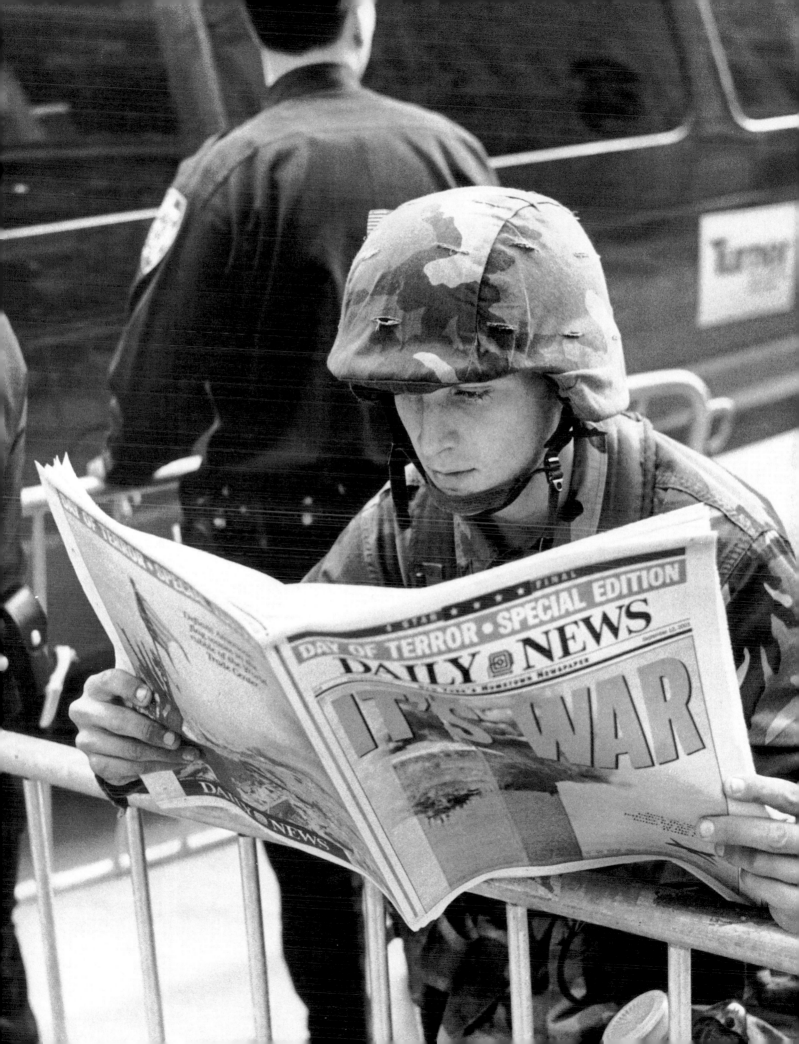

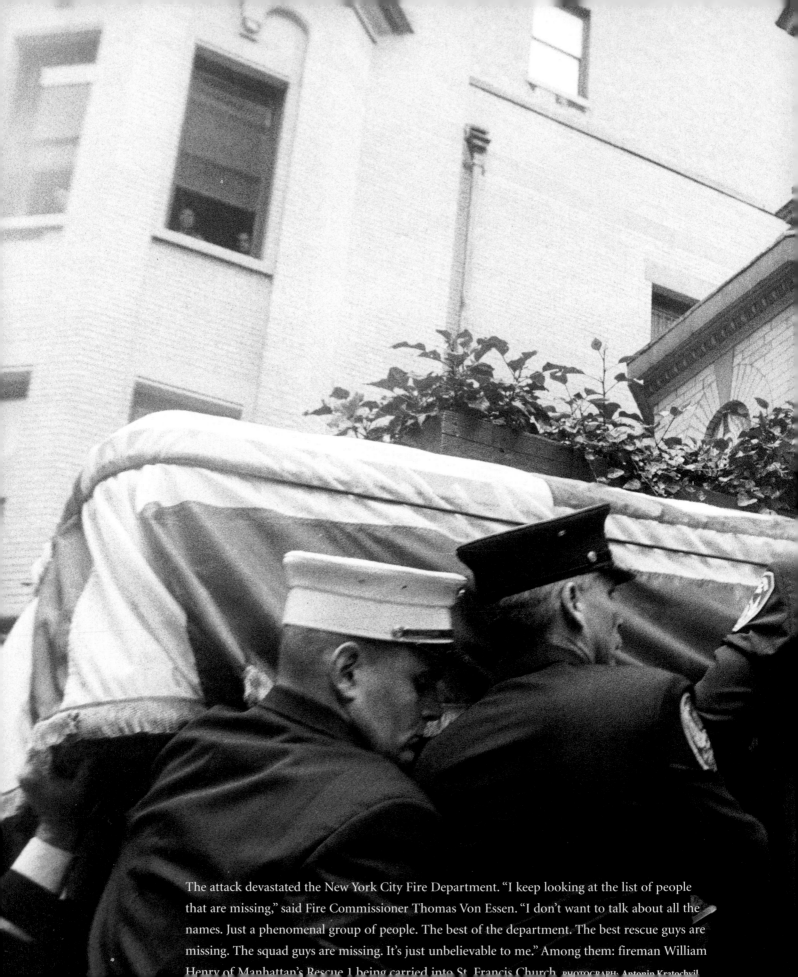

The attack devastated the New York City Fire Department. "I keep looking at the list of people that are missing," said Fire Commissioner Thomas Von Essen. "I don't want to talk about all the names. Just a phenomenal group of people. The best of the department. The best rescue guys are missing. The squad guys are missing. It's just unbelievable to me." Among them: fireman William Henry of Manhattan's Rescue 1 being carried into St. Francis Church. PHOTOGRAPH: Antonin Kratochvil

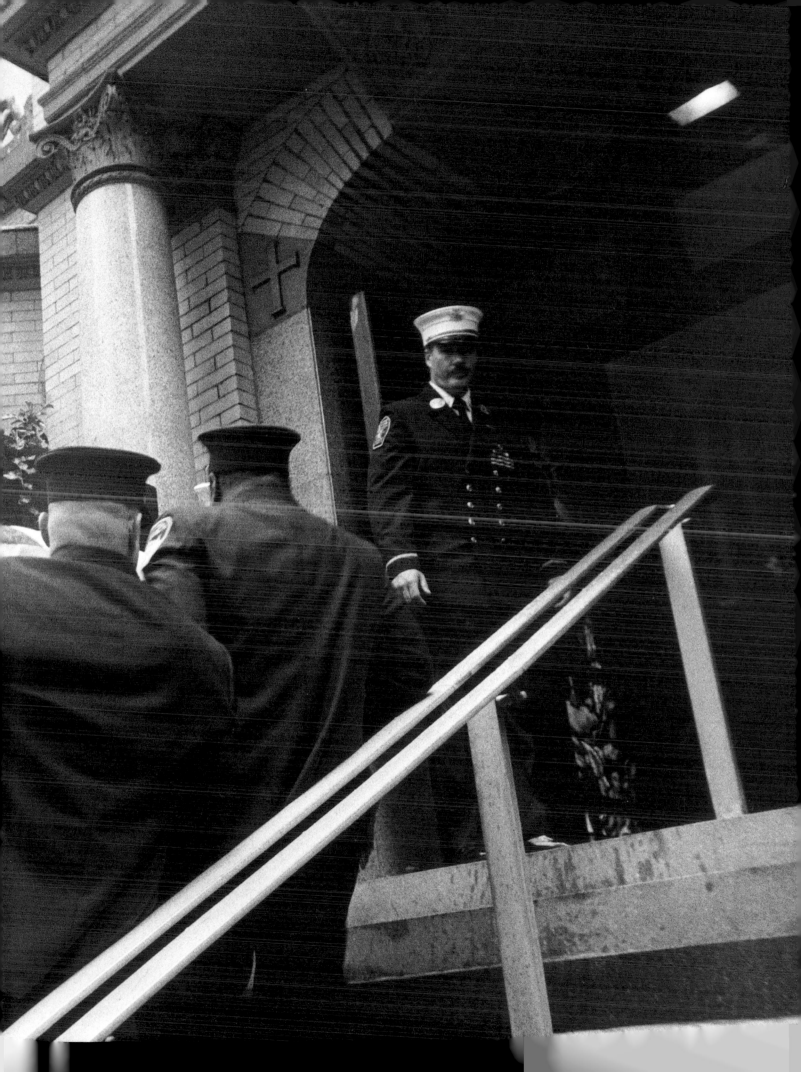

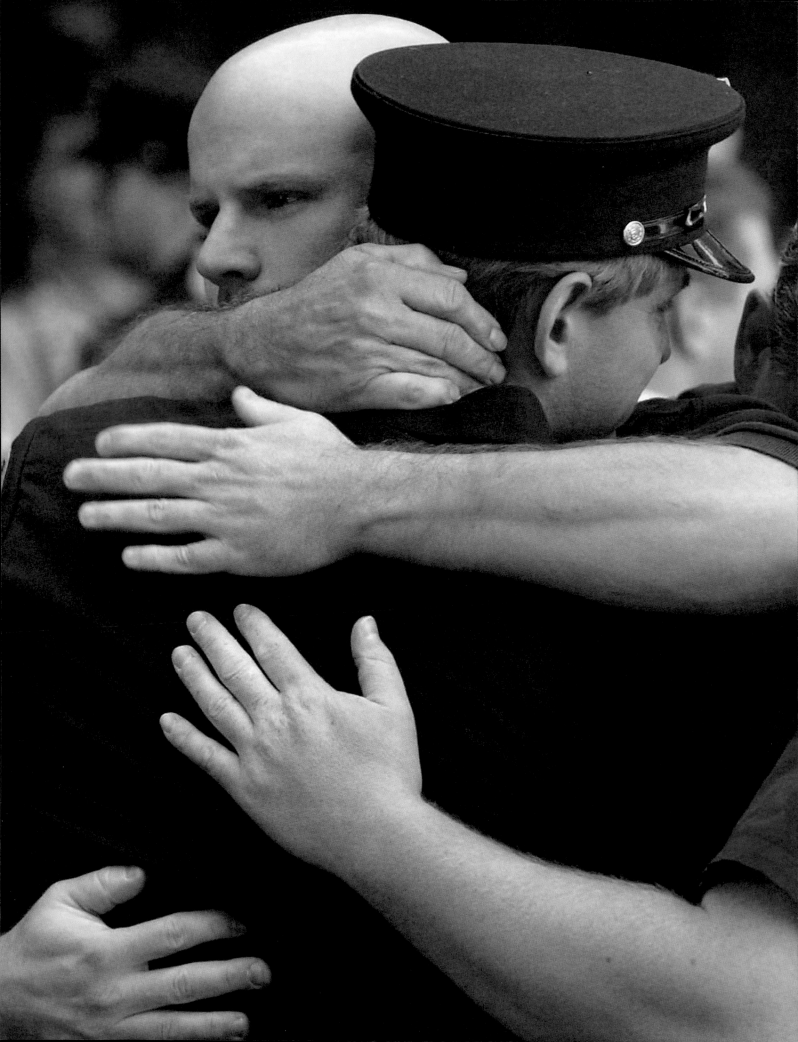

In a war fought without soldiers, the city's firemen became the closest thing New York had to Marines. As the tragedy unfurled, there were countless stories of individual heroics performed by men who went into the towers but did not come out. At a ceremony to promote 168 officers and firefighters into the thinned departmental ranks, Mayor Giuliani quoted Churchill: "Courage is rightly esteemed the first of human qualities because it's the quality which guarantees all others."

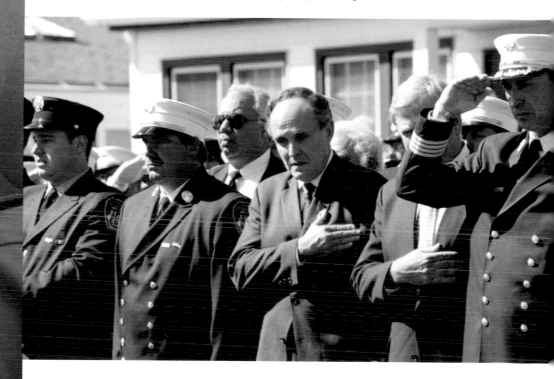

Firefighters embraced at Chief of Department Peter Ganci's funeral. The department's senior officers, joined by Mayor Giuliani, bade farewell to their fallen leader. In his eulogy, the mayor said, "When the tower came down, he got his men out. He sent them north, and he went south—right into the danger—to get more of them out. You have to pay a big price for democracy. And now we're learning what that means. It means that we have to sustain these losses; we have to have the strength to get through it." PHOTOGRAPHS: Joe Raedle/Getty Images (left); Michael Sofronski/Gamma (above)

Firehouses soon became memorials to fallen comrades. In the firehouse at Manhattan's 49th Street and Eighth Avenue, fifteen men were missing from the units headquartered there. At Ladder 13 on East 85th Street in Manhattan, firefighter Thomas Hetzel's portrait was hung with his gear.

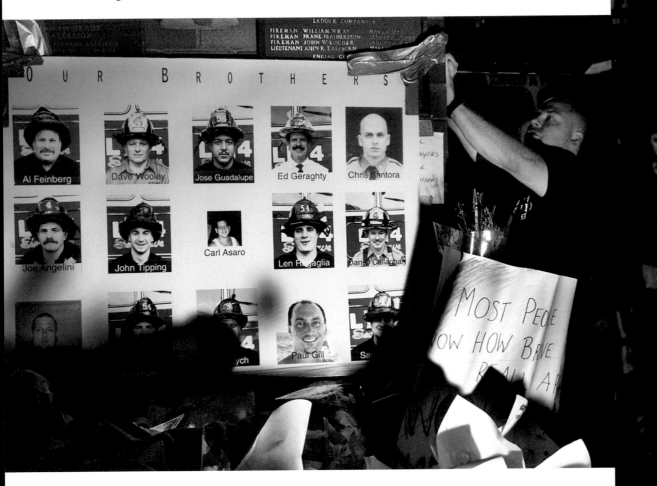

New Yorkers converged on their neighborhood firehouses, bearing dry socks for those who hadn't been home for days, more food than anyone could eat, cards and children's drawings, checks for widows and orphans, and flowers— seas of flowers. Certain streets became so clogged with well-wishers that they had to be closed to traffic. "Hey, these are our neighbors and our friends. We have been returning the love and respect that they have shown us for one hundred years at this station," explained Lt. Daniel Mullins of Engine 5 at East 14th Street in Manhattan. PHOTOGRAPHS: Gary Hershorn/Reuters/Timepix (above); Brian Finke (right)

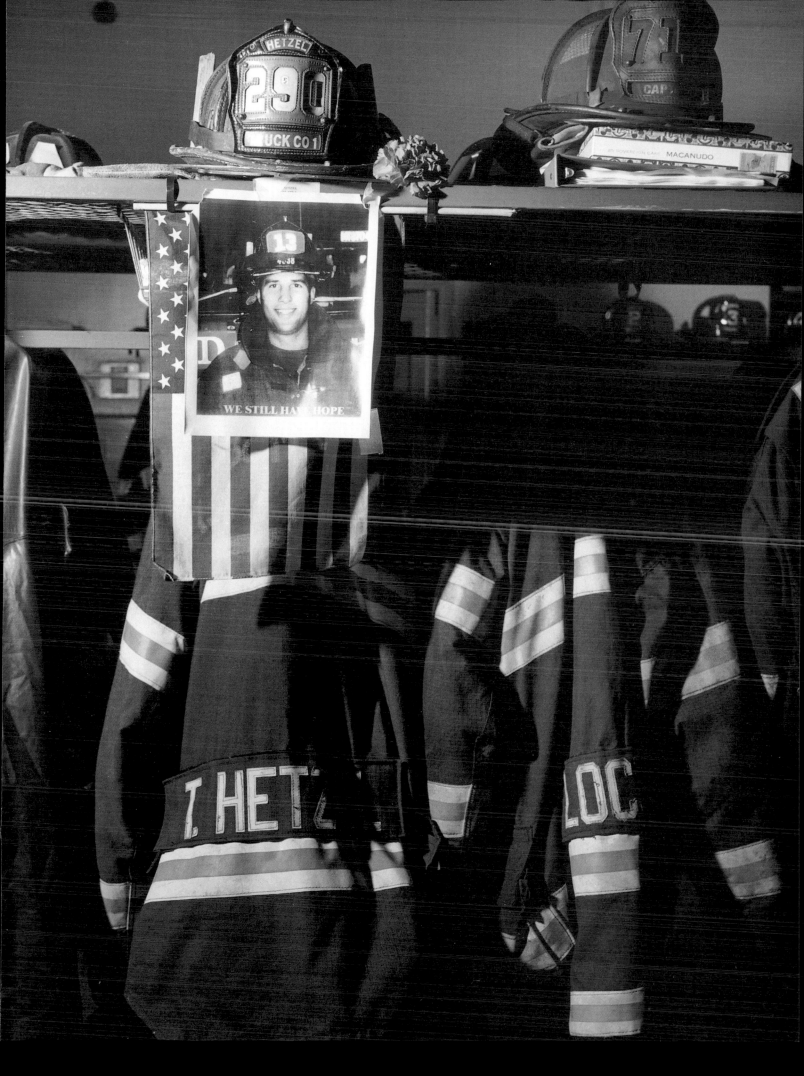

You will
always be
My
Hero Love
 Tiffany

A funeral Mass for thirty-six-year-old Port Authority officer Dominick Pezzulo was held at Our Lady of the Assumption Church in the East Bronx. Outside, Tiffany Massagli, eight, who lives across the street, expressed the feelings of the entire city. "Dominick dug himself out of the rubble to safety," the Reverend Donald Dwyer said at the funeral. "But when he realized that a fellow officer was still covered with the rubble, still inside, he returned through the rubble, through the same tunnel that he helped dig, to save a comrade, to save a brother. He died trying to save the life of a fellow police officer." PHOTOGRAPH: Beth Keiser/AP Wide World Photos

Rescue workers who spent brutal days down on the rubble emerged to find a hero's welcome lining the West Side Highway. "I had no idea what to make of it when I came out. But it's encouraging," said one exhausted firefighter. On a chain link fence across the street, people tied yellow ribbons to honor the missing and hung banners expressing their gratitude. "The best of us donned hard hats and workman's gloves and face masks to deal with this horror as decent, civilized human beings," New York's Cardinal Egan said in tribute. "And the rest of us supported them, applauded them and prayed for and with them."

PHOTOGRAPHS: **Robert Stolarik/Gamma** (below); **David Corio** (right)

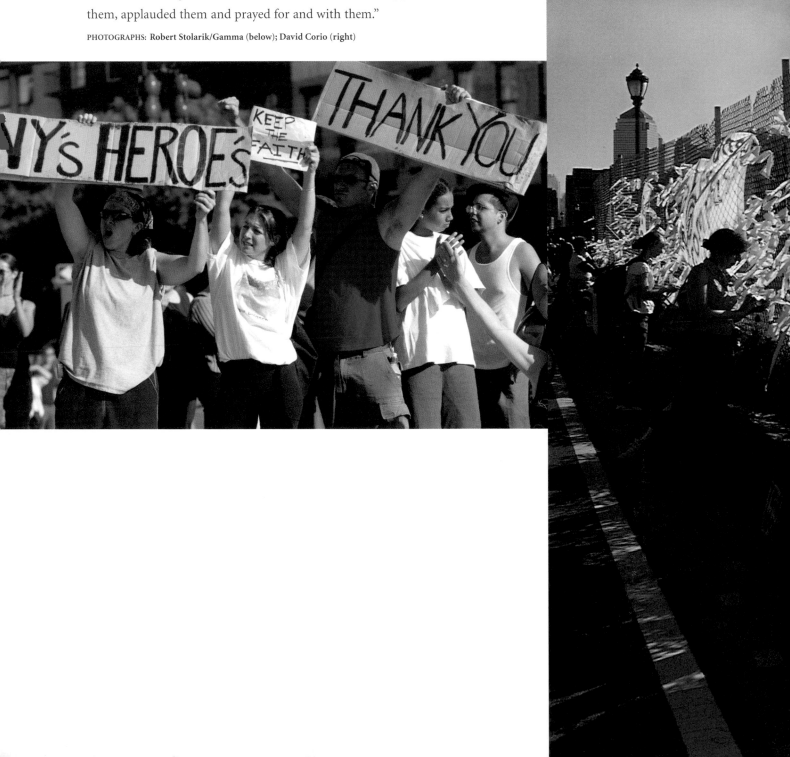

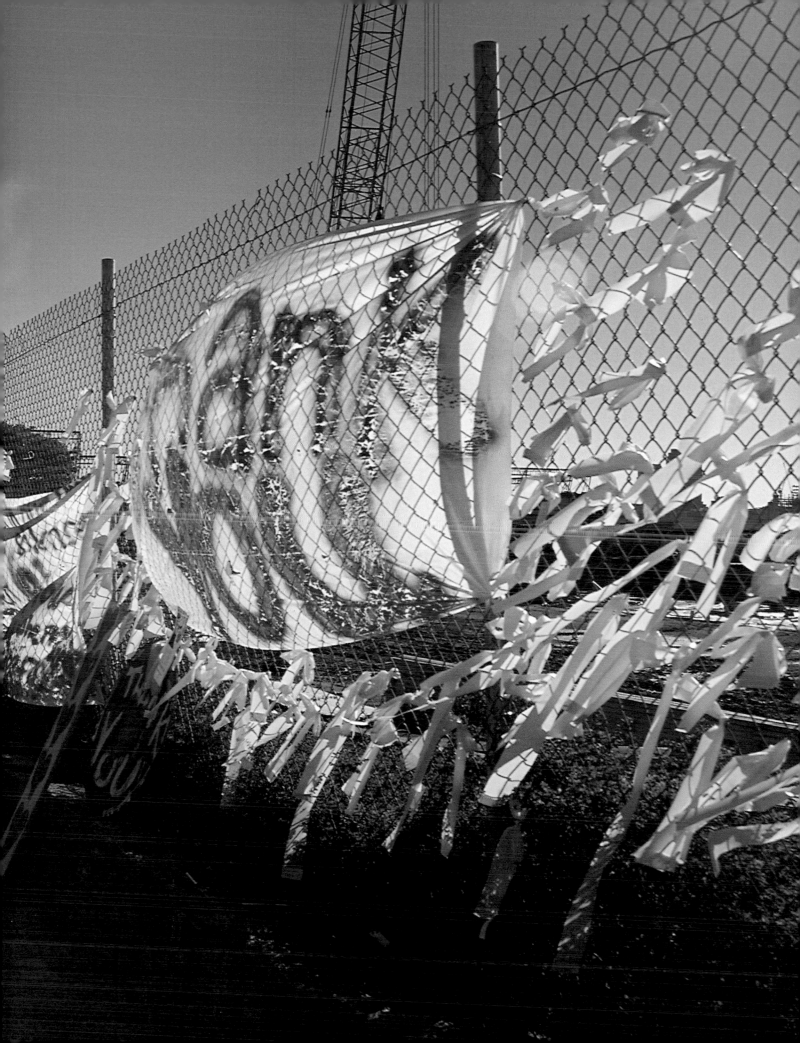

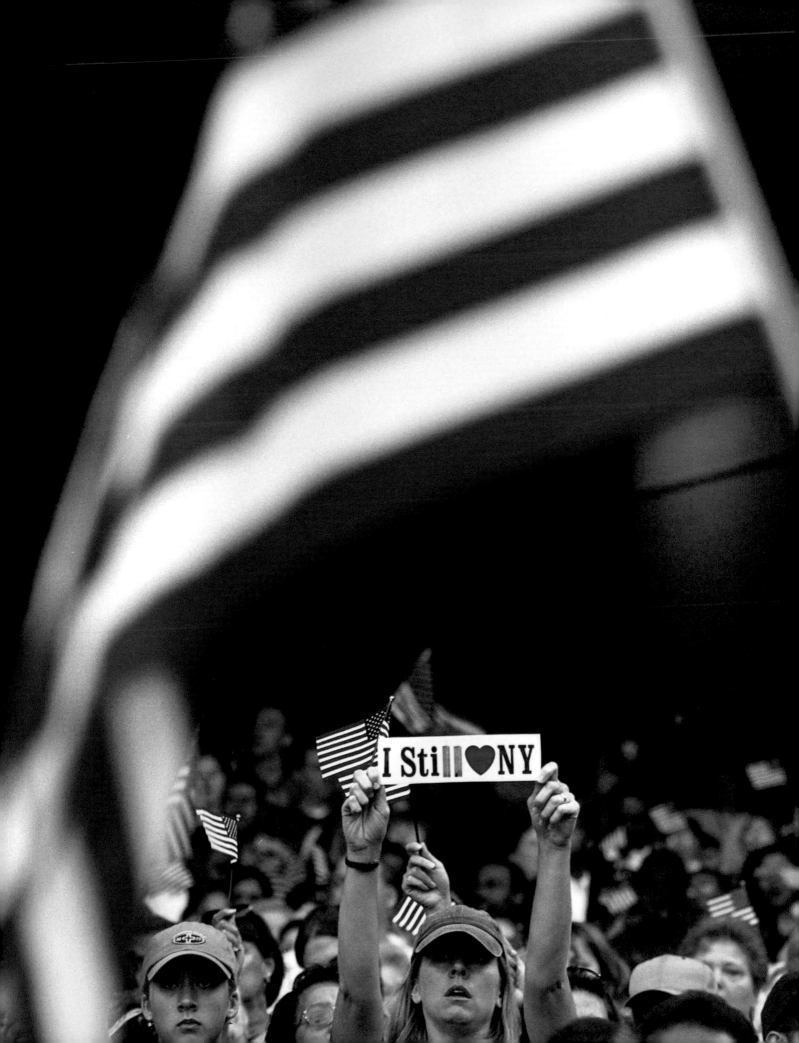

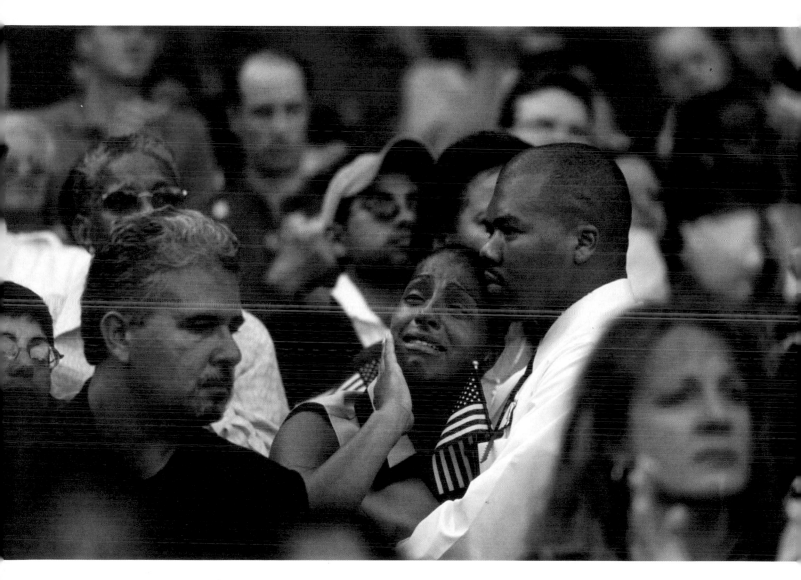

"We shall not be moved," Oprah Winfrey told 20,000 people assembled for a prayer service at Yankee Stadium almost two weeks after the attack. A gathering of Christian, Muslim, Jewish, Sikh, and Hindu leaders listened as chants of "U.S.A." rolled over the stadium in waves, reaching a crescendo when Mayor Giuliani declared, "To those who say our city will never be the same, I say, you are right. It will be better." Governor George Pataki struck a more reflective note: "We're powerless to bring our loved ones back. But it is well within our power to bestow on them the honor they deserve. The highest honor we can pay them is to rise above the evil that claimed their lives." PHOTOGRAPHS: Timothy Fadek/Gamma (opposite); Lisa Quinones/Black Star (above)

Smoke from the rubble continued to drift over the city, but each day represented a step toward normalcy for its children. Looking skyward, they could still see the work of human hands reaching up in improbable ways. The towers are lost, but the imagination and conviction that built them remains. "Courage," Mark Twain said, "is resistance to fear, mastery of fear—not absence of fear." PHOTOGRAPH: Mark Peterson/Corbis SABA

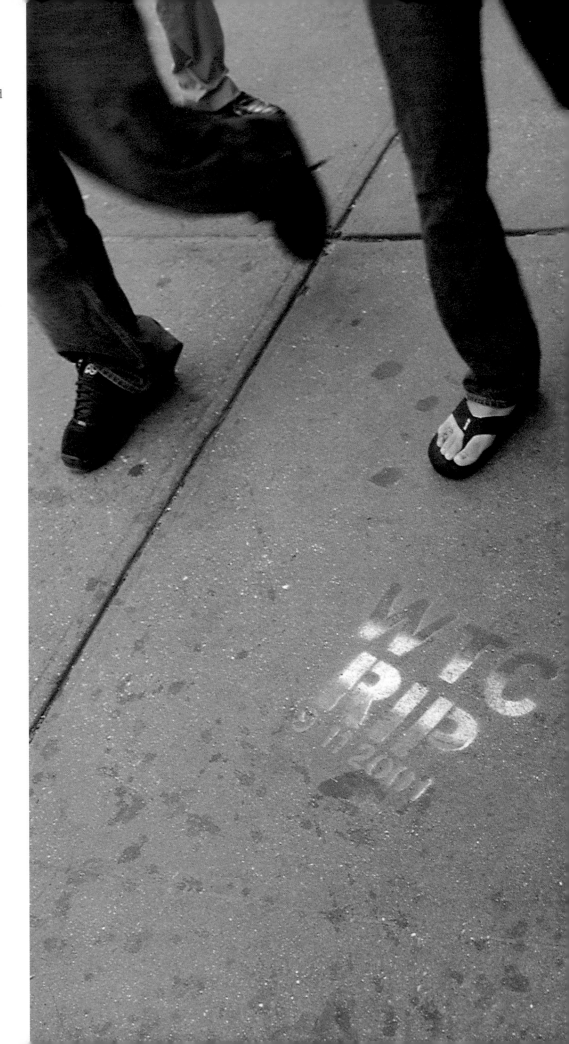

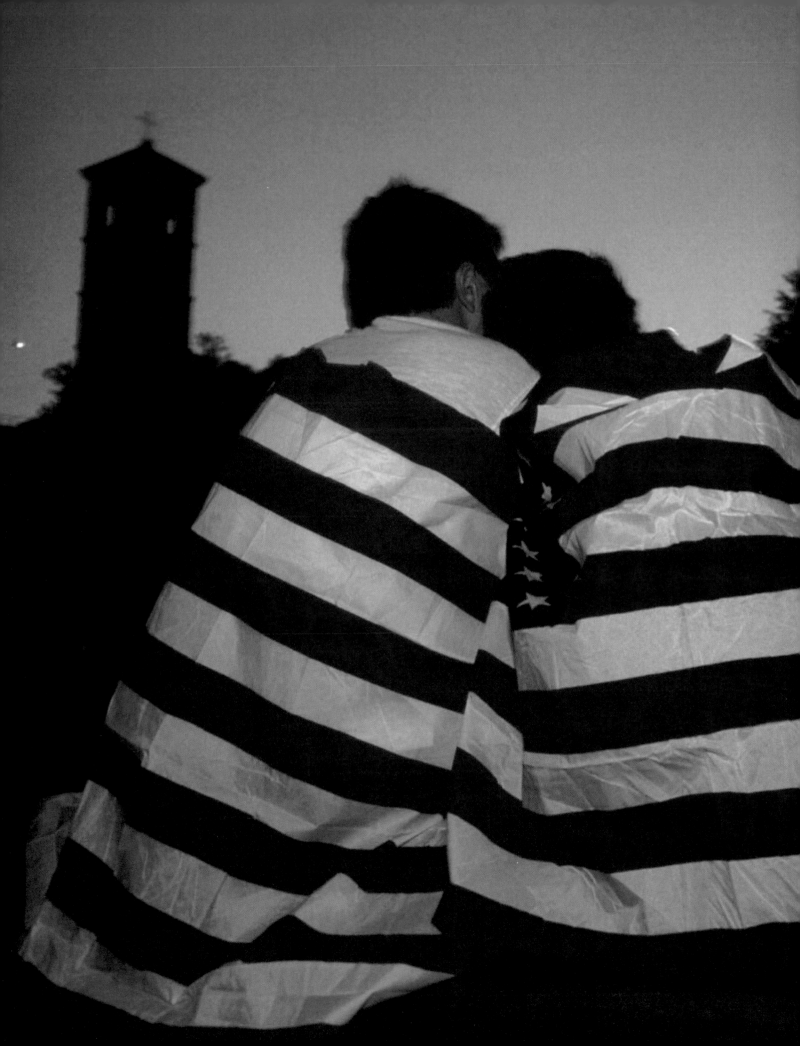

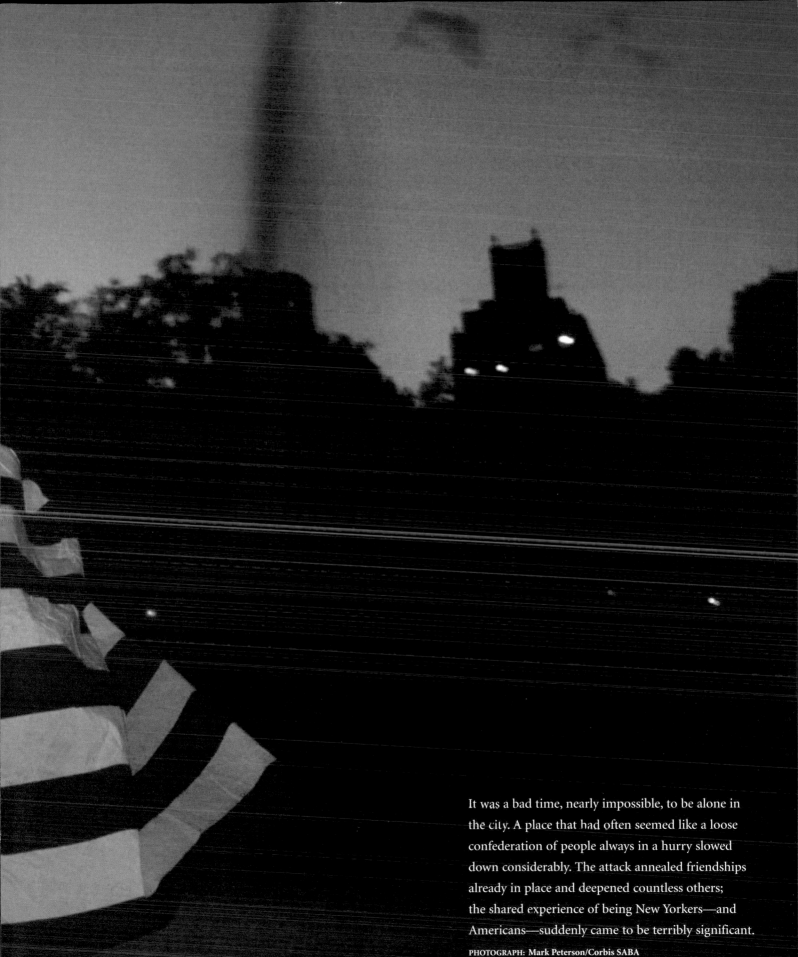

It was a bad time, nearly impossible, to be alone in
the city. A place that had often seemed like a loose
confederation of people always in a hurry slowed
down considerably. The attack annealed friendships
already in place and deepened countless others;
the shared experience of being New Yorkers—and
Americans—suddenly came to be terribly significant.

PHOTOGRAPH: Mark Peterson/Corbis SABA

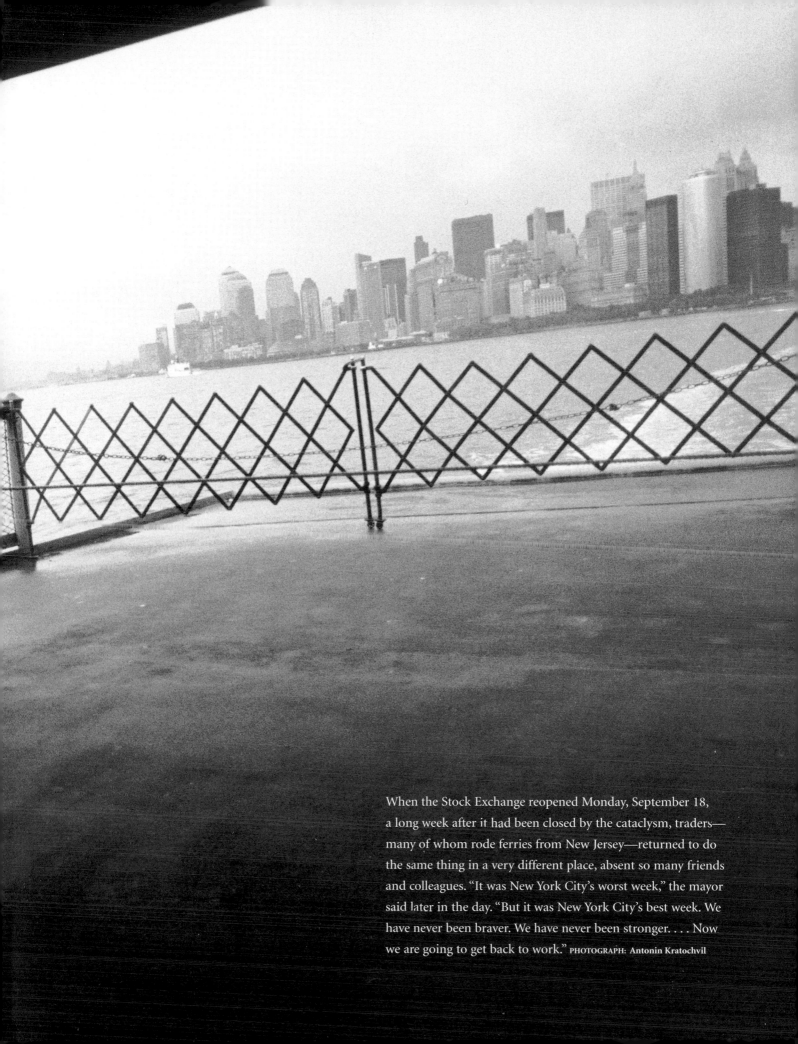

When the Stock Exchange reopened Monday, September 18, a long week after it had been closed by the cataclysm, traders— many of whom rode ferries from New Jersey—returned to do the same thing in a very different place, absent so many friends and colleagues. "It was New York City's worst week," the mayor said later in the day. "But it was New York City's best week. We have never been braver. We have never been stronger. . . . Now we are going to get back to work." PHOTOGRAPH: Antonin Kratochvil

ACKNOWLEDGMENTS Many photographers and photo agencies generously donated photographs to make this book possible. Thanks to photographers Mary Altaffer, Jerry Arcieri, Zana Briski, Chris Corder, David Corio, George Farinacci, Brian Finke, Sean Hemmerle, Thomas Hoepker, Rob Howard and Lisa Howard, Jose Jimenez, Clark Jones, Antonin Kratochvil, James Leynse, Richard B. Levine and Francis Roberts, Michael Parmelee, Mark Peterson, Spencer Platt, Joe Raedle, John Reardon, Mark Stetler, Tom Stoddart, Jonathan Torgovnik, and Nathaniel Welch. Thanks, also, to agencies and their staffs that donated photographs: Jeffrey Smith of Contact Press Images; Marcel Saba, Leslie Powell, Christina Cahill, Travis Ruse, Katy Howe, Janet DeJesus, Charleen Chan, and Kristine Reichert of Corbis SABA; Colleen Stoll and Amy Lentz-Sauer of Getty Images; Nathan Benn, Rebecca Ames, Laura DeKorver, and Natasha O'Connor of Magnum Photos; Woodfin Camp of Woodfin Camp & Associates; and United Press International/Newscom. Thanks to the AOL Time-Warner Book Group for contributing distribution services.

Other agencies and their staffs went out of their way to help with this project. Thanks to Jim Wood and Camille Ruggeriero of AP Wide World Photos; Barbara Sadick of Matrix; Jean Pierre Pappis, James McGrath, and Florence Nash of Gamma Press; Maria Mann of Agence France Presse; Anh Stack of Black Star; and Rona Tucillo of Timepix. R. R.

Donnelley & Sons provided timely production assistance.

A number of people at New York magazine and Harry N. Abrams, Inc., worked particularly hard to create this book. At New York, thanks to Chris Dougherty and his staff, Armin Harris, Lauren Reichbach, Sally McKissick, and Tania Fernandez, as well as John Homans, David Carr, Jeremy Gerard, Marion Maneker, Amy Boshnack, Alexandra Lange, and Jennifer Callahan. At Harry N. Abrams, Inc., thanks to Michael Walsh, Deborah Aaronson, Brankica Kovrlija, Hope Koturo, Alyn Evans, Bernard Furnival, Walter de la Vega, Elisa Urbanelli, and Kate Norment.

Speeches and statements by public figures quoted in this book are taken from the public record as printed in newspapers or on the websites of news-gathering organizations. All other quotations were reported by New York magazine, with the exception of the following: Louis Lesce (page 19), The New York Times; Reverend Michael Duffy (page 34), New York Daily News; Steve Kastenbaum (page 39), WINS Radio; Linda Blackman (page 42), People magazine; Robert Doremus (page 83), The New York Times; Mayor Rudolph Giuliani (page 86), Tim Russert interview, CNBC News; Senator Chuck Schumer (page 90), The New York Times; Howard Lutnick (page 95), The New York Times; Rabbi Peter Rubinstein (page 101), New York Daily News; Reverend Donald Dwyer (page 114), The New York Times.

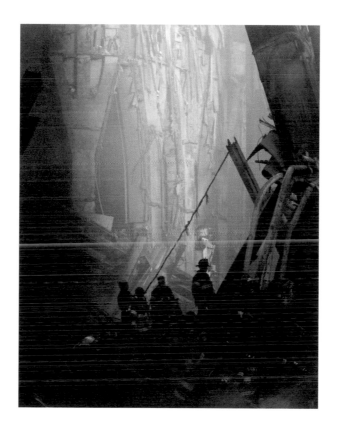

Proceeds from the sale of this book are being donated by *New York* magazine,
Harry N. Abrams, Inc., and other contributors to the September 11 Fund.

ISBN 0–8109–0562–0

PHOTOGRAPHY EDITOR: Chris Dougherty, with the assistance of Armin Harris, Lauren Reichbach,
 Sally McKissick, and Tania Fernandez
EDITORS: Caroline Miller and Eric Himmel, with the assistance of Deborah Aaronson
DESIGNERS: Michael J. Walsh, Brankica Kovrlija

Printed in the United States of America
10 9 8 7 6 5 4 3 2 1

Harry N. Abrams, Inc.
100 Fifth Avenue
New York, N. Y. 10011
www.abramsbooks.com

Abrams is a subsidiary of

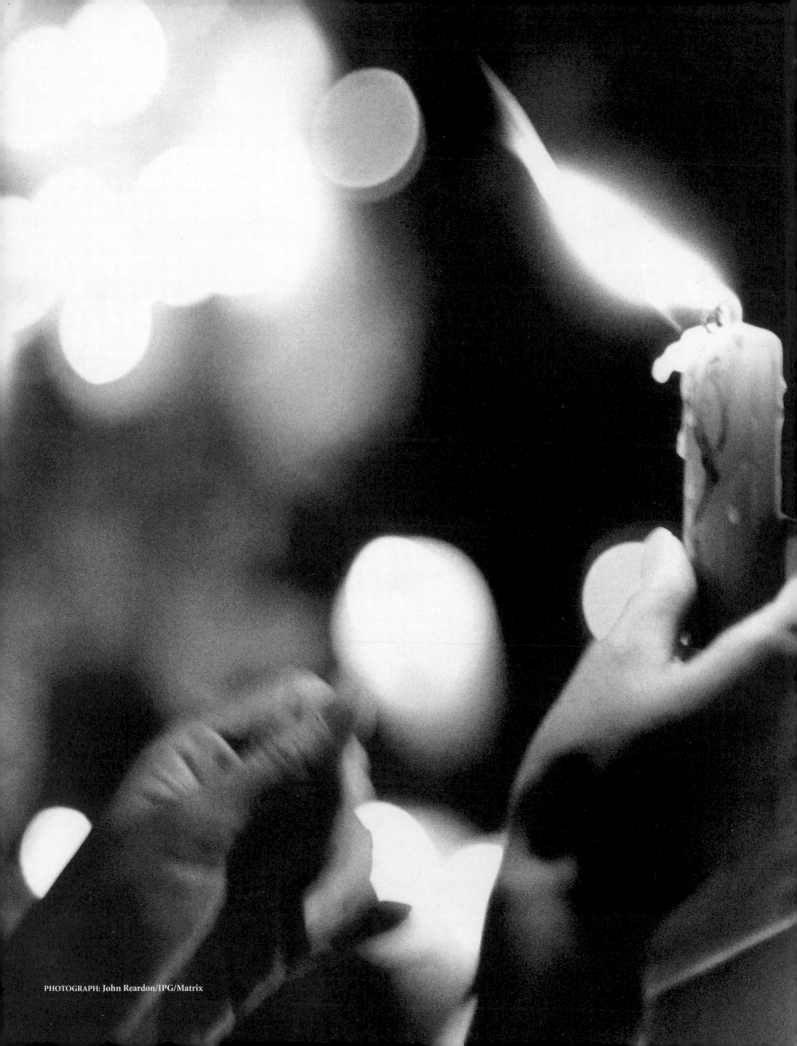